ORIENTAL
EROTIC ART

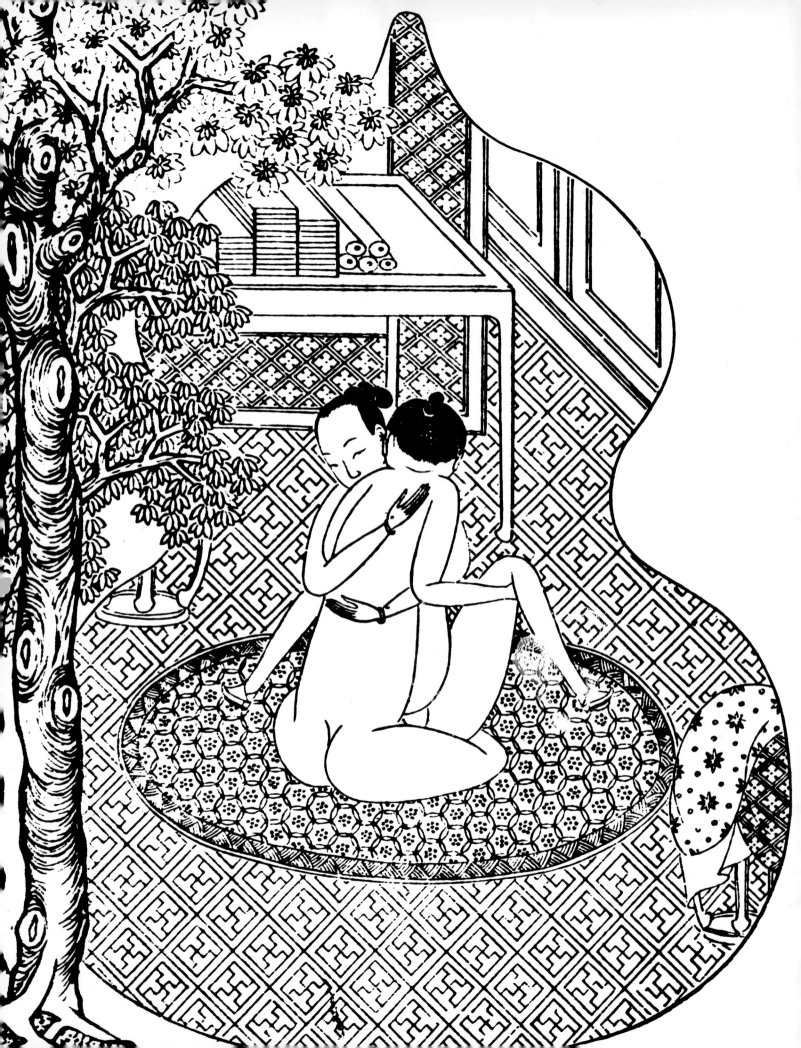

ORIENTAL EROTIC ART

Philip Rawson

Book Club Associates

London

This edition published 1981 by
Book Club Associates
By arrangement with Quartet Books Ltd

Copyright © John Calmann and Cooper Ltd 1981

This book was designed and produced by
John Calmann and Cooper Ltd, London

ISBN 0 7043 2291 9

Phototypeset by Input Typesetting Ltd., London SW19 8DR
Printed in Hong Kong by Mandarin Offset Ltd

1. (*Frontispiece*) Union of Yin and Yang in a *hu-lu*,
symbol of the enclosed world of Paradise.
Engraving from the Chinese novel *Su Wo P'ien*
('The Moon Lady'), published about 1610.

Contents

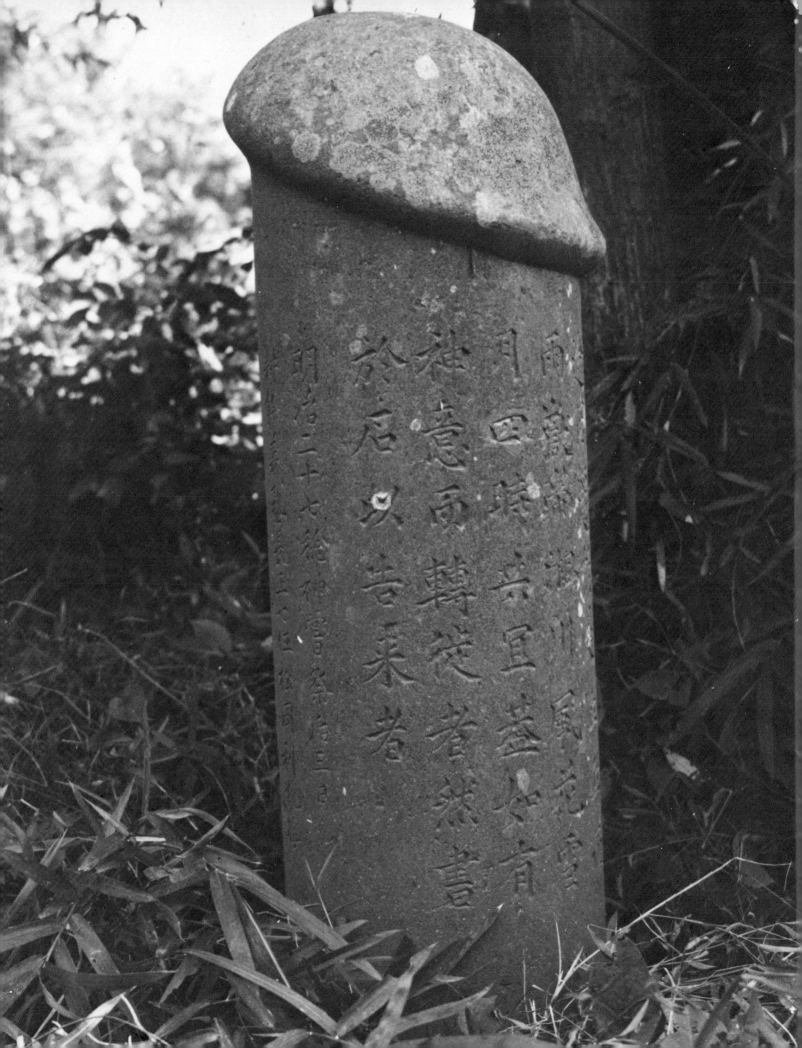

ONE

Introduction

Human thought has evolved over a long period of time, together with the languages that express it. From being able to signify facts and feelings quite simply, men became able to deal with very complex and abstract ideas. They did this by weaving together references to similar things, and compiling a wealth of metaphor by criss-crosses of analogy. So when we understand and explain some complex aspect of our lives the language we use refers back to groups of relatively immediate experiences which we can all share.

The realities of sex and sexual experience have provided mankind with very important components of meaning. Nowadays we tend to hide and forget the body-references buried in our language, though our analogical understanding and explanation of how things come into existence continually refer to them.

Lost components of meaning lie sleeping, so to speak, in our language and thought, and one of the tasks of art is to wake them up and revitalize them in various ways. We think of how that which 'is' (the word implies breathing) comes to 'be' (implying growth swelling before us) as a process of Genesis. 'Generate', along with all the senses of 'generation', refers directly to birth, descent and physical race, perhaps even to body fluids. And 'fertile', meaning fruitful, is connected with carrying and giving birth. Our entire existence depends on the fertility of our earth and its animals.

The experiences lying behind these kinds of original metaphor are, of course, rooted far deeper in immediate bodily experience than the words which now express our meaning. One of the penalties we pay for our abstract languages is that we spend a large part of our life out of touch with direct experience. But artistic metaphor can reach down to a region of recognition and memory which lies below the surface of normal discourse. One of the cardinal notions of Western philosophy, for example, is expressed in the beautiful image that 'materia appetit formam ut virum femina' – 'matter seeks (and desires) form as woman does man'. The analogy brings out the philosophical

2. Phallus-shaped memorial stone, with calligraphy. Kanagawa district, Japan, dated 1894.

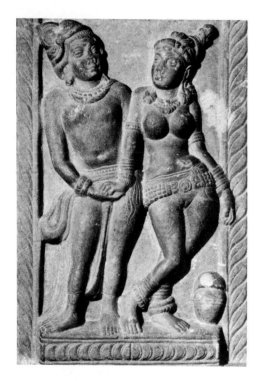

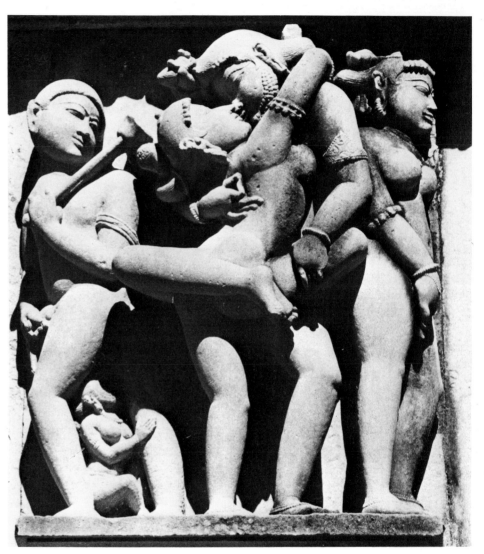

3. (*Above*) A beautiful couple carved on a shrine. Limestone, from a Buddhist site at Nagarjunakonda, south-east India, second century AD.

4. (*Right*) Sexual intercourse in heaven. The erotic images personify the 'charm' of the transcendent realm represented by the temple. Divine presence is identified with the sense of deep sexual arousal. Stone carving on the heaven-bands of a temple at Khajuraho, central India, c. 1000 AD.

relationship between matter as maternal substance and form as masculine shaping principle. But if we take the trouble to think back to the reality suggested by the image, and read the implied relationship in reverse, we can see how it dignifies the fact that woman seeks man with the light of philosophical intuition, and carries our imagination back to questions and ideas about origins.

The arts we shall be looking at here were made by and for people conscious of exactly this kind of mutual illumination of realities. They accepted that the human body, complete with its senses and emotions, as well as its intellect, is the organ by which we know our worlds. So they did not represent sex and its functions for the sake of casual stimulation. On the other hand, they knew that sexual symbolism becomes devalued and inexpressive if it loses the wealth of its reference to actual sexual experience with its pleasures, pain and ecstasy. Here is the chief thought behind this book. The sections follow a kind of descending curve, from the conscious and careful use of sexual

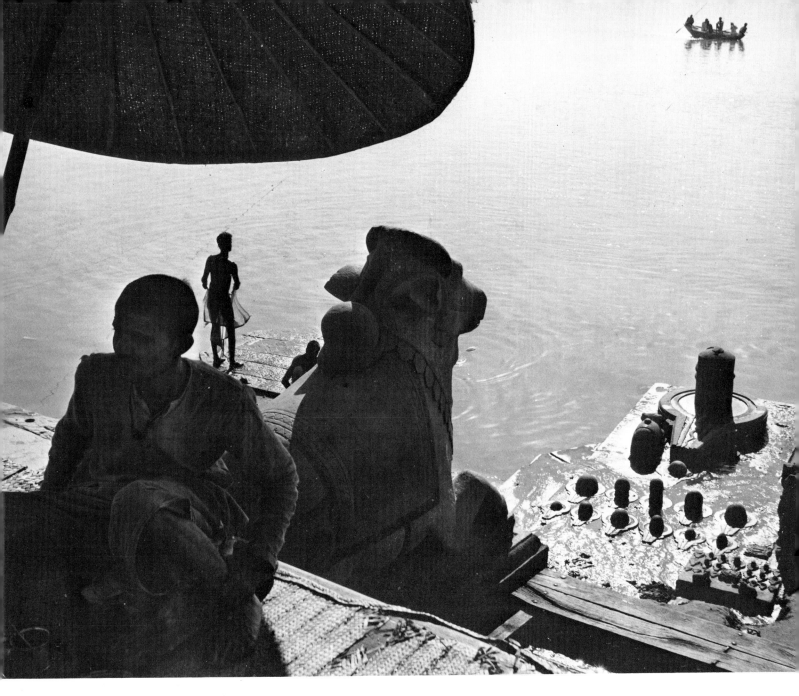

5. Lingam-yoni altars, with Shiva's bull, on the banks of the Ganges at Benares. Stone, modern.

metaphor in India, to the subtle allusions and metaphors of China, and ending in Japan, where the metaphor is only just discernible through the convoluted and sensual lines of the painters and print artists in Tokyo.

Of the three countries, India's overt interest in erotic matters is the best known. The great second century AD Sanskrit manual on all the arts of love, called the *Kāmasūtra*, has now been translated – unexpurgated – into virtually every Western language; only thirty years ago one needed Latin to be able to read it all. Two other texts, the *Kokashāstra* and the *Ratīrahasya*, have also been translated entire. Yet others exist in Indian languages which deal very explicitly with, for example, the erotic life of women. All these works treat love as truly an affair of giving and receiving pleasure. Yet paradoxically Indian culture was always profoundly concerned with asceticism. Since antiquity, Indian society has been divided into castes; until about 600 AD these were relatively broad categories distinguishing priests,

9

soldiers, citizens and so on. A few centuries later, however, they had evolved into a complex network of occupation groups, each governed by exclusive obligations and hereditary rights. Nowadays Indian society seems extremely rigid. Marriages are arranged by families in childhood, and sexual continence is widely believed to be both a virtue and a recipe for success in any undertaking. But these attitudes are not in fact conflicting: both the cult of pleasure and the reverence for abstinence are sides of the same coin – sex is metaphysically serious.

The author of the *Kāmasūtra* is reputed to be Vātsyāyana, a high-caste Brahmin sage. The *Kokashāstra* is called after another sage, Koka. The text describes him as the only person able, by his self-restraint and erotic skill, to satisfy a certain extravagantly sexy lady at the court of a king. Such sexual prowess counted as wisdom, but it was important that it give genuine pleasure, and not be a solemn affair nor at all inhibited by false shame. This literature belongs to a group of Indian classics that deal with the legitimate rights and duties of the different social classes. Those who have successfully worked their way up through the cycles of rebirth and are reincarnated as well-to-do citizens are entitled to enjoy all the pleasures that go with their new status. So long as he observed his caste rules such a citizen was doing nothing wrong in availing himself of the services of those whose own caste obligations were to give pleasure.

There are, however, higher things to aim for than the status of well-to-do citizen. For someone who has attained a higher rank in his series of rebirths, sexual energy becomes serious in a different way. Instead of spending it in physical sex he should 'turn it round', and convert it into a radiant inner heat, called tapas. The force that normally surges through the body as sexual desire is intrinsically divine. Stimulated, hoarded and contained, it becomes a fuel for metaphysical achievement, to propel an ascetic to ultimate release. It is this particularly high-caste attitude towards sex which has filtered down through the rest of Indian society today, for various historical reasons. But the opposite attitude, that of sexual generosity, was more important in the past, as we shall see. Here let us remember that a sublime metaphor in one of the oldest and most sacred Sanskrit texts defines his lack of sexual delight as the reason why the Original Creator projected from himself an Other with whom he could creatively couple.

China's interest in erotic matters is less well understood than India's. Her society has always been intensely secretive about personal affairs; though a happy and sexually fulfilled private life was always considered to be the basis for a successful public one. This secretiveness may have much to do with the harshness of China's history, and the rank materialism by which it was so often corrupted. History records innumerable episodes of disruption and hideous cruelty which caused men and women to suffer extremely. In the social disasters

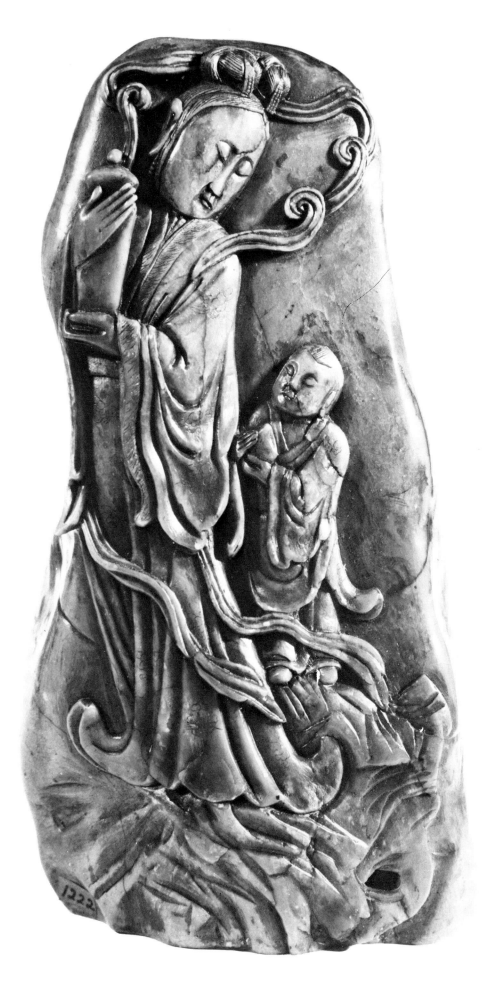

6. A female personification of Yin bearing a
Yin-vase, and accompanied by a male Taoist
'child'. Stone seal, China.

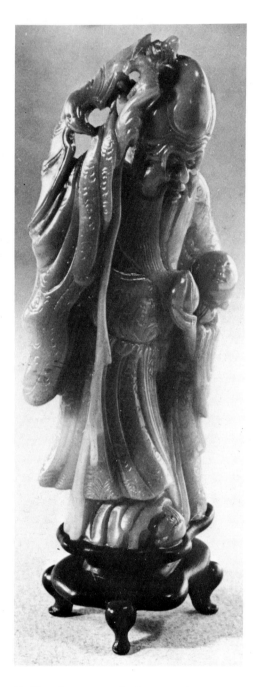

7. Shou-lao, star-god of Immortality. His skull is elongated by meditation, and over it peers the dragon-staff of cosmic power. A Taoist 'child' offers him the peach-fruit of female sexuality. Miniature jade carving, China, eighteenth century.

inflicted by invasions and decades-long civil war, women were seized as chattels; and even in time of peace they could be taken from husband and family by any powerful man who coveted them. Men were wrenched from their livelihood and enslaved; sometimes they were also castrated, either as a legal punishment, or in order to enlist them in the corps of eunuchs who staffed the palaces of emperors, provincial governors and wealthy men, and guarded their concubines.

In Chinese a very large number of manuals on the arts of love were composed, though none has yet been translated in its entirety. No single one seems to have attained the status of sacred classic as the *Kāmasūtra* has in India. Nevertheless the erotic teaching they contain was taken, if anything, even more seriously than such teachings were in India. There was no aspect of life to which, in the last resort, sexual fulfilment was irrelevant. Many of the teachings are put into the mouth of a mysterious incarnation of Femininity called either The Dark Girl or The Plain Girl. Their descriptions of the possible variations in the sexual act are even more varied and vivid than the Indian. Whereas Indian texts describe static postures, the Chinese texts go into considerable poetic detail about the kinds of physical movement that raise the pleasure of lovers to its peak; and movement as change is integral to Chinese ideas about cosmic reality and harmony. They are shot through with sexual metaphor. The creative energies coursing through the universe are held to fluctuate according to the dialectic of a pair of polar forces; and these forces are also embodied in the organisms of men and women. Hence they are thought of as male and female. To live in harmony with the currents of change running through the universe is the ideal of both personal and public life. For the individual, sexual relations play a very important role in attaining this harmony.

If the intercourse of man and woman re-enacts the intercourse of the cosmic forces, then pleasure is the index of successful interchange. So in Chinese theories of love as metaphysics there is never any doubt about the importance of shared delight. Even for people of high spiritual ambition, the Chinese never held that sexuality should be eliminated, but only controlled and etherealized. Once again, however, puritan episodes in recent history – a consequence of the influences of Confucianism and fundamentalist Buddhism – have fostered meditative teachings which demand that sexual stimulation be avoided. In the past, on the other hand, Taoist sects, whose teachings incorporated sexual meditation, played significant parts in Chinese social history.

In Japan the Chinese Dark Girl texts were imported, along with the huge mass of Chinese literature – largely Buddhist – which was assimilated from the sixth century onwards. But literary culture was very much the property of the Imperial and great feudal courts. These cut themselves off radically from the peasantry, who were treated

virtually as a race apart. They had no access to the refinements of life; and economically and socially they were bitterly oppressed, even though the rice they produced was literally the sole wealth of the island empire. Trade contributed little until the sixteenth century. But partly because of their isolation from outside influence the Japanese peasantry preserved an archaic sexual culture, virtually to the present century. It embodies metaphors of great strength and purity which relate sexual love and fertility. The oldest Japanese-language mythical texts, which record the legends of Shinto, share something of this culture. But the illiterate peasantry have left many works of art and rituals which illustrate how deeply they felt their personal lives to be bound up with their animate countryside.

Even during the early middle ages little seems to have been written about the physical realities of love at the courts. Two ladies of the Imperial court wrote extensively about the romantic aspects, however. Murasaki (*c.* 980–*c.* 1030), in her *Story of Prince Genji*, gives a vivid picture of the handsome young courtier's love affairs. Sei Shonagon (*fl.* 1000) in her diary records rather more astringently the amorous intrigues of her fellow ladies-in-waiting. To them love affairs were an art-form, expressed in exchanges of minimal poems hinting at classical allusions, by subtle messages conveyed through sprigs of symbolic plants, or by wearing the clothing in certain ways.

All this vanished after the military dictatorship – the Shogunate –

8. Section of a painted scroll illustrating a palace of amorous women. In the right foreground are dildos and peacock feathers (Chinese Yang symbols) in a vase. In the background are pierced female Tao stones. Japan, nineteenth century.

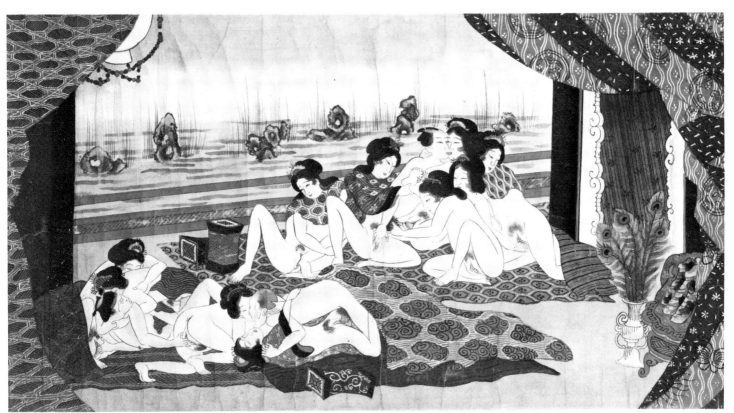

was set up in the twelfth century, expressly to reform what it saw as the effeteness of court society. The puritanical Samurai code was imposed upon Japanese feudal society. This code was nominally Buddhist, and revolved around intense feelings of personal honour and minutely defined social status. Men and women were closed into a rigid structure of mutual obligation, in which formally arranged marriages played a cardinal role. There was no scope for what we should consider freedom of choice or romantic love. A few stories record scandalous instances of sexual libertarianism, which were punished with extreme severity. The normal end to a socially unsanctioned relationship was the suicide of both lovers. Even the episodes of ferocious civil war which punctuated Japanese history, and brought disaster to thousands of people of all kinds, did not soften the code. Oddly, the greatest freedom from social oppression seems to have existed in some of the Buddhist monastic orders.

All of this changed radically after Edo (Tokyo) became the capital in the sixteenth century. With the growth of both internal and external trade the populations of the capital and other cities expanded. A prosperous city bourgeoisie and a proletariat of immigrant peasants and artisans appeared, who were not bound by the feudal Samurai code. But neither were they free in any modern sense, being subject to severe external control by the Shogunate. They were, however, permitted to devote themselves to the 'floating world' of immediate pleasure, so long as their activities did not erode the feudal structure of upper class society. In practice, of course, they did, by degrees; but only to a limited extent.

Some confusion of goals arose. Married women were supposed to be respectable, and bring up their families with single-hearted dedication. But their husbands pursued personal pleasures as a kind of right. The pleasures themselves – prostitution, theatre, the arts – were organized and controlled, subject to censorship not on 'moral' grounds but on political and pragmatic. Things are pretty much the same today for Japanese men, who may be sent by their industrial firms in parties to tour the pleasure quarters of the world's great cities – Bangkok, Hong Kong, Paris, London and New York. Japanese erotic culture thus seems to show a double aspect. On the one hand, it reaches back to an archaic level of symbolism; on the other, it has become a cult of primarily masculine pleasure, which is nevertheless infused with the archaic feeling that sex is still intrinsically good.

In relation to all these phenomena, what were the roles of the visual arts? First of all, there is no doubt that they were meant to stimulate sexual response. This is obvious in the case of the picture albums and scrolls of lovemaking techniques intended for the use of young lovers. But all Eastern erotic art is also meant to convey what it feels like to be filled with desire. Indian and Shinto temple sculpture add dimensions of depth and mystery to erotic feeling. The state of being

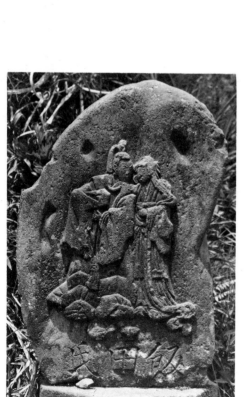

9. Dosojin couple. They are the guardians of both the peasants and their fields. Niigata area, Japan.

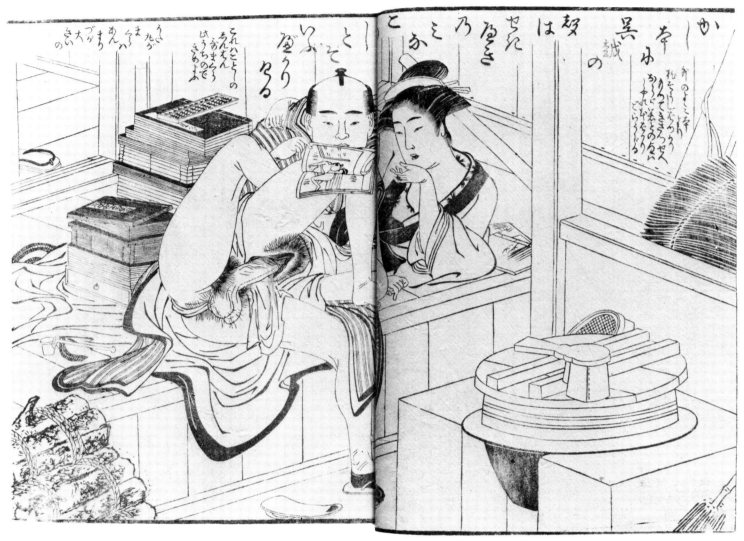

10. Studying the erotic posture book together: the couple enact the beneficent union. Woodblock print, Japan, late eighteenth century.

possessed by desire was valued by the patrons of these arts not merely as the prelude to a biological spasm of relief, but as an inner experience of the transpersonal or divine. Sexual love in all its physicality was taken as a means of access to the realm of the psyche where human and divine meet, and the higher self, transcending ego, may flower.

The styles of Indian erotic art emphasize the eternity, sublimity and vastness of their subject matter. Chinese arts, with their subtle metaphors and allusions, lead the mind into a world woven together by invisible threads of force and significance; while Japanese art, especially that of Edo, conveys a sense of the splendour of sex, but reflects at the same time a Buddhist view of the phenomenal and transitory in that splendour. In all these arts the criterion of value lies in their expressive invention. What matter are the extra depth and resonance of meaning with which the artistic language invests the image. The artists laid before the eyes of their societies a wealth of metaphorical implication in the acts and qualities of the sexual love they portrayed.

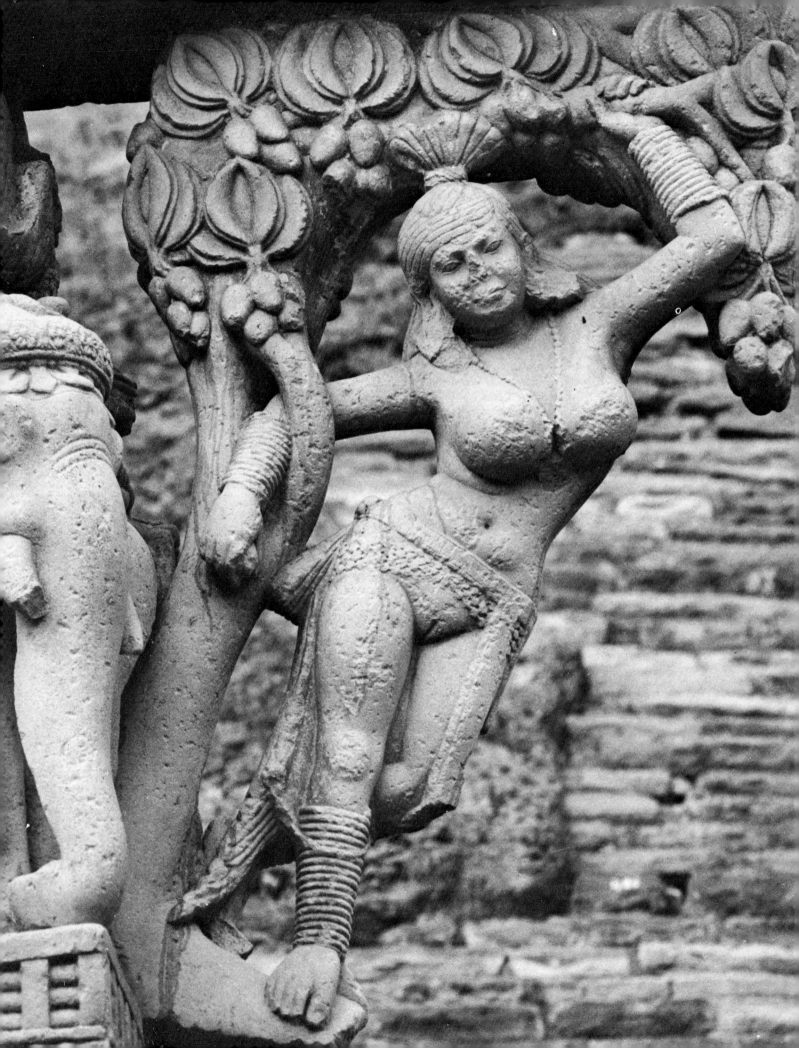

TWO

India

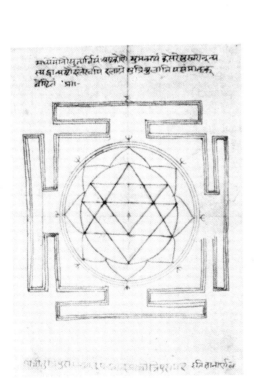

12. (*Above*) Yantra. Ink on paper, Rajasthan, eighteenth century.

11. (*Left*) Tree goddess on one of the gateways at the Buddhist shrine of Sānchi. Sandstone, central India, first century AD.

Spirit and body

It is in India that art, religion and sexual love have been most completely fused. The Great Duality appears there in many different shapes and forms, each of them revealing one of its many possible implications. This is partly because until very recently Indian culture has continued to develop extremely archaic strands of imagery and thought, into which the image of sex has been woven as metaphor. That which the Western intellect might be inclined to think of in conceptual dialectic as a cold polarity of opposites – say, as positive and negative – has remained in India suffused with emotional warmth. This has meant that feelings have been taken seriously as a means of insight into and understanding of the structural unity of the cosmos.

The key image to which all of Indian culture refers back in one way or another is that of the 'centre', a placeless, timeless nucleus from which all phenomenal things 'were once' projected, and which, after the destruction of all things, alone remains. It contains all the possible infinities of space and time, but occupies none of them. To begin the processes of cosmic Genesis, this nucleus first polarizes itself. The polarity is seen as Heaven and Earth, and as Male and Female. But in this original thought a whole series of analogies and metaphors are implied which are followed out in later Indian art and philosophy.

The first, and metaphysically most important, is that the act of polarized projection is continuous; for without it there would be no creation during the earthly time which that projection also creates. Each human being is a location where this projection of the world is being carried on. The centre and source may be symbolized by a central column, and this may be referred to in art by the symbol of a pillar representing the axis of the world, or by the divine phallus – lingam – standing in the 'womb house' of the Hindu temple, uniting the supreme principles of Male and Female. In the person the spine is interpreted as that column. In yoga a progress of reintegration, of

17

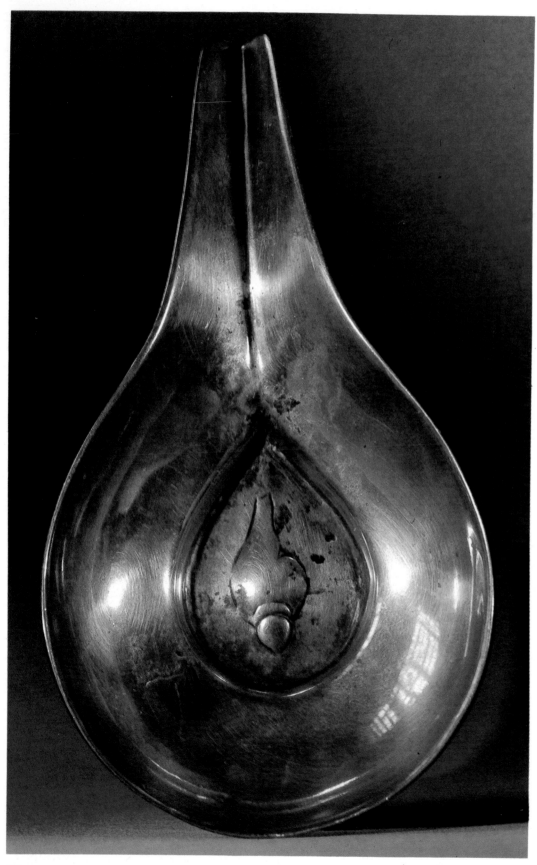

13. (*Left*) Offering vessel, in the shape of the vulva. Bronze, South India, eighteenth century.

14. (*Right*) The union of Vajrasattva with the Supreme Wisdom Viśvatārā; male and female unite to become the transcendent self. Miniature, jewelled gilt bronze, Tibet, eighteenth century.

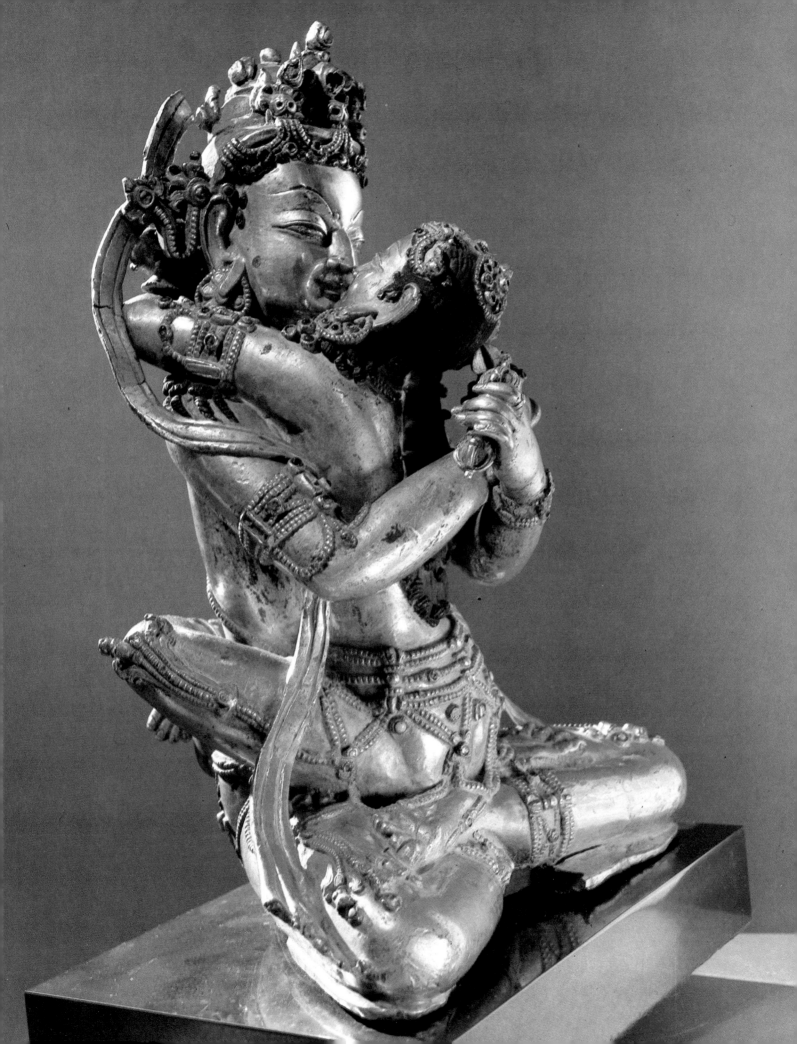

return beyond Genesis, may be achieved by 'recombining' the male-female polarity into one energy within the person which is then sent back up the column to its Original Source. These images will be discussed later in detail. But one important implication is that, in this light, human sexuality can be seen as having a double value. On the one hand, if it is used unwisely, it becomes one of the agents for generating a diffracted, time-ridden and miserable world. But if it is used properly, it is perhaps the most important aid in returning beyond Genesis.

Most Indians, of all sects, have believed that to return, to leave the world of misery, was the only really important aim of life. They also believed that the world which seems so real to the men and women imprisoned in it age after age, birth after birth, is in fact an epiphenomenon, an apparition due to the divine creative act continually taking place, perhaps even its principal result. Hence every act which carries individuals and humanity as a whole further from the centre is to be avoided; while every act which brings the individual and humanity closer, reconstituting the world into its natural polarized whole, is a good thing. Hence a well-ordered society with stable sexual relations was seen as good – especially by conservatives with a vested interest in the *status quo*—whereas irregular behaviour threatened everyone. This is one of the chief reasons for the relatively static nature of Indian society, even today. But art itself was actually explained as a vital part of the machinery for reconstituting the whole. And this helps to explain why Indian art is so profoundly sexual in its expression, as we shall see.

15. On this boundary stone, the monsoon clouds, symbolized by an elephant, fertilize the feminine earth. The stone is thus a fertility charm. Baroda state, c. 1000 AD.

If this conforming attitude were universally accepted in a simple way, and uniformly enforced, Indian society would be exceedingly dreary. But it has not been. India is so vast an area of land, her people so mixed and varied, that the unifying theory has been stretched in all sorts of unexpected and fascinating ways. Some changes were the result of the need to include ancient and primitive religious customs into the system, which was tolerant of variations. Others were due to extraordinary waves of emotion which swept over large tracts of India at different times, and burst the bounds of convention. Some of these attached themselves to very archaic ideas and revitalized them. Individual Indians may therefore have differed considerably in their customs and beliefs; but these were all in practice interpreted by the learned as aspects of a whole. They may represent specific developments of deep-lying analogies pervading large stretches of cultural expression. Even highly abstract philosophical concepts can be derived from metaphorical interpretation of physical experience. We shall discuss some of these in a moment.

Religion, in its broadest sense, has been taken as the focus of the whole of Indian society, and all its different strands deliberately synthesized under the rubric of Vedic Brahmanism. This is the oldest surviving religious form, whose texts have come down to us virtually intact in a sacred language called Sanskrit. Until very recently every Hindu accepted that social organization, family life, personal aspirations and state government were all oriented towards the same vision of the unspeakably vast, all inclusive and unified Ultimate Ground of existence which was also somehow the Centre. This was first expressed in a collection of sacred literature called the *Veda*, 'that which is known by seeing'. Its original, mythical composers were thus 'seers'. The nucleus of the collection is a group of hymns, which found their final form probably in the second millennium BC and are composed in an ancient version of the Sanskrit language. They are addressed to various gods, only a few of whom remained actively in worship in later times. Around these hymns, which were treated as divine revelation, gathered a mass of explanation and philosophy during the next thousand years, the most important for us being the *Upanishads*. The developments of Indian scholastic philosophy until modern times were still inspired by the insights of the ancient philosophers. It is possible to understand Buddhism and Jainism as themselves originating in unorthodox versions of the same insights.

The collected *Veda* became the spiritual property of a special class of society called the Brahmins. They were descended from the priests who used its hymns in sacrificial rituals, on behalf of the rest of the old Aryan population. As a matter of course they became the lawyers, administrators, poets, philosophers, scientists and doctors, when Aryan customs eventually came to dominate the whole of Indian society by about 800 BC in the North, and 200 AD in the South. The Aryans

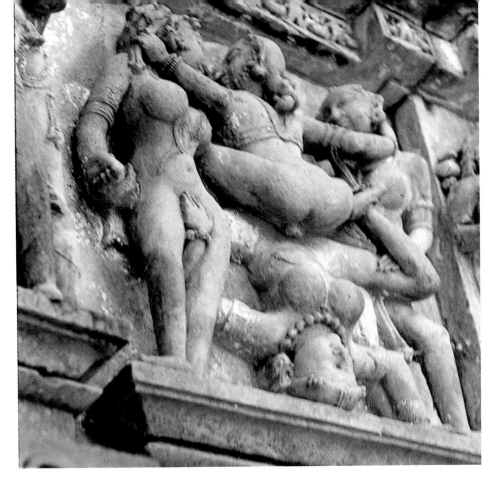

16. (*Far left*) Kālī, goddess of Time, standing over her consort Shiva. Miniature painting, c. 1800.

17. (*Left*) Apsarās, from the celestial bands of a temple at Khajuraho, central India; c. 1000 AD.

18. (*Below*) Celestial lovers, from the decoration of the Temple of the Sun at Konarak, Orissa; c. 1230 AD.

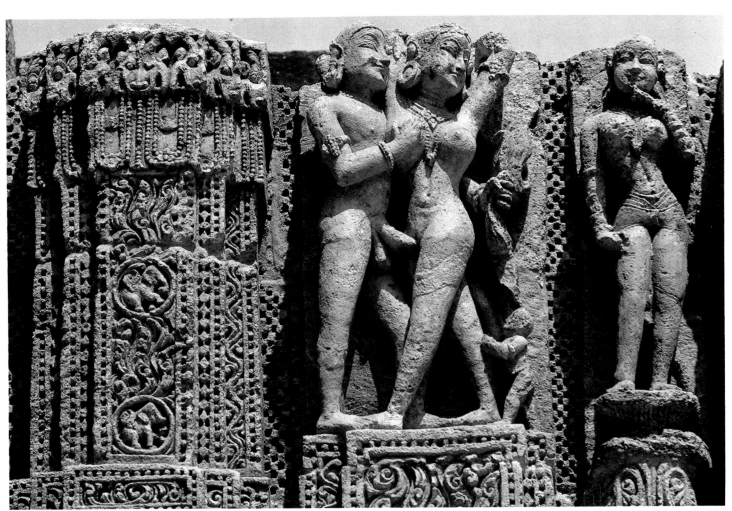

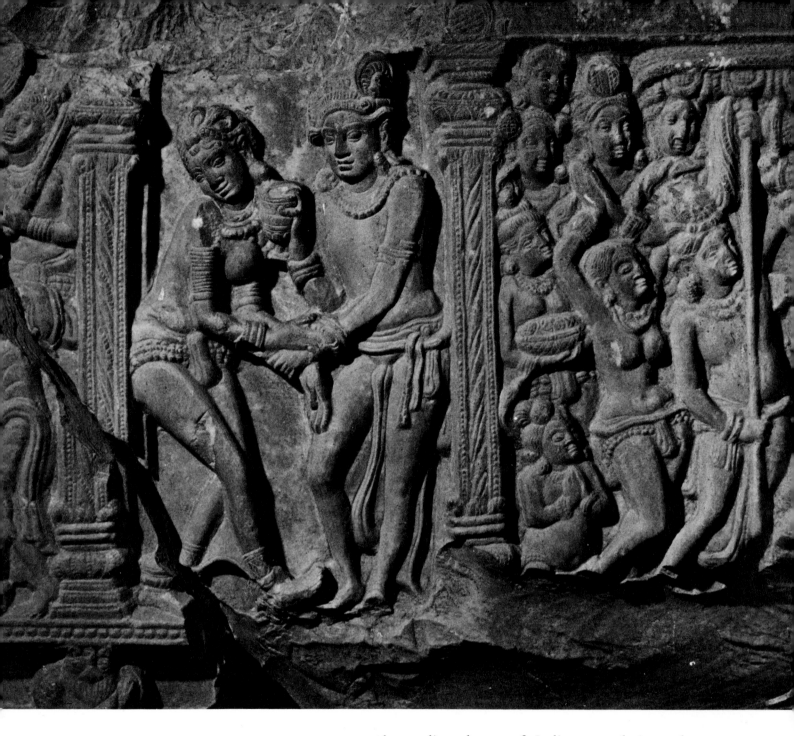

19. Lovers, and visitors to the Buddha. Limestone, from a Buddhist shrine at Nagarjunakonda, south-east India, second century AD.

were not the earliest layer of Indian population; they were a conquering people from inner Asia who infiltrated through the north-western passes about 1800–1500 BC. The peoples whom they eventually came to dominate had no literature of their own that has survived; though the somewhat later literature of the Tamils in south-eastern India is composed in an old language totally unrelated to Sanskrit. It is clear that during the process of infiltration, Sanskrit traditions picked up and absorbed a mass of custom and belief from the earlier inhabitants. In fact, a great deal of what has come to be called Hinduism is non-Aryan, although it has been gathered by the encyclopedic Brahmin mind into the vast complex of Sanskrit learning, and doctrinally assimilated.

The Brahmins became a sacred, priestly caste across the whole of India, regarded as vessels of truth and knowledge, actual containers

of the Ultimate. This they called the Brahman. And because they were the guardians and creators of literary tradition in their ancient sacred language, Sanskrit, all the evidence we have for early Indian beliefs and social customs, Aryan or not, is contained in the Brahmins' own texts. The non-Brahmin elements have thus been filtered into the Aryan Sanskrit conceptual system. But the Brahmins did not try to eradicate older sacred beliefs and customs; they merely installed themselves as the overseers and protectors of them, and interpreted them as additional manifestations of the divine in their encyclopedias. So a great deal survived into the nineteenth and twentieth centuries at 'folk' level among country people that may be far more ancient than the Aryan literature. It was then collected and reported by the Europeans who ruled India, and passed into the European body of anthropology. Among this ancient material is a whole complex of ritual and personal culture which explores and uses the relations between the sexes. It has been the main driving force of all the arts in India.

Like all other peoples the Indians are deeply aware of their bodies as organs of experience and knowledge. The body gives them many of the overlapping concepts by which they interpret the world they live in. One fundamentally important function they devoted much thought to is breath. For when a person dies the factor most obviously missing is in-and-out breathing. So the energy of life is often seen as being congruent with the breath. In the West we still use the metaphor and talk about 'the breath of life'. Both our words 'spirit' and 'animate' are derived from Latin words meaning 'breath' or 'wind'. The principal term the Indians developed in historical times to point towards the vast Ultimate reality, embracing all manifested things, is the Brahman. One of those old philosophical texts called *Upanishads*, the *Taittiriya*, identifies the Brahman with the 'breath' (prāna) of all beings; we could say: their 'spirit'. One of the basic practices in yoga – which is probably derived from a very ancient pre-Brahmin type of Shamanism – involves overcoming death and gaining enlightenment by controlling the breath. Yogic theory identifies different 'breaths' inhabiting different parts of the human body, and thinks of them as being distributed through a network of branching channels. Another *Upanishad*, the *Chandogya*, calls the sense-powers 'breaths'. Sacred texts were chanted on the breath in sacred Sanskrit; so Sanskrit speech, with its terminology defining the world of things, actions and relationship, came to be seen as a metaphor for the Ultimate reality behind that world which its terminology defined. A subtle air and its complex vibrations embodied the Ultimate, permeating and generating the world as the breath permeates (and, according to Indian ideas, generates) the body and its world.

Again, when someone dies or approaches death by starvation or disease, they dry up, becoming skin and bones, losing fluid and

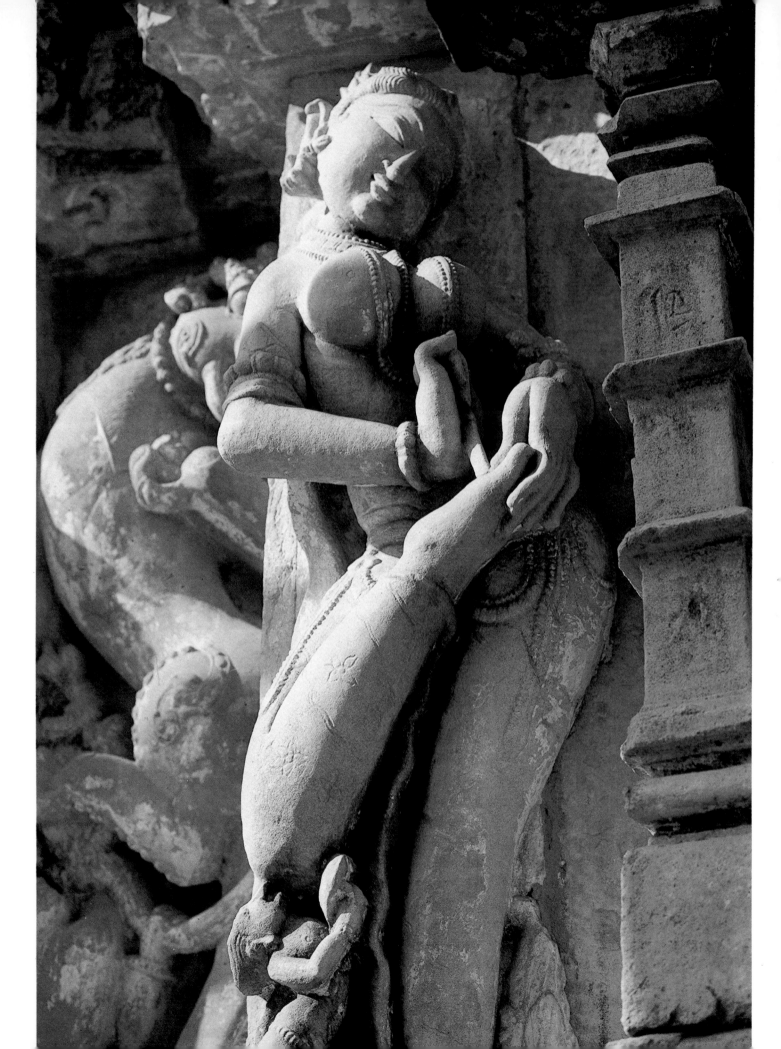

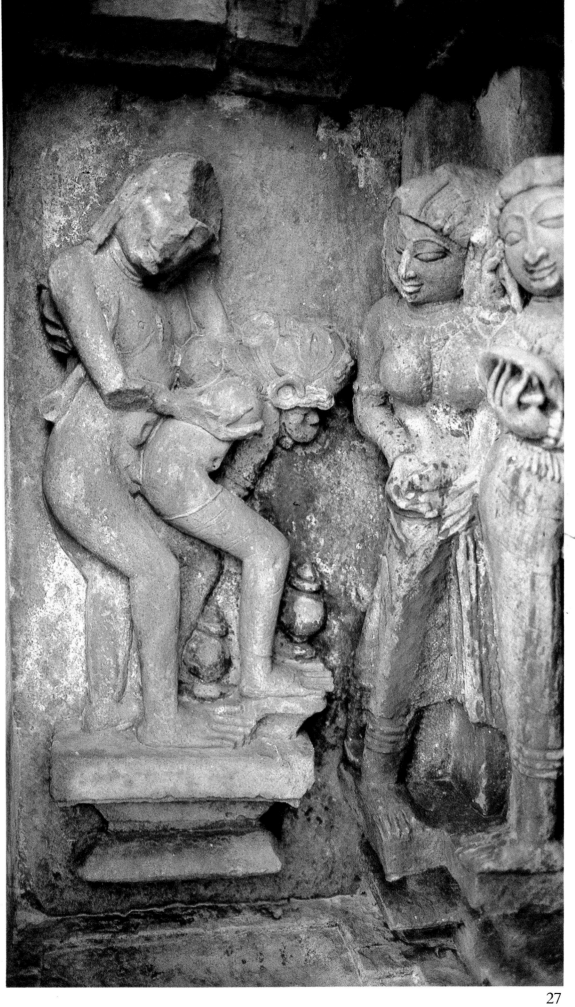

20. (*Left*) Apsarās, from the celestial bands of a temple at Khajuraho; c. 1000 AD.

21. (*Right*) Lovers, from the celestial bands of a temple at Khajuraho; c. 1000 AD.

fatness. The Indians, in common with many other people, feel that body fluids and oily essences, especially fat, oil, butter and milk, are full of the energy of life, under another aspect. The fatty parts of the animal, oil or butter are transmitted to the gods in sacrifices. Of all the fluids, however, the most significant is the male semen. For it has the power of creating life, and must therefore in some special way transport the generative principle. In palaeolithic times humanity seems to have recognized the special fertilizing property of male semen (although it has been said that there are living peoples who are not aware of any connection, since sexual intercourse is such a normal continuous process). But there does seem to have been a time, probably during the neolithic period, when the fertilizing element was identified as a single drop, seed or nucleus deposited in the female body, perhaps by analogy with crop seeds which men were then learning to sow in the earth and harvest. In India this 'drop' (bindu), or invisible seed-point, came to be interpreted as the chief principle of reality, enlightenment and effective religious power in the more male-oriented Brahmin forms of religion; though the female principle did remain fundamental and was carefully cultivated, as we shall see.

There is a great deal of evidence in the *Upanishads* and in modern research that the male semen was felt somehow to be the physical form of the ultimate Brahman. And all Brahmins expected to be able to perform Brahmāchārya, an asceticism of which sexual abstinence was the main component. The point was quite literally to build up a large inner store of the physical substance of enlightenment. Outflows of semen, either in ordinary intercourse or by accident, were looked on as entailing a serious 'spiritual' loss.

Certain forms of yoga built on this reading of conserved semen as spiritual power, and concentrated on transforming it. Popular mythology described great saints and ascetics as filled with a radiant inner force which actually consisted of an energized mass of semen. One story describes how an ascetic was attacked by a robber, who cut him with his sword; and the ascetic bled not blood but semen. In fact, any man seeking high spiritual status, even a soldier, was supposed to conserve his semen; though his wife had a right to it at certain times, notably at the end of her monthly period.

In view of this imagery it is not surprising that one of the most ancient Indian icons of the divine creative principle is the lingam, a stylized image of the erect male sexual organ. Nowadays it is perhaps the commonest icon in Indian temples. Historically it has long been identified with the god Shiva; but there is evidence that the lingam-deity was once not quite so specific.

Semen is white, and masculine. The feminine analogue was red: not exactly the blood, but embodied in the menstrual discharge. The combination of these two energies in joyful sexual intercourse was felt to be the creative factor in pregnancy; and such sexual intercourse

was a metaphor of the higher type of divine intercourse which constantly creates the world. But since the cosmic energies involved were somehow cognate with the bodily energies, the whole vast cosmic creation itself was ultimately a function of bodily energies which the human experiences in his or her own body. The two, human and cosmic-divine, were not separate. The human was a pattern of the divine. The *Bṛihadāraṇyaka Upanishad* records that 'In the beginning this world was the Self alone in the form of a Person (Purūsha). Looking around he saw nothing else than himself. He first said "I am". Thence arose the name "I" . . . Indeed he had no delight. He desired a second. He was actually as large as a man and a woman closely embraced. He caused that self to fall into two pieces. From it arose husband and wife. . . . He copulated with her. And she thought "how can he couple with me after he has produced me from himself? Come; let me hide myself." She became a cow, he became a bull. With her he copulated. Then cattle were born. She became a mare; he became a stallion. Then horses were born . . .' and so on. 'He knew: I am indeed this whole creation, for I emitted it from myself. . . . Certainly he who knows this comes to *be* that creation of his.'

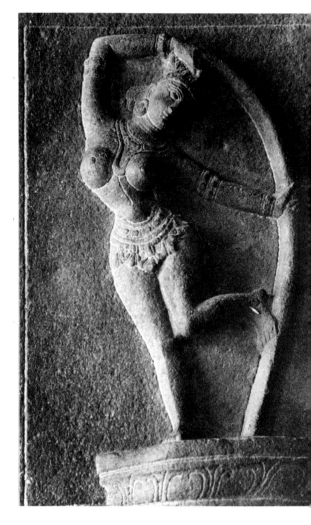

22. Celestial girl bending a bow, exhibiting her beauty like a dancer. Carving in relief on a temple column at Tiruranāmalai, South India; twelfth century AD.

Several other Upanishadic quotations reinforce this sexual image of creation. But, like the above, they were Brahmin texts, giving pride of place to the idea of the creating Self as male – 'He', 'Him'. There is, however, a probably more archaic India, still very much alive, which gives the chief role to the feminine component. The Great Goddess, in many different personifications, has always played a central part at the more popular level of Hinduism. The earth is called 'Mother of all'. And societies survive from ancient pre-Aryan times, which are matrilineal and matrilocal – that is to say, family descent and property pass on according to the female line. The wife may therefore marry several husbands, as Draupadi – a heroine of the early epic *Mahābhārata* – did the five Pāndava brothers. There is a considerable amount of evidence that kings in early India, as well as in Indianized regions of Southeast Asia, owed their kingship to marriage or sexual union with female 'owners' of the terrain. This may be one of the ancient strands in the 'heroic' Aryan conception of royal male polygamy: to possess the regions of his kingdom, a hero must possess its female personifications.

The Great Goddess is known in India under many names. One, Durgā, her myth defines as embodying the combined energies of all the gods. But fundamentally she is worshipped as the fertile womb of the world, giving birth to all things – animals, food, children. All female creatures, including women, are her personifications. As cosmic womb her icon in a shrine or temple is called 'yoni', 'vulva', represented in several forms by a cleft, hole, spouted basin or pot. An open lotus blossom, by an obvious and beautiful physical analogy

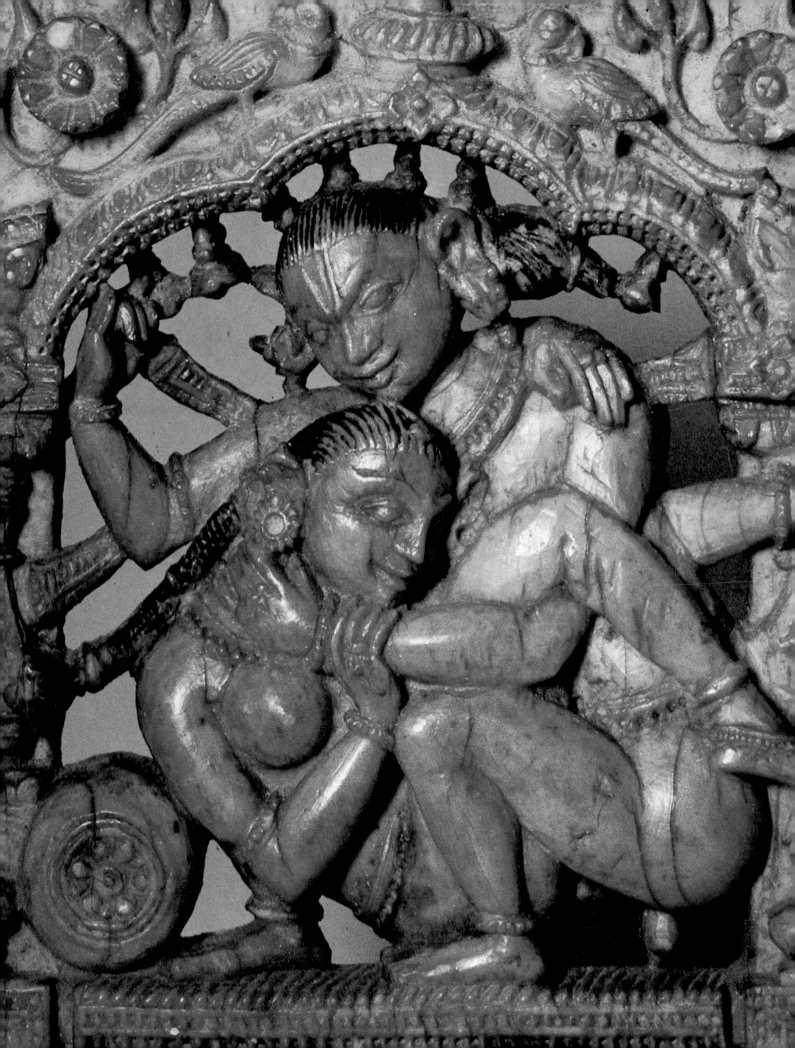

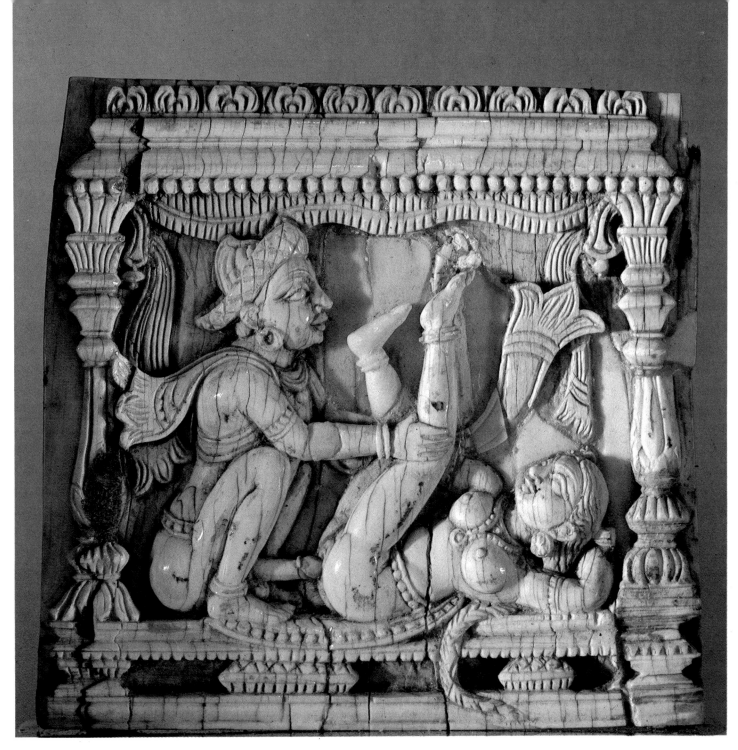

with the female labiae, is a widespread emblem for the process of generative creation. As Earth she holds within herself great reservoirs of subterranean liquid which nourish the world as milk nourishes the child. Her womb also symbolizes the creative role of human consciousness and imagination according to certain philosophical ideas.

Traces of the ancient and powerful analogy between the processes of physical birth and those of cosmic Genesis survive in Indian culture and philosophy. Although these traces were downgraded by the male-oriented Aryan stratum of society, whose system of family and descent was based upon fatherhood, they did not simply disappear. Instead they constantly emerged in different guises during Indian history, through being enshrined in temple customs, social institutions – including marriage and prostitution—in the concept of the

24. Love scene. Carved ivory, South India, eighteenth century.

23. (*Opposite*) Ivory plaque of a man and woman coupling. South India, eighteenth century.

heavens, in certain types of personal ritual and in yoga. The Brahmins' effort to orientate society and ritual towards the male even led them to attribute different persons of the Goddess as wives to the male gods in whom Aryan society was chiefly interested. Under these guises the female principle entered the stronghold of high-caste Hinduism.

Anyone who travels in rural India will see sacred natural objects everywhere among the villages and fields. Sometimes they are fronted by altar stones, and have little shrines built around them. They may be living trees, the remains of ancient trees coated with cow-dung plaster and painted with red and white bands, a large stone with one of its faces painted red, an old anthill daubed with white and red, or a little clutch of stones, like eggs in a nest, dotted with splashes of red paint. These are the ancient homes of the sacred. For one of a large number of possible reasons, usually miraculous, each of these objects has revealed to the local people that a spirit dwells in it. Everyday someone will leave offerings to that spirit, such as a handful of flowers, a few little squeezed-up balls of rice, a pot of milk. Trees and rocky places may also be inhabited by spirits, who participate quite actively in the life of the village, even going so far as to pick up the village babies in the manner of the more benevolent among the Western poltergeists.

Something like this seems to have been the religious pattern prevailing throughout the older strata of society when the Aryans moved in, and their Brahmins took charge of local shrines and ceremonial. An additional element of ancestral cult, with megalithic tombs, probably survived in parts of the South and West. The Brahmins collected and compared the many different spirits they came to know with their folklore, and interpreted them as different manifestations of divine principles already familiar to them. Among these principles were three major deities: Shiva, Vishṇu and the Goddess who has many names, such as Lakshmī, Parvatī, Durgā, Kālī.

The city courtesan

Overlaid on this stratum of archaic imagery was the cosmopolitan art and thought of the great cities of India. From about 600 BC onward, first northern then later southern India came to be scattered with large and beautiful fortified cities, surrounded by gardens, which were the capitals of dynasties of kings. Most of the kings claimed descent from original mythical dynasties of sun and moon. Such kings used continually to fight among themselves, seeking to dominate and tax each other's lands. Occasionally one would gain such power that he became a Mahārāja, Great King, or Emperor. The Brahmins, as the literate class of society, became the chief ministers, lawyers, theoreticians, and even the artists of this city-society. Hence

they were much concerned with the principles of kingship. Shiva and Vishṇu became the two chief deities taken as patrons by the kings, though Surya, the sun-god, was also adopted sometimes. Queens adopted goddesses. One of the reasons why we have the number of medieval Hindu temples we do is that each member of a Hindu dynasty built his or her own personal shrine at the capital city, where he maintained personal contact with his divine patron.

A vast wealth of early literature composed in and dealing with the early cities survives. Hardly any of it is known outside India. Some of it is religious – especially Buddhist. Much is secular. During the thousand years between about 500 BC and 500 AD a galaxy of great writers composed epic and lyric poems, plays, novels, philosophy, and works on the practice and theory of dance, drama, poetics – and love. All this literature demonstrates clearly how much the people were preoccupied with erotic affairs; and it has acted as the filter for our knowledge of how the life and thought of antiquity was shot through with the pleasure-principle. Buddhist texts refer to the happy sounds emanating from pleasure gardens beyond the city gates in the cool of the evening. Poems and novels were full of love affairs and erotic adventures, faithfulness and infidelity, treated very frankly. There were canonical types of heroic male and female sexual beauty, which were also reflected in visual art. Men's 'great arms' were 'like plantain trees', their torsos 'like the face of an ox', their eyebrows 'like a strong bow'. Women's faces were like 'the full moon'; they were 'long-eyed', 'tiny-waisted' and 'broad-hipped'.

By this time Indian society was almost completely male-dominated; and most – though not by any means all – of the leading writers and artists were men. But women were not then at the social disadvantage in India they have been in more recent times, after epochs of medieval Hindu rigidity, and of Muslim and British puritanism. Among the polygamous upper classes they tended to be seen as precious private property, hemmed in by caste restrictions, and captured as booty in public and private warfare. But all the texts agree that men's prime duty and pleasure was to make their women as happy as possible, cherishing them and never being brutal towards them. Husbands should spend their wealth on gold and jewels with which to cover the bodies of their wives to demonstrate social status. In the figurative art of this period both men and women do indeed wear fantastically elaborate jewel-strings in their hair, precious necklaces, hip-girdles, armlets, anklets and finger rings.

Woman as erotic goddess was felt to be fickle, sexually omnivorous and virtually unsatisfiable; she was willing to enjoy all kinds of sexual intercourse with any creature, male or female. Hence men were always supposed to make sure their women received ample sexual pleasure. (Venereal disease, with its associated fears, was then, of course, unknown in India.) Men certainly liked to think of their

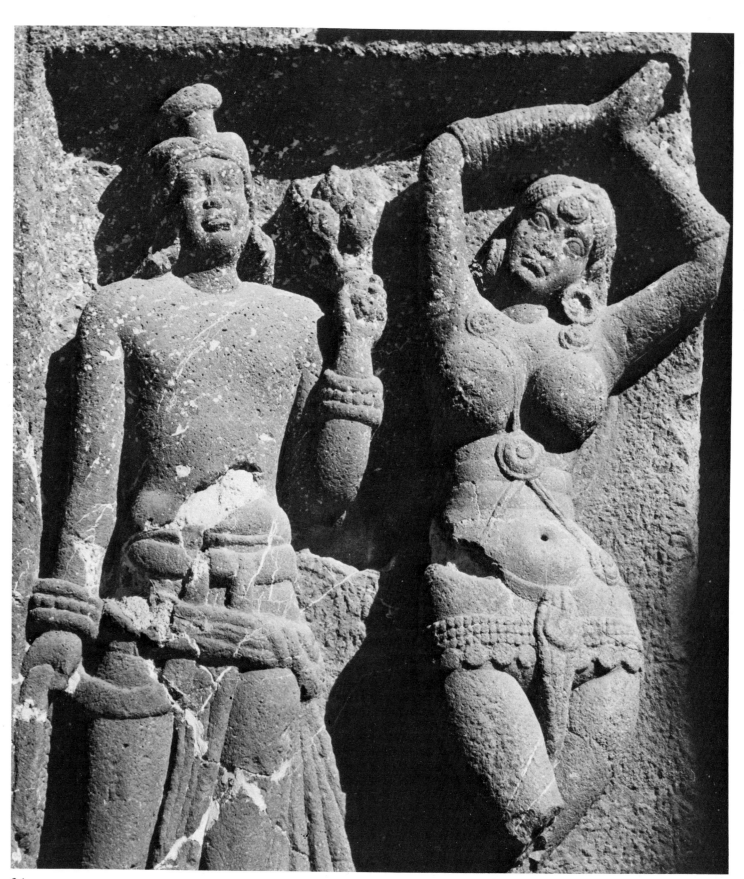

women as happily submissive; but the literature agrees that they rarely were! In fact, there is one category of poem in early South Indian Tamil-language literature that deals only with how husbands pacify the injured feelings and rage of wives and girl-friends. Even the heroic warrior on the battlefield naturally took leave of absence to return home when his wife had finished menstruation, because then she had a sacred right to sexual intercourse.

One aspect of this society – what in the West we call prostitution – was very important, and taken for granted at all social levels and for all sorts of reasons. It had attached to it none of the guilt and furtiveness that Western societies imbued with Christian traditions feel. Like the Classical Greek Hetaira, an Indian prostitute was supposed to be a highly educated woman, usually a skilful musician, actress and poet. She could become very wealthy and her house might be a sort of 'salon' for people of artistic interests. The classes of semi-permanent concubine and general prostitute shaded into each other; the profession tended to be hereditary; and families of women traditionally served a group of client families. The profession was certainly valued very highly indeed. It was protected by kings and princes, who looked on it as a natural income-generating arm of the royal exchequer. Rulers would maintain a special corps of particularly beautiful women, some to wait upon themselves, others to be given to courtiers as a mark of royal favour.

Since they were so recognized and specially protected by society, prostitutes were in a position to find all kinds of genuine personal fulfilment. They were frequently sought in marriage by wealthy men. The second century AD Sanskrit manual of love, the *Kāmasūtra*, now a worldwide classic, describes the conditions of a courtesan's life in considerable detail. It asserts that a woman who is pleasing and beautiful, and skilled in the arts, has the right to an honourable seat among men; she must be respected by the king, and praised by the wise. Altogether the courtesans of the early Indian cities were probably the most cultured and highly educated members of society – as we know their modern descendants to have been. And they were probably also very important custodians of tradition in art, which may help to account for its strongly sexual flavour in early times.

The *Kāmasūtra* gives a list of the arts and sciences a courtesan should have at her command. They include music, dancing, acting and singing, of course, but also a knowledge of architecture, clay-modelling, the composition of poetry, different languages and philosophy. Other skills, perhaps more to be expected, are the compounding of perfumes and cosmetics, embroidery, conjuring tricks, riddles and tongue-twisters, cooking, gardening, flower arrangement, and teaching parrots and mynah birds to talk. But more surprising is the required knowledge of chemistry, mineralogy, carpentry and the training of fighting cocks, partridges and rams. Sorcery and writing

25. (*Opposite*) A pair of royal donors. Rock carving on the façade of the Buddhist cave at Karla, Western Deccan; second century BC.

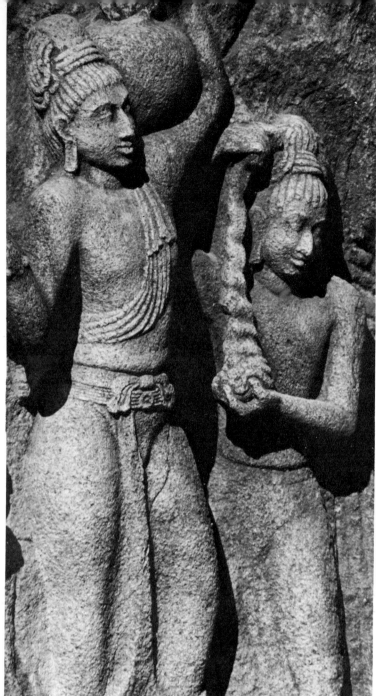

26. (*Above*) Girl dancing. Terracotta, from Patna on the Ganges; third century BC.

27. (*Above right*) Ideally beautiful male figures, in a mythical scene carved on a cliff at Mahābalipuram, south-east India; c. 700 AD.

in code are also useful accomplishments for someone of the courtesan's profession. But very important, too, were gymnastics, fencing and archery. We know that early kings used armed women to guard the female quarters of their palaces, and European accounts of the seventeenth to nineteenth centuries describe vividly how acrobatically supple Indian prostitutes were. Medieval Indian sculpture shows it clearly, too. One girl, for example, was described by the seventeenth-century Frenchman Bernier as being able to bend over backwards and pick up a coin from the ground with her lips. Such athleticism was highly valued in lovemaking; the woman was expected to play the more active part in vigorous sexual intercourse, to give and take pleasure. Among the most important erotic skills of the man was his ability to prolong the act for a very long time – an hour or more – to ensure that his partner could satisfy herself as often and intensely as possible.

Since virtually the whole realm of cultural achievement was theirs, the bevy of beautiful professional women gave to a royal court an important part of its splendour. They were leading musicians and performers in the theatre for which Sanskrit and Prakrit and Tamil poets wrote so many hundreds of sophisticated plays and dance-dramas. Even in the early part of the twentieth century the traditional association between theatre, music, dance and promiscuous sex remained so strong that it was very difficult for 'respectable' girls to overcome the prejudice against their becoming performers. In the fragments of visual art – sculpture and painting – which survive from these early times erotic subjects are very common; and even expressly Buddhist religious art is imbued with vivid sexual overtones because, of course, the artists were normally employed on secular work.

We know from literary sources that a vast quantity of art was produced in the last centuries BC and the early centuries AD, a very large proportion of it secular. In fact, what remains comes usually from religious buildings made of stone. Most work in other materials has perished in India's devastating climate; though a few precious things do survive. We can read that those great vanished Indian cities contained many halls, pleasure houses, 'brothels', garden pavilions and public baths, built of wood and filled with wall paintings. It was normal for there to be a large public picture gallery on the main street or at the chief crossroads. Innumerable storytellers carried picture-scrolls with them to illustrate their performances. We can trust these descriptions because modern archaeology has confirmed the literary sources in many details.

A few fragments of early wall painting survive in the Buddhist caves at Ajanta (second century BC – 600 AD) and at Bagh (fifth century AD) in the Western Deccan, in the Hindu caves of Badami (fifth century AD) further south, and on the huge palace-rock at Sihagiri in Shrilanka (Ceylon, *c*.500 AD). They give us an idea of the special beauty of what we have lost. The style of all them is imbued with a decidedly sensual sweetness. There are two important clues as to how these works were understood by their makers. The first is a fifth-century AD inscription in cave XXVI at Ajanta, which describes it as 'a dwelling of the gods' built for monks to inhabit. The second consists of a series of amorous graffiti written near the pictures at Sihagiri. The importance of both these clues will appear later.

The fragments of early secular sculpture illustrate how the aesthetic and the erotic were closely identified in the Indian imagination. From early city sites, dating between the third century BC and the third century AD, come a whole variety of pieces. Many carved beads and small terracottas represent the pleasures and pleasurable things of life – chariot-riding, animals, flowers, beautiful girls smothered in jewels, heroic men scarcely less bejewelled, girl dancers, and sex in one form or another from simple embraces to actual intercourse.

28. Girl in intercourse with two soldiers, who are engaged at the same time in sword-play. Early European visitors commented on the gymnastic agility of the temple dancer-prostitutes, which was part of their sexual charm. Carved wooden bracket from a temple in South India; seventeenth century.

India

29. Girl putting on her necklace. She embodies all that India came to see as the essence of female beauty. Panel for a piece of furniture carved in ivory; found at Begram, Afghanistan, but made in India, first century AD.

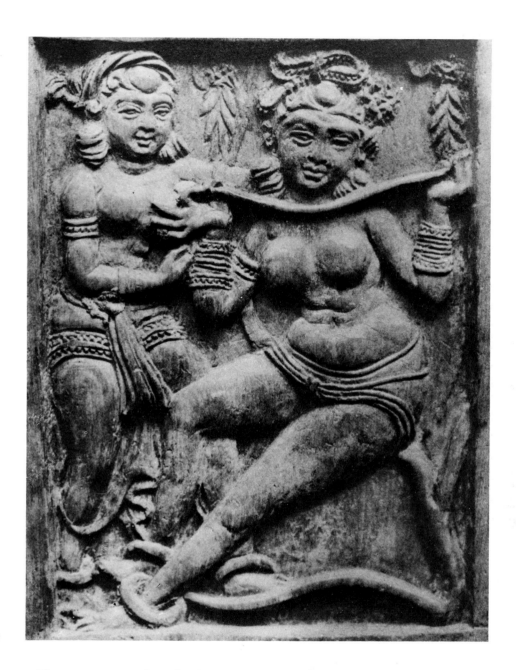

Two groups of early ivory carving illustrate secular eroticism beautifully. One Indian figurine was found in the Roman city of Pompeii, which was overwhelmed by an eruption of Vesuvius in 79 AD. And a whole set of carved panels, probably from the second or third century AD, was discovered at Begram in Afghanistan. They seem to have been parts of boxes and chairs. The Pompeii carving, perhaps a mirror handle, must have been traded to that Roman city. It represents in very sensuous terms a beautiful woman standing in a twisted posture, accompanied by a pair of smaller maids by her feet. The maids are scarcely less opulently dressed than the central figure. Their sexual organs are all heavily emphasized, and much is made of their breasts and narrow waists, standard attributes given in

38

Sanskrit literature to any beautiful woman. There is no reason to believe that this ivory is in any way religious. But the long hair of the principal woman is elaborately braided into a kind of hanging flap behind her head, and exactly the same type of woman and hairdressing is found carved in stone, incorporated into the gateway pillars of the Buddhist shrine at Sānchi (first century AD). The images here are also extremely sensual, emphasizing female sexual charms.

The Begram ivories are carved with relief figures of beautiful women, also with narrow waists, generous breasts and wide hips. They posture under gateways with one hip out, chatter together or fasten jewels around their necks, within decorative frames. One rides a leaping leogryph, which formed the bracket for a chair-arm. They are obviously intended to be sexually stimulating and appeal directly to the sensual imagination of both men and women. No one knows where they were made but they very much resemble female figures on early second-century AD shrine railings, carved from beautiful pink sandstone, which were excavated at Mathurā. Even more closely they resemble the figures carved on the decorative white limestone panels of the Buddhist stupas at Amarāvatī of comparable and later date, whose charms are no less obvious. These figures, however, are usually meant to be human, playing their part in stories: ideal types of well-born women conversing with the Buddha or paying their respects to his emblems. But on the parts of railings of the earliest Buddhist shrines which survive many of the same types occur but without any specific story context. Embracing couples, jewelled girls and dancers appear carved in relief on the stone lintels of Barhut and Sānchi stupas, on pillars at Bodhgāya – where Buddha achieved enlightenment – and on other objects from Mathurā city.

Around the main doors, on the pillar capitals and the façades of the early cave monastery-halls at Bhājā, Karle, Kondane, Pitalkhora and Kanherī in the Western Deccan beautiful people appear in large numbers. At second-century BC Bhājā there are the ruins of colossal figures of beautiful jewelled girls carved on the rock; and on the sculptured balconies the busts of beautiful couples appear. At Karle are four stupendous couples, epitomes of well-being, cut into the rock façade in deeply rounded relief, who stand facing out between the main doors. At Nasik, in the early second-century AD Nahapāna monk's living-cave, there appears for the first time what became later a common ornament for the door frames of western Indian Buddhist shrines: a continuous band of little panels containing couples who stand embracing each other.

It is not easy to grasp why such figures should appear on the monuments of an expressly ascetic religion such as Buddhism, whose monks were forbidden even to look at a woman, let alone embrace one. However, there are several clues to the explanation. The first is the (admittedly later) Ajanta inscription mentioned above – that

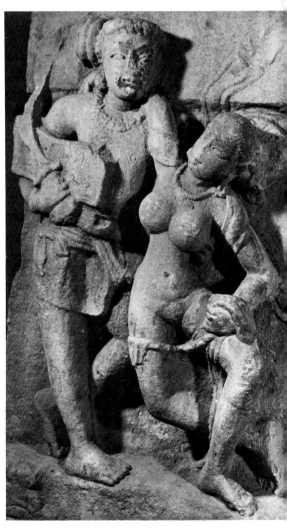

30. Courtesan and soldier, carved on the pillar of a temple. This refers to the notion of the rewarding of heroes, both on earth and in heaven, by courtesans and apsarās; thus the temple is equated with the royal court. Pattadakal, Deccan, eighth century AD.

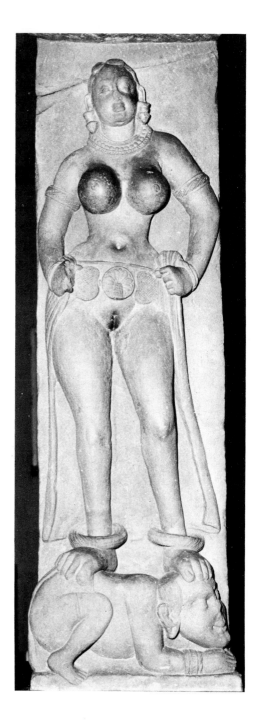

31. Female celestial on a Buddhist shrine railing-pillar. Sandstone, from Mathurā, central India; second century AD.

shrines were meant to be like 'dwellings for the gods' for the monks. And as we know that Indian kings of this epoch used to surround themselves deliberately with beautiful people, and earthly shrines were thought of as 'heavenly' palaces, then they should naturally, according to Indian ideas, be populated by figures more beautiful even than the most beautiful on earth. For India imagined that beauty as such was a transcendent quality. A person, man or woman, was brought near to the divine by the degree of his beauty; and only inevitable human imperfections prevented man from actually being divine. A god or goddess was a perfect embodiment of transcendent beauty. Hence all Indian art strives to establish its own canons. Except in the icons of a few horrifying deities, to capture sexually appealing beauty is the chief aim of every Indian sculptor or painter down the ages. Male and female imagery represents the sex-objects of human dream; not merely human but divine.

Some early sculptures, terracottas and carvings on Buddhist shrines certainly represent the goddess Shrī, the earth-mother of good fortune and fertility. We know that her images used to stand by the gates in early cities, gleaming with melted butter. Women used to dance before them. Her stupendous jewels demonstrate that she is the divine source of wealth, her great breasts and hips that she is the paragon of fertility. Her icons show her as broadly of the same type as the well-dressed women on many of the other terracotta plaques, who are also loaded with anklets, bracelets, and many jewelled hip-belts with strings of gems braided into their hair, and whose sexual organs are emphatically modelled even though they may be supposed to be covered by fine cotton clothing. Shrī may be shown standing on an open lotus—symbol of watery fecundity – with elephants sprinkling water on her from their trunks, symbols of the monsoon clouds. Goddess and girl differ principally in the degree of the richness of their ornament. Since it is more than likely that the city courtesans were exceptionally well dressed, as well as cultivated, it is probable that both these kinds of plaques use the same figure-type to depict the highest power of opulent femininity in both divine and human persons, which at the same time represents a conception of the 'most desirable good'. We meet opulent ladies similarly dressed on the railings of the Barhut stupa; they are named in inscriptions as godlings of tanks and trees. One, however, is named 'Sirimā', that is, Shrī. The images of courtesan and goddess were thus equated.

The large number of beautiful women represented at various monastery-shrine sites in the city of Mathurā were, however, obviously not meant to be merely human. They stand upon dwarfish supporters who, in Indian imagery, serve to symbolize the super-human status of the people they carry. There is no mistaking the intention of the sculptors to give these girls the highest possible degree of sexual appeal. They are compounded from sculptural forms

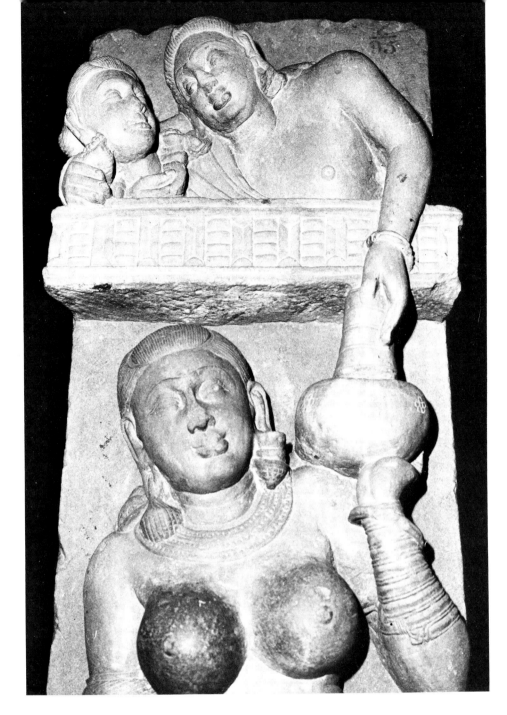

32. A pair of lovers on a heavenly balcony, receiving water from a celestial girl. Carving in sandstone on a Buddhist railing-pillar, from Mathurā; second century AD.

which refer to the sexual aspects of the human body, so their whole essence is sensual. They carry bird-cages, oil-vessels or covered trays of sweets; on one or two shoulders perches a parrot, the Indian love-bird, being fed or perhaps taught to speak; one girl washes under a shower; others look at themselves in mirrors; some play musical instruments; others carry swords, as if they were those female guardians in the palaces of emperors, described in Greek sources of the third century BC. Above them are extravagantly blossoming trees or small latticed balconies where busts of happy couples can be seen embracing, fanning or stroking each other, or with the man holding a mirror for the woman to apply her make-up. On one group of such girl-encrusted pillars there is no balcony, but instead a male head peers over a drooping swathe of curtain. The curtain may represent a theatrical setting, but the man is probably no simple voyeur. Such girls were indeed meant to be accessible.

41

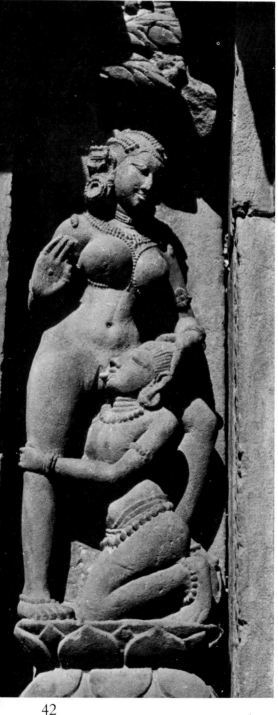

33. Attendant stimulating an Apsarās with her tongue. The Apsarās are filled with unassuageable desire, which symbolizes the longing of the transcendent being to be desired by humans. Stone-carving on the Rājarānī temple, Bhuvaneshvara, Orissa; c. 1000 AD.

Palaces and heaven

A final clue to the whole interpretation is a relief cut on one of the second-century BC pillars at the great central Buddhist pilgrimage site of Bodhgāya. The vertical space of the pillar is framed into a series of storied spaces festooned with garlands. In the lowest appears a nude female dancer. As she twirls, a man unwinds her clothing from her. Behind the two the male head peering over a curtain appears again. In some of the framed spaces above appear emblems which probably refer to the story of the Buddha visiting the 'heaven of the thirty-three gods' to preach to his dead mother. (At this period the Buddha, who has passed into Nirvāna, was not represented in human form.) The erotic dance scene thus probably shows one of the sensual pleasures which was visualized as taking place in the Indian heaven.

The idea of heaven came totally to dominate Indian art during the early middle ages. But where precisely it came from is an interesting question. It is not an essential part of any orthodox Brahmin or Buddhist teaching, though both Hinduism and Buddhism made their own particular use of it. The heavens are often referred to and described in the early Sanskrit epic poems, and later in texts called *Purānas*. Initially, rather like the Nordic Valhalla, it is a place where dead heroes go to be rewarded for their valour with all the pleasures the heart can desire. The idea was probably taken over by the great religions from folklore and from lost ballads of the heroic period of Aryan culture – say, soon after 1500 BC. At that time the main occupation of the upper castes of society was warfare. But their interests naturally included sex.

In those early epics, the *Mahābhārata* and *Rāmāyana*, it was taken for granted that a hero would impress into his personal harem all the women he could. He naturally carried off the wives and daughters of anyone he could dominate, including his own subjects; and one of the prizes of war were women seized from his beaten enemies, or even from his allies. At home in his palace he would thus be able to live 'like a bull among his cows', enjoying to the full every possible sensual pleasure. He owned vast hoards of fine clothing and chests full of chains of emeralds, rubies and strings of pearls, with which he would adorn his household of magnificent women. In the *Mahābhārata* the wife of a dead hero laments his shattered hand in these terms: 'This is the hand that slaughtered heroes, gave thousands of cattle to Brahmins, dealt death to warriors. This is the hand that unfastened women's girdles, pressed swelling breasts, caressed their navels, thighs and secret parts, and opened skirts.' His house would be hung with jewels and filled with perfumes, resounding with music and feminine laughter. The body of the hero himself would naturally be beautiful and plump. His arms and legs would be thick and strong; his eyes wide and clear.

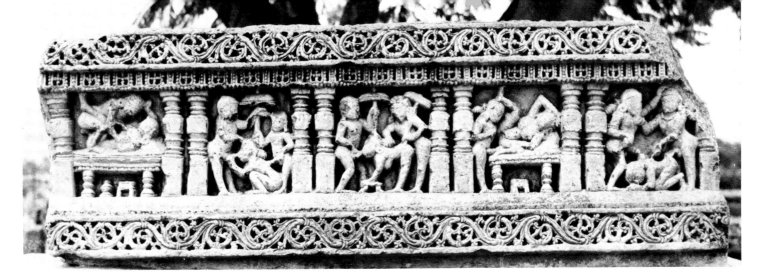

34. Erotic scenes on a temple doorway lintel. Stone-carving at Halebida, thirteenth century AD.

Celestial girls

Heaven was a heightened version of such a royal palace-household, which would also include those official courtesans mentioned earlier. In it, of course, the gods lived. There were other celestial beings, such as the Gandharvas, about whom little is said, who were male celestials of enormous sexual appetite. However, the male-oriented early literature of India paid far more attention to the female celestials called Apsarās. These were glorious creatures, full, like unmarried girls, of unassuageable sexual desire. They waited in heaven for dead heroes and sages, to reward them for their good lives on earth with supernatural sexual pleasure – exact celestial prototypes of the palace courtesans.

In the *Rāmāyana* an Apsarās called Rambhā is asked 'Where are you going, beautiful hips? What pleasures are you seeking for yourself? On whom is the sun now rising that will enjoy you? Who will drink his fill of the lotus-perfumed liquor of your mouth, sweet as nectar? To whose breast will those swelling close-set breasts of yours, like golden goblets, grant their touch? Who will mount swiftly into your broad secret parts, that are like a great golden wheel enclosed in a golden band, the embodiment of heaven?' Another Apsarās, Urvashī, went out when the moon had risen:

broad-hipped . . . shining in her soft, curly long hair, in which she wore many jasmine flowers, the heart breaker went her way. With the moon of her face, and the delightful movements of its eyebrows, the sweetness of the words tripping from her mouth, her charm and soft loveliness, she seemed to be challenging the moon as she walked along. As she went her breasts, scented with heavenly oils and black nippled, rubbed with the sandalwood of heaven and glittering with necklaces, bobbed up and down. By the uplifted burden of those breasts, and by their heaving at every step, she was bowed forward, she whose amazingly beautiful waist was ringed with three soft creases. Below, spread like a mountain, with its high, swelling buttocks, shimmered the sanctuary of the temple of the god of love, encircled by dazzling splendour, adorned with the band of her jewelled girdles; her faultless seat of modesty, covered with thin muslin, tempted with stirrings of the senses even divine ascetics. Her feet, in which the ankles were deep embedded, and

35. (*Right*) An Apsarās, an early wall-painting from Shrilanka.

36. (*Far right*) Multiple sexual intercourse among the Apsarās in the celestial bands of a temple: the paradigm of ultimate bliss. The female body of the temple represents the core of the phenomenal world. Stone-carving at Khajuraho; c. 1000 AD.

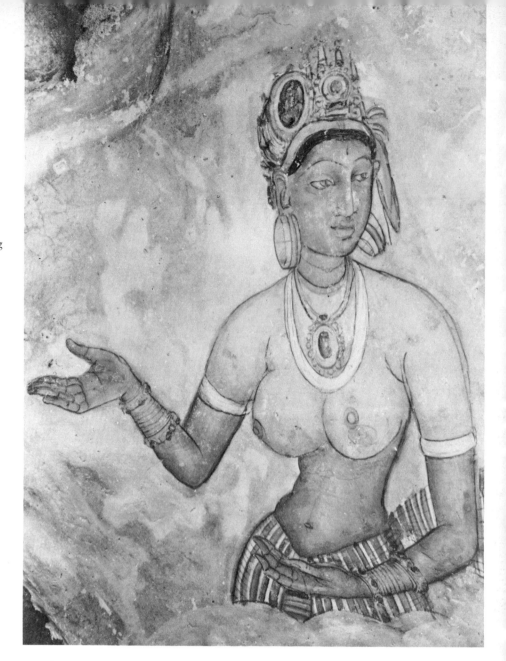

in which her toes made deep, pink crevices, glittered with small bells, and her insteps were arched like the turtle's back. Her behaviour was made captivating by her having drunk heavily, by her contented anticipation, by her awoken passion, and by her coquetry . . . even in heaven a figure to catch the eye, in the thinnest of bodices that shimmered with misty colours, like a slender sickle moon riding along veiled in cloud.

There survives in Shrilanka one group of the few remaining early wall paintings which we know to illustrate Apsarās. It is on the rock face above a path which climbs to the abandoned palace on the top of a 600-foot rock, Sihagiri. A handful of paintings on plaster represent celestial girls; they are the relics of a far greater number painted probably about 500 AD. We know they are Apsarās because, after the palace had been abandoned, casual visitors in the eighth and ninth centuries AD scratched verses on the wall facing them. The scribblers proclaimed their love for the heavenly girls. 'The lily-coloured ones', 'The doe-eyed beauties', they wrote, 'bewilder the mind'. The cruel

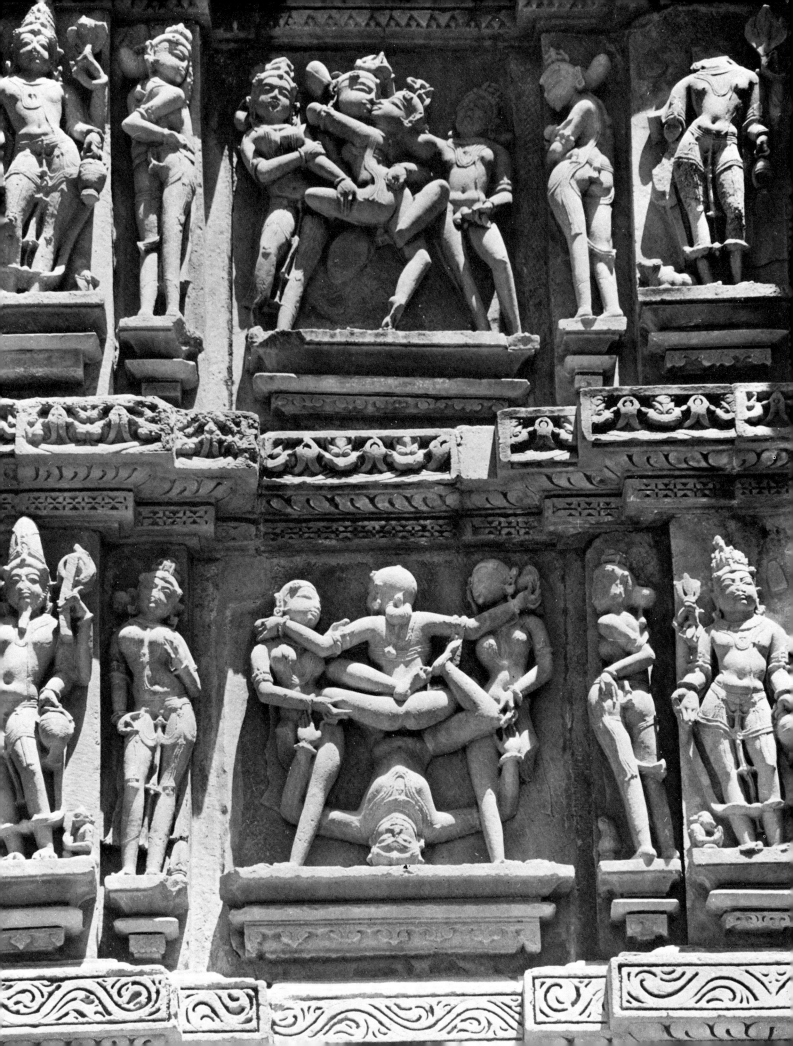

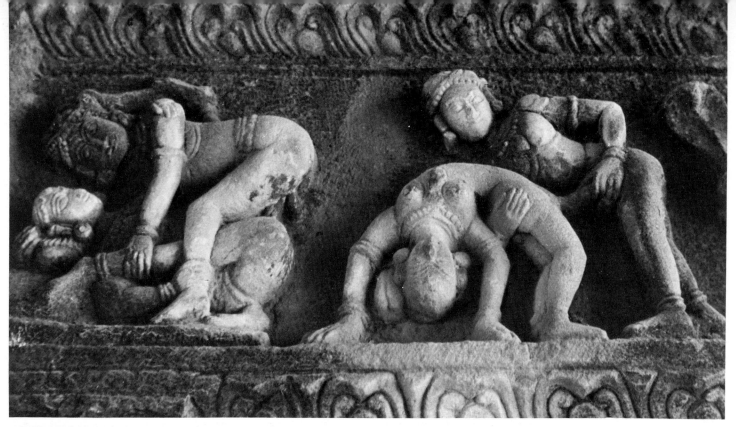

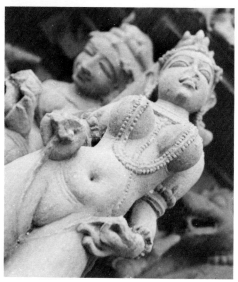

37. (*Top*) Sexual intercourse on a celestial balcony. Stone-carving on the Koilkuntola, a temple at Ellora, western India; ninth century AD.

38. (*Above*) An Apsarās. This shows very clearly how the great depth of the relief symbolizes the blissful efflorescence of divine essence from the structure. Stone-carving on a temple at Khajuraho; c. 1000 AD.

beauty of these celestial beings, with their fluttering eyes and flowers combed into their hair, has 'destroyed the sleep' of some of the writers, and turned others away from their wives; while one proclaims that, now he has glimpsed them, death no longer perturbs him. It seems virtually certain that at least some of the sculptures on the early Buddhist monuments – especially those at Mathurā – must also represent these divine and beautiful girls; while other carvings, such as the dance-scenes at Bhājā and Kondane, illustrate comparable celestial pleasures. On medieval Hindu temple architecture there are hundreds of such images.

One important Buddhist text makes much of the Apsarās. This is a poem by the great second-century AD Sanskrit poet called Ashvaghosha. It describes how the Buddha tricked his cousin-brother Nanda into joining his monastic order. Nanda was in love with a beautiful girl, and refused to abandon her to become a monk. The Buddha, however, lured him away from her one day, and took him by his magical power up to heaven. There he showed Nanda the Apsarās. Nanda was seized with such desire for them that he no longer had any use for his earthly girl; he became obsessed with the desire to reach heaven and enjoy those celestial beauties. The Buddha pointed out that the best way he could achieve this was by joining the order of monks. Nanda did so, and after a while realized the vanity of his sensual desires. But it is an important point that the Buddha had not been ashamed to use upon Nanda the supernatural sensual lure to wean him away from his old obsession with lower earthly pleasure. This story could be seen as an allegory for the way in which the imagery of supernatural pleasure is invoked throughout the later history of Indian culture, to engage the whole sensuous being in the religious ambience. If the senses are not genuinely captivated, the lure will not work.

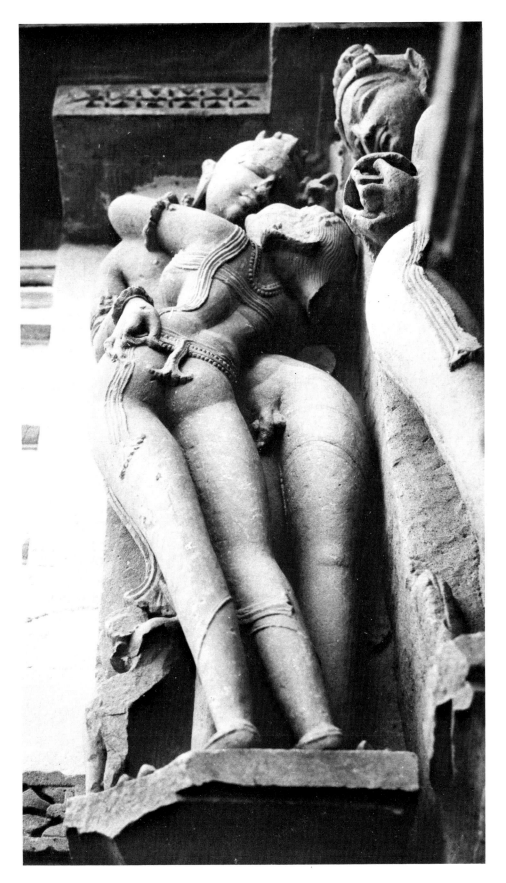

39. Pair of lovers in heaven. This shows clearly the pure convexity of the sculptural style. The figures seem to be 'inflated' with divine energy. Stone-carving on a temple at Khajuraho; c. 1000 AD.

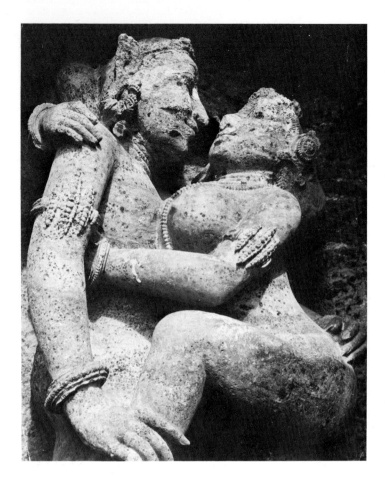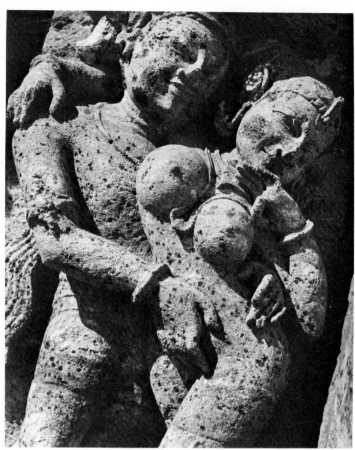

40. (*Above*) A celestial girl with her lover. She gives herself to him just as the female body of the temple gives itself to the visitor as an emblem of delight. Stone-carving on the temple of the Sun at Konarak, Orissa: c. 1220 AD.

41. (*Above right*) Celestial lovers. The Apsarās is the heavenly prototype of earthly temple courtesans, who distribute the joy of divinity in a literal sense. Stone-carving on the temple of the Sun at Konarak, Orissa; c. 1220 AD.

There can be little doubt, however, that behind the idea of the Apsarās in heaven, behind the fantasy of the heroic household described in the epics, lies the cultural fact that pleasure, especially sexual pleasure, was looked on in early historical society as an entirely legitimate goal. No shame or guilt attached to it for those who were not aiming to be ascetics or monks. As we have seen, the courtesan, the earthly counterpart of the celestial Apsarās, was an honoured member of society. The principal feeling or tone of virtually all Indian art is thus set in this early phase: erotic and opulent. And the fundamental imagery was laid down which, for the rest of Indian history, was to interpret every shrine as a palace of celestial delight.

Theory of dance

In fact, the connection between erotic feeling and art was established by one of the most distinguished theories of aesthetics known to the world. From early historical times there had been a vital tradition of dance and drama at the many courts of India. We know a good deal about the works themselves. Some survive, and many were discussed by later theoreticians; but of course the dancing itself does not survive. We can only see some of its moments frozen into stone or terracotta sculpture. In the fourth century AD, however, a long and detailed handbook on the actual techniques of dance, stage-writing and production was composed, based upon far older material and a highly evolved tradition. It is the earliest such work to survive intact.

Although it deals with essentially secular arts, in India it came to be accepted as a sacred text, known as the *Nātayashāstra* and attributed to a sage called Bharata. A long series of commentators down the centuries spun out a unified theory from its implications. It was given its final form by Abhinavagupta soon after 1000 AD.

The forms of executant art arrived at then have survived down to the present day principally in a type of temple-dance, called Bharat Natyam, in Southern India. This illustrates a fundamental phenomenon in Indian culture: the way established religion has assimilated arts which may initially not have been intentionally 'religious'. All over Southeast Asia where Indian ideas and customs were adopted, court dancing was set up on an originally Indian pattern. Until very recent times these have developed and survived, most notably in Bali, Java, Thailand, Burma and Kampuchea.

The full assimilation of the imagery of the dance-drama to temple decoration took place during the early middle ages in India, between about 400 AD and 800. It gave to Indian sculpture its particular ways of presenting human figures, inducing them to address themselves to the spectator as if they were performers on stage. They pose and place their heads, limbs and hands carefully, to make their 'own' feelings clear. Most important for our purposes is the general expressive atmosphere enveloping this presentation, and which the aesthetic theory explained.

This theory taught that dance and the other arts work by evoking in the memory of the spectator strong reminders or traces of his own

42. (*Above left*) Female attendant assisting the pleasure of celestial intercourse. This is referred to in the classic of love, the *Kāmasūtra*. Stone-carving on the Temple of the Sun at Konarak, Orissa; c. 1220 AD.

43. (*Above*) Detail of plate 40, showing how this kind of sculpture offers itself to the caressing hand – another dimension of pleasure.

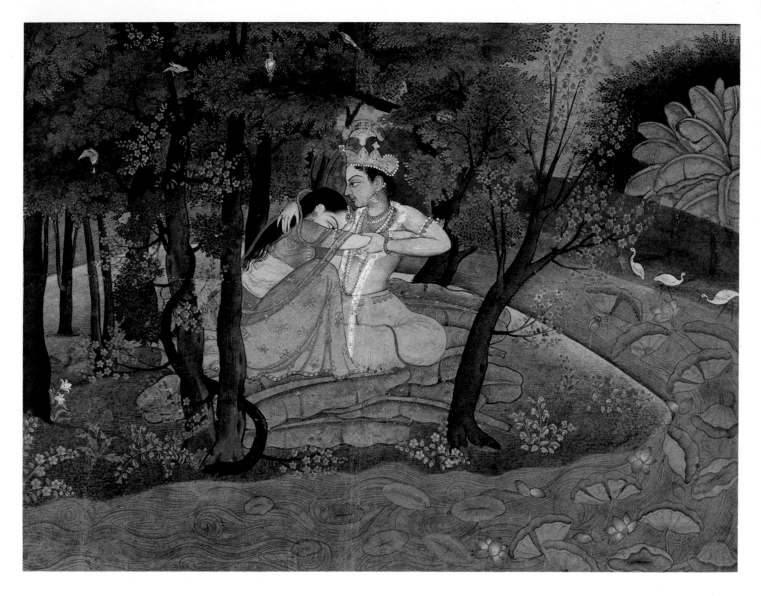

44. (*Above*) Kṛṣṇa and Rādhā in a grove.
Miniature painting, Kangra state, c. 1785.

45. (*Opposite*) Prince and lady on a terrace.
Miniature painting from Bundi state,
eighteenth century.

past experience. These are always coloured by some emotion; indeed such emotion, and its associated feelings, may be the spectator's only means of access to some of his own genuine experience. He may never have seen the persons represented on stage or the actors before. He must not react to the people represented as if they were real, or to the human actors as people. Instead he should 'taste' his own memory-traces of situations and human reactions analogous to those portrayed on stage. The artists' skill will appeal to a wide range of these situations, and build them up into a unity. Emotions and feelings are not evoked directly, only their traces as a kind of memory-resonance in the mind. If the spectator were to become absorbed in an *actual* feeling, he would react as if to facts in the real world, and the process of 'tasting' would be spoiled.

There is a kind of spectrum of the possible human emotions which can colour the spectator's memory-traces: anger, heroic commitment, the comic, disgust, amazement and so on. But far the most important is the joy of love. All Indian art accepts that its principal objective is to bring the spectator to 'taste' that condition of delight, which he naturally welcomes; and finally to lead him to a state in which he is

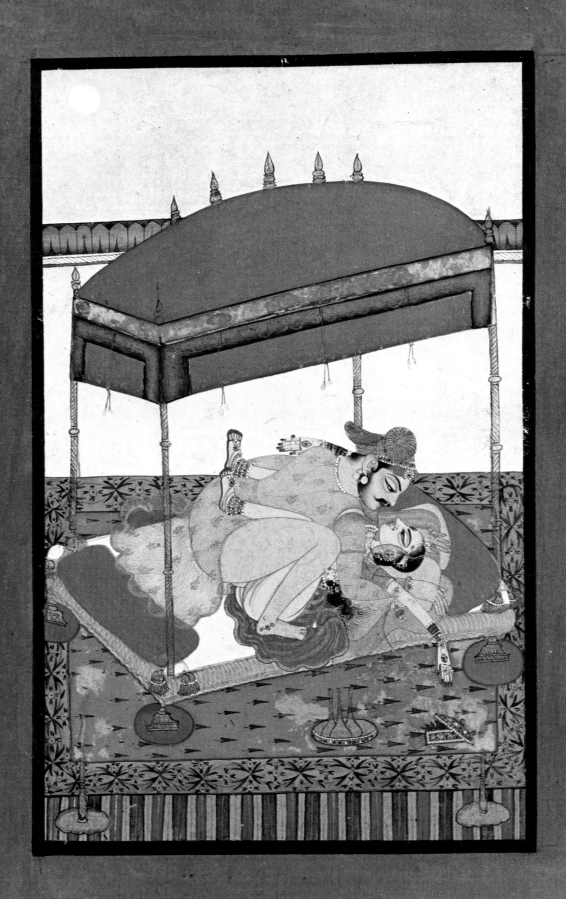

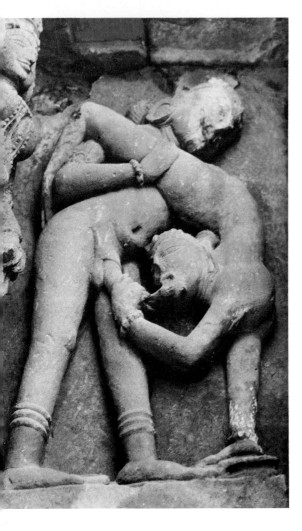

46. Reverse intercourse with an Apsarās as one of the sublimely blissful pleasures of heaven. Stone-carving on a temple at Khajuraho, c. 1000 AD.

tasting his whole emotional consciousness. This came to be recognized in the theory as a very high spiritual state indeed, virtually equivalent to religious enlightenment. Of course, the better the art, the more complete the experience. So the erotic mode of feeling-response in art came to be intimately connected with the goals of religion. The emotional flavours the spectator 'tastes' are called 'rasas'. The final combined state is called either 'Harsha' – 'joy', or 'Rasa' – the 'Great Flavour'.

Bharata explained the purpose of creating wide-ranging artistic unity in mythical terms which refer back to the nuclear idea of the centre, described earlier. He pointed out that as the world moves further out from its original centre, and the first golden age of men and gods is left behind, society and its members become enveloped in an increasing tangle of conflicts. Art's job is to resolve these in the spectator's consciousness and restore him to his own and the world's centre. In this emotional restoration process the meetings and reconciliations of love which result in union of the sexes provide an obvious central strand. It was precisely such a concept of sexual reunification, but at a transcendent level, that inspired the great waves of devotional religion which swept India between the twelfth and fifteenth centuries. These we shall discuss in a moment. First we must consider the imagery of the temple, and the idea behind the devotional practice which calls for the personalization of the adored deity.

The Indian temple, Hindu and Jain, is a development of the old and simple village shrine. From about 200 BC onward it evolved to its peak of artistic sophistication between about AD 1000 and 1250. However, the earliest structure to survive intact belongs to about AD 400, and temples are still being built. The principle of the structure remained the same during that whole epoch. A cell, called the womb house, contains the main icon. A door leads to this cell, whose frame very often incorporates bands of beautiful couples, and has images of the great purifying river goddesses Gangā and Yamunā at the foot of each jamb. Outside the door is a portico, sometimes small, sometimes large enough to be called a hall. Here the people stand to make their offerings – through the priest, usually a Brahmin – and to receive in return individual portions of offerings which have been sanctified by contact with the indwelling deity. Beyond that portico there may be further halls aligned with the main icon. One of them, often called the 'dance pavilion', will be discussed in a moment. The whole complex may be raised on a high plinth, and surrounded by an ambulatory with open verandahs. After about AD 500, the shrine came to be crowned with a towering spire, built of massive stone; the portico and auxiliary halls were crowned with their own lesser spires. The main spire was interpreted mythically as the mountain which marks that central axis of the world referred to earlier.

The most important part of the temple, from our point of view,

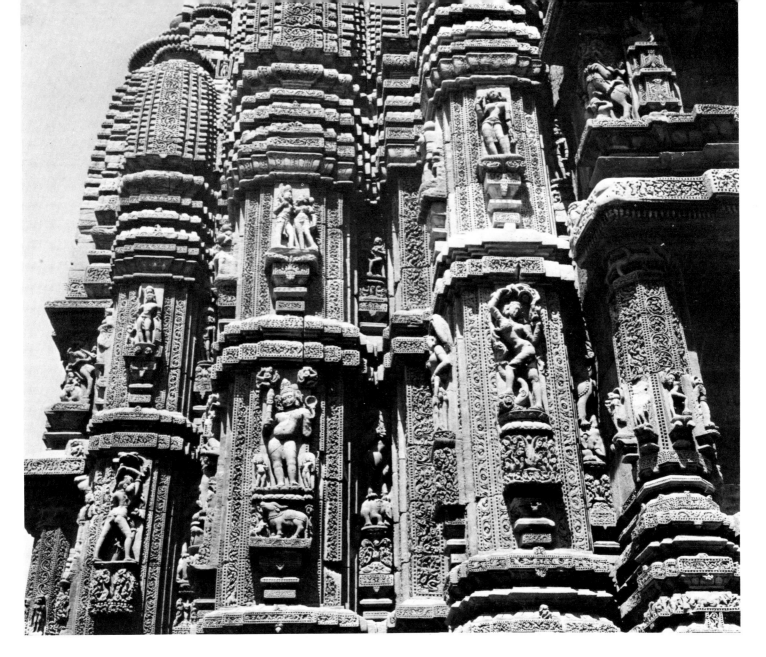

is its carved decoration. At first it was confined mostly to the exterior, but later after about AD 800 it appeared all over the interior as well. Among an extraordinary proliferation of mouldings and profiles, foliage ornament creeps over the whole exterior and a vase brimming over with foliage and flowers is often incorporated into the carving of the inside pillars. These both refer symbolically to those inner, female waters of fertility mentioned above. Then there is the figure sculpture. On the plinth, there may be representations of divinely inspired human activity such as tales from the epics, or rituals. But at the level of the main shrine, the divine level, are representations of the gods in their heavens. These are conceived as slung like a garland round the terraces of the cosmic mountain. This level of the temple is interpreted as a great 'palace of the gods'. And there, along with the named deities of the Hindu pantheon, we find the Apsarās. These celestial beauties posture alluringly on the fabric; they dance, make music, and above all, embrace and pleasure their worthy lovers by a great variety of erotic techniques. The temple itself thus demonstrates that sensual lure of perfect, and hence trans-human, sexual

47. The shrine tower of the Rājarānī temple, bursting with divine figures, who embody the blissful essence of the divine structure, and with foliage symbolizing fertility. Bhuvaneshvara, Orissa, c. 1000 AD.

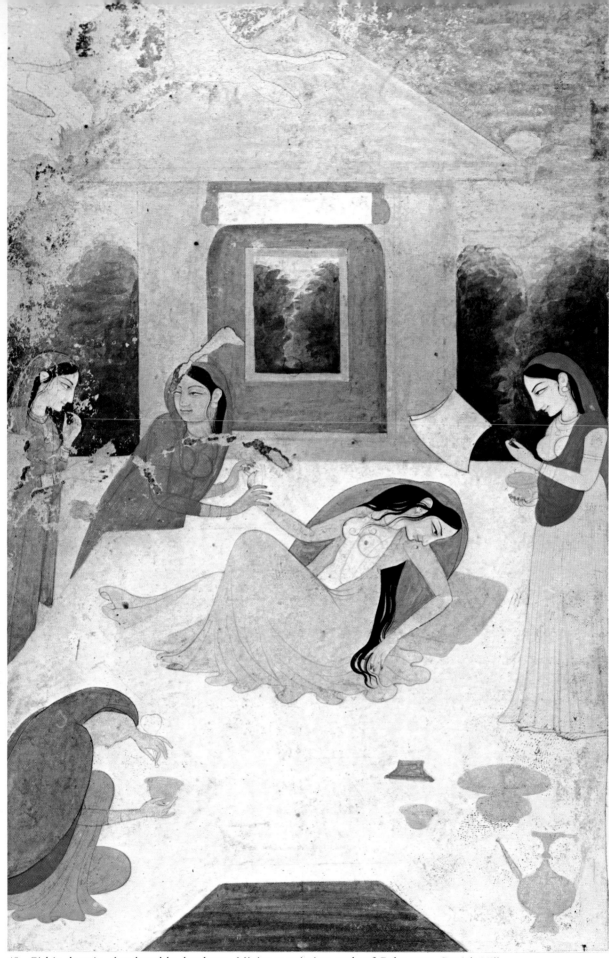

48. Girl in despair, abandoned by her lover. Miniature painting, style of Guler state. Punjab Hills;
early nineteenth century.

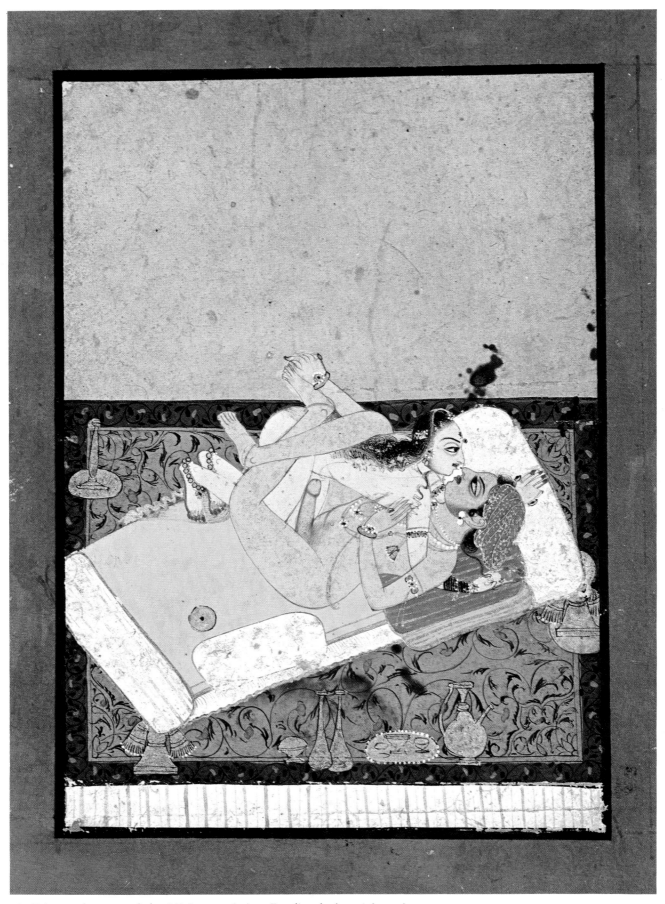

49. Prince and amorous lady. Miniature painting, Bundi style; late eighteenth century.

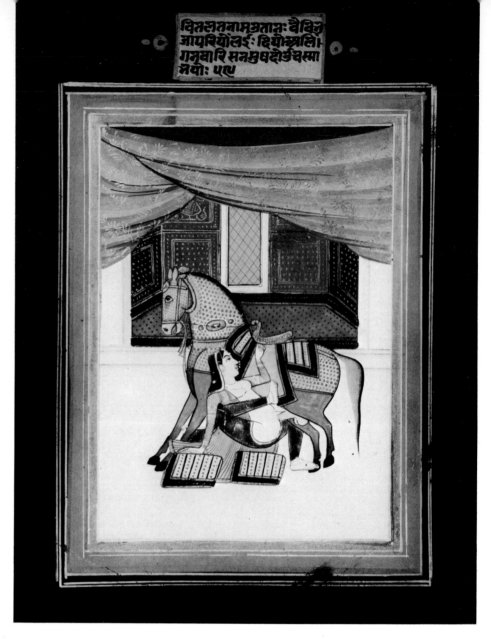

50. Lady personifying love, in intercourse with a stallion. This image has overtones of the ancient Aryan ritual of the horse sacrifice performed by emperors. During it the empress had symbolic intercourse with the white stallion to be sacrificed. Miniature painting, Rajasthan, nineteenth century.

51. (*Right*) Celestial courtesan in intercourse with a stallion. Carved wooden panel-bracket from a temple car, South India; seventeenth century.

52. (*Far right*) A celestial girl approached by an amorous monkey. Miniature painting in monochrome, made probably by an Indian painter for a European in the eighteenth century from a medieval Indian temple sculpture.

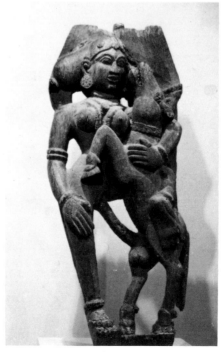

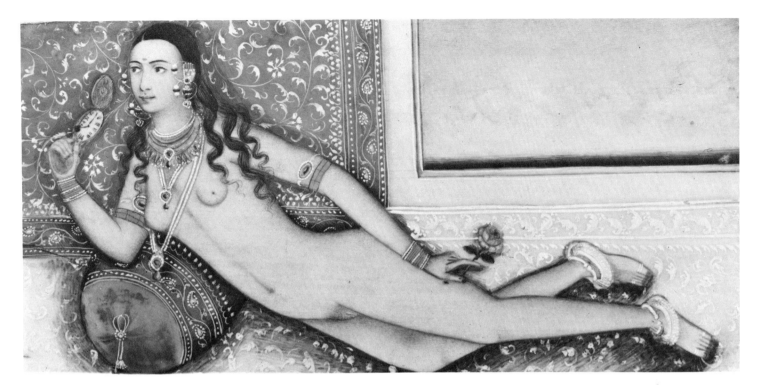

53. A beauty reclining. Miniature painting, from Rajasthan (?), nineteenth century. The style is influenced by European miniature painting.

enjoyment which ensnared the Buddha's cousin-brother Nanda. Furthermore, the presence of these celestial courtesans represents a major part of the glory of the deity whose home the temple is. Some Hindus assert that they also give pleasure to the deity so that he feels well disposed towards the people.

It is, however, important not to treat these erotic images as mere fantasy, for at the major temples the heavenly Apsarās had their human counterparts – the dancing girls called Devadāsīs, or 'servants of God'. They illustrate once again the extraordinary mingling of the secular and the sacred in Indian society. Not only did the Devadāsīs perform in the dance pavilion at temple services for the deity, making music, singing lascivious songs and dancing lascivious dances to stimulate his potency, but they also did the same in the houses of royalty, nobility and the rich. In addition some would have sexual relations with male visitors to the shrine. And since they became Devadāsīs by performing the rite of marriage to the god, for them to couple with a man was a powerful way of stimulating the divinity in him. In India, divine presence is associated with the sense of deep sexual arousal.

However, this custom of temple sex is far older than any Aryan texts. It goes back, in fact, to an era when the Great Goddess was supreme, probably into the later Stone Age. Although they had taken over the role of the earlier city courtesans, and been impressed into the service of a religion dominated by the Aryan Brahmins, the Devadāsīs were acting out customs which belonged originally to the shrines of the Western Asian Mother Goddess, Inanna-Ishtar, in the third and second millennia BC. Her many images in stone and terra-cotta show her with exaggerated vulva exposed; and her high priestess used to impersonate her to have intercourse with the ruler at the beginning of each new year, in a Sacred Marriage enacted as a fertility

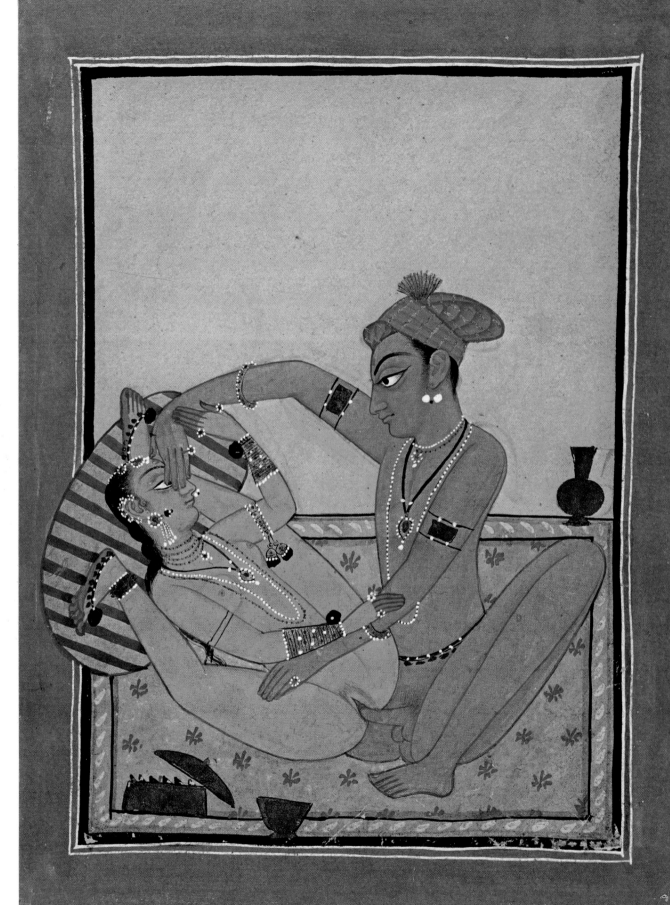

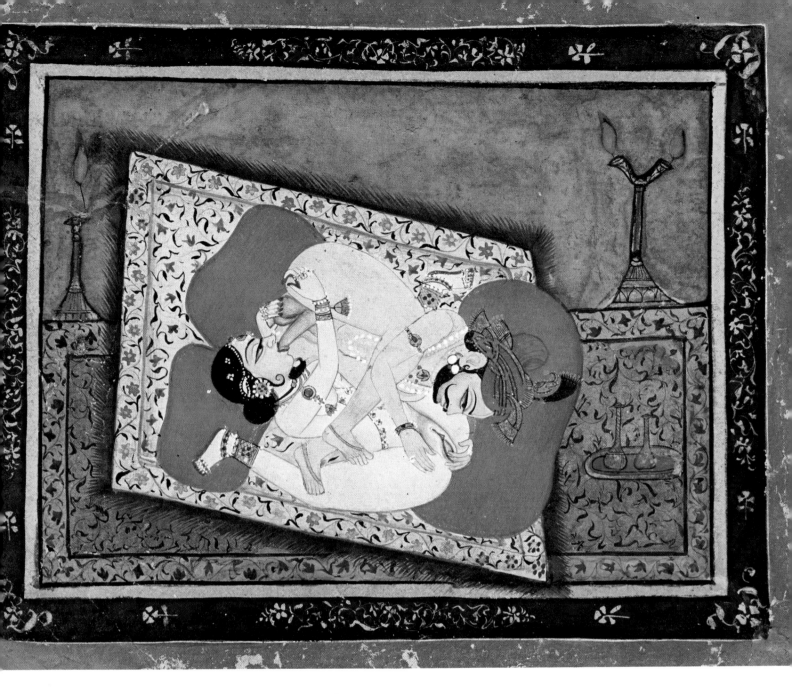

charm. One Sumerian hymn (belonging to the same genre as the Biblical *Song of Songs*) declares that 'With the high rising of the king's penis, the flax rose together, the barley rose together, the desert filled with delightful gardens'. In another poem Inanna recalls, 'my beloved met me, took his pleasure in me, had joy together with me'. Other priestesses representing the goddess had relations with male devotees; and their profession embraced what we would call ordinary prostitution. There are also many terracotta and stone images from Western Asia representing the sacred act of sexual love. The Greek writer Herodotus describes how it was normal in his day (fifth century BC) for all women to visit the temple at least once in their lives for ritual intercourse with a priest or a stranger – a custom also known in late medieval India. The connection between Indian and Western Asiatic customs is reinforced by the presence at many temple sites in Syria, Palestine and Mesopotamia of stone phallic emblems which are closely reminiscent of the Indian Shiva-lingam.

55. (*Above*) Lovers on a terrace at night lit by a double lamp. Miniature painting in the style of Bundi state; late eighteenth century.

54. (*Opposite*) Prince and lady. Miniature painting from Mankot state, Punjab Hills; mid-eighteenth century.

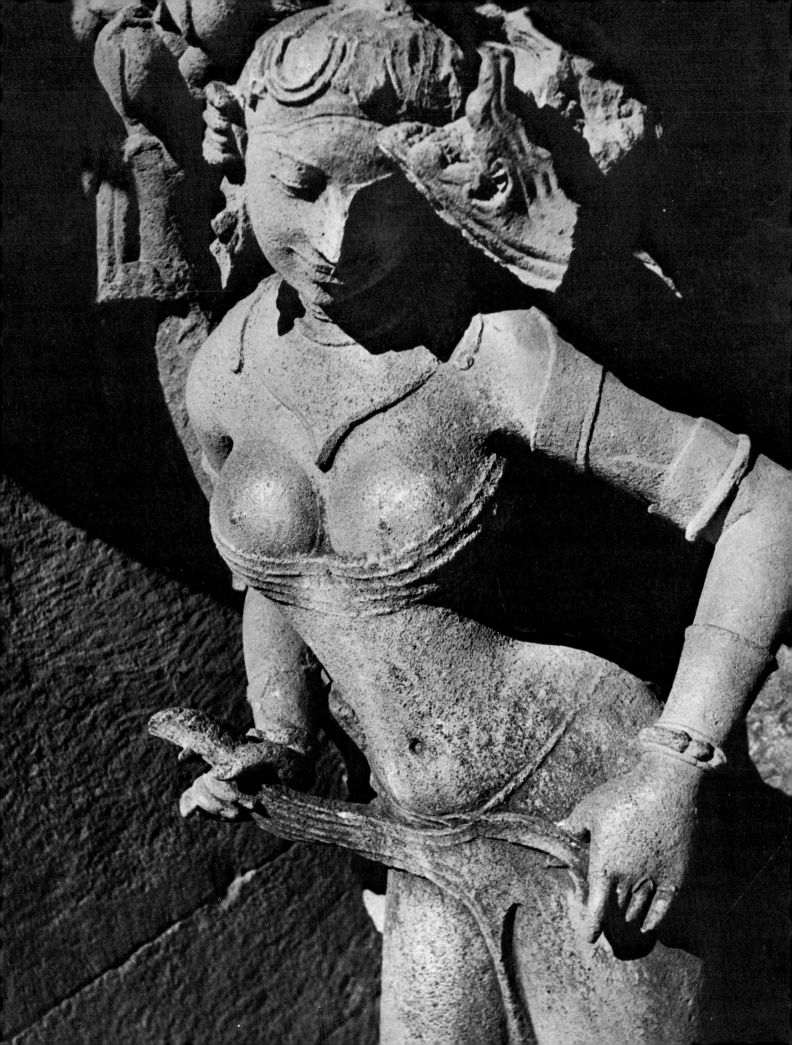

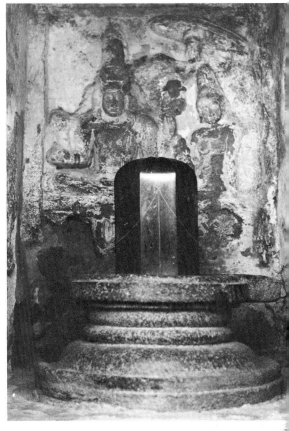

Temple and icon

The main icon which is installed in each Hindu temple is looked on as a kind of metaphysical power terminal and is the focus of the temple's meaning. The lingam is emphatically male, though nowadays the more intellectual Brahmins tend to explain it as a purely abstract emblem, far removed from any physical reference. That this is not the whole truth is proved by the wide distribution of those Tantric forms of religion discussed below. But one can understand the reasons for high-caste squeamishness which cuts the meaning of a potent symbol from its roots in direct experience. Many Brahmins view the loss of their sexual fluids – even accidental loss—as a dangerous leakage of the spiritual essence it is their duty to contain. Even their wives may expect intercourse – if at all – only when they have a sacred right to it, after their menstruation. Brahmins may thus view their own sexuality with a mixture of reverence and dread, and so incline to interpret its emblem abstractly. This, of course, is simply the reverse side of that same conceptual coin whose other face identifies the semen with spirit.

As we have seen there is a female counterpart to the male lingam, still installed in many shrines and often used in the inner quarters of private households today. It is that stylized version of the female vulva called the yoni. In Shiva temples it has been reduced to the

57. (*Above left*) A sacred spot, marked by many small lingam-yoni offerings. Benares, India, modern.

58. (*Above*) Octagonal lingam icon of stone, marked with stylized lines of the glans of the penis, in front of a relief representing Shiva and his wife, in a temple near Kanchipuram, south-east India; eighth century.

56. (*Opposite*) An Apsarās unfastens her skirt. She personifies the bliss-giving feminine nature of the temple built of stone, the body of mother earth, which charms the mind. Stone-carving on the Rājarānī temple, Bhuvaneshvara, Orissa, c. 1000 AD.

61

59. Part of the decoration of a house: a
house without love is not properly alive.
Painting from Rajasthan; nineteenth century.

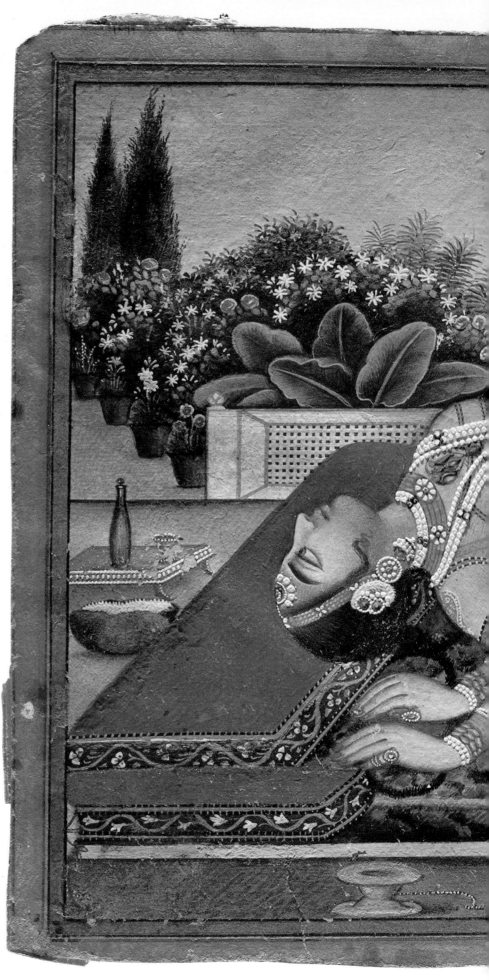

59

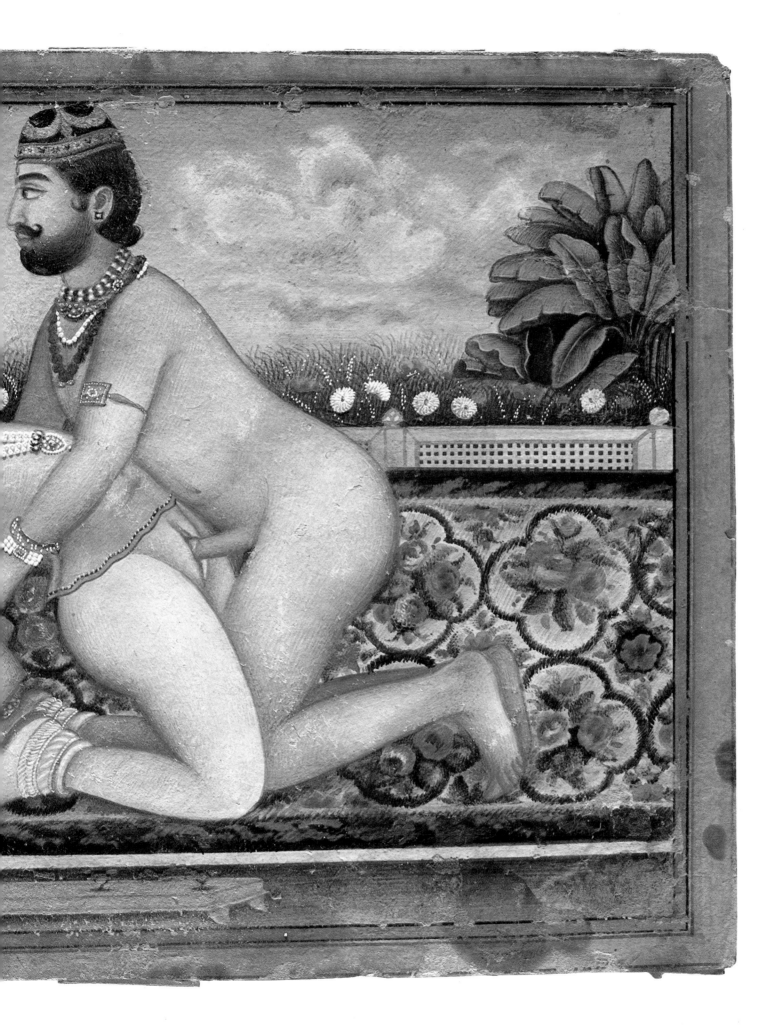

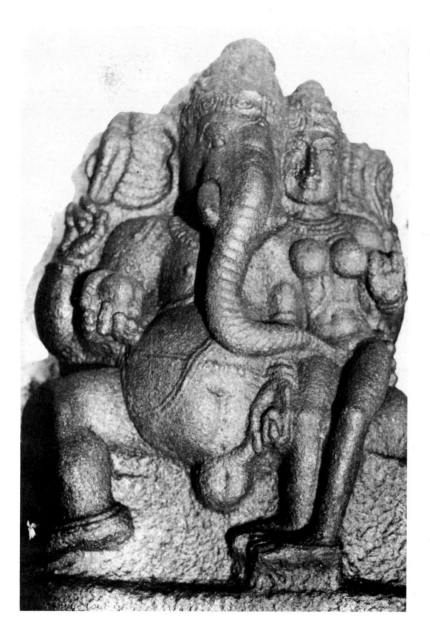

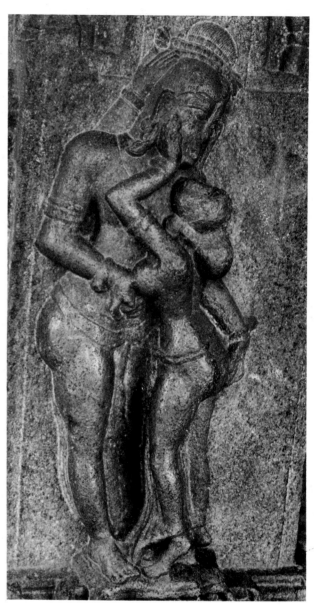

60. (*Above*) Ganesha, the elephant-headed god of good fortune, with his wife. Stone-carving, from a temple at Deccan; fourteenth century.

61. (*Above right*) King with girl. Carved on a stone pillar of Vridachalam temple, Madras state; thirteenth century.

shape of a pierced stone basin, which is slotted down over the lingam. In the more remote goddess shrines it may consist of a direct representation of the female genitals, or may represent a female figure lying with her legs apart to expose her vulva. These icons are worshipped with offerings and anointed with butter or oil in the same way as the lingam. But the feelings with which that worship is offered may be far warmer and more intense than those with which other icons are adored. And feeling is of the essence of Hindu worship.

Adoration

Here is a crucial point. One major ingredient in Indian religion is called 'Bhakti', that is, adoration. As a religious attitude, carefully

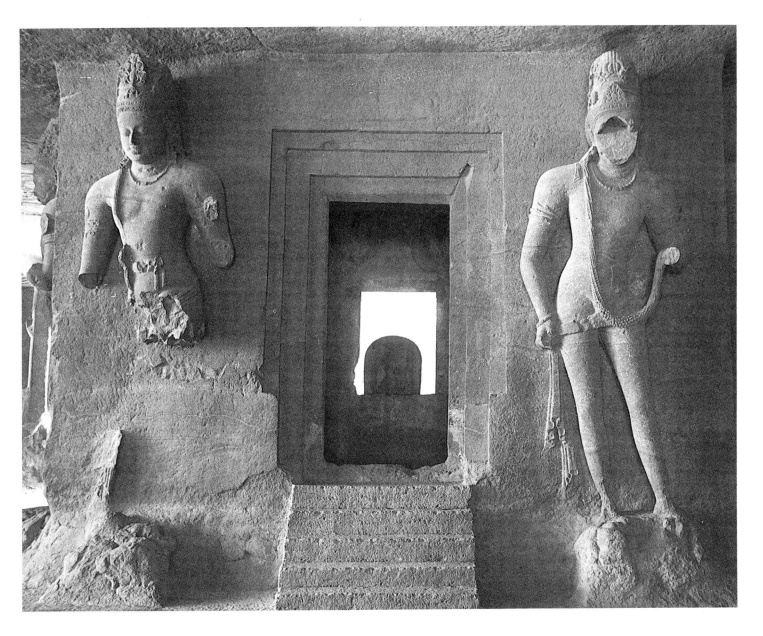

62. Lingam in a cubical womb-house. Rock carving in Elephanta cave-temple, eighth century.

cultivated, it appeared in very early times – at least before the second century BC. It was by then accepted that an individual deity was able to personify the Supreme Principle, the Ultimate Ground, in a generically human form. And the personified deity whom each individual chose to worship could condense the Ultimate Ground into a presence for him or her. The cult of Bhakti spread all over India, developing to its most extreme pitch of intensity during the twelfth to fifteenth centuries. Communal singing, rituals, processions, ceremonial, all came to be used to stimulate the uttermost love and devotion of which each person was capable. And that love was focused upon the personalized deity.

Naturally such a divine person had to be imagined as stupendous, awe-inspiring, usually compassionate, but always as beautiful –

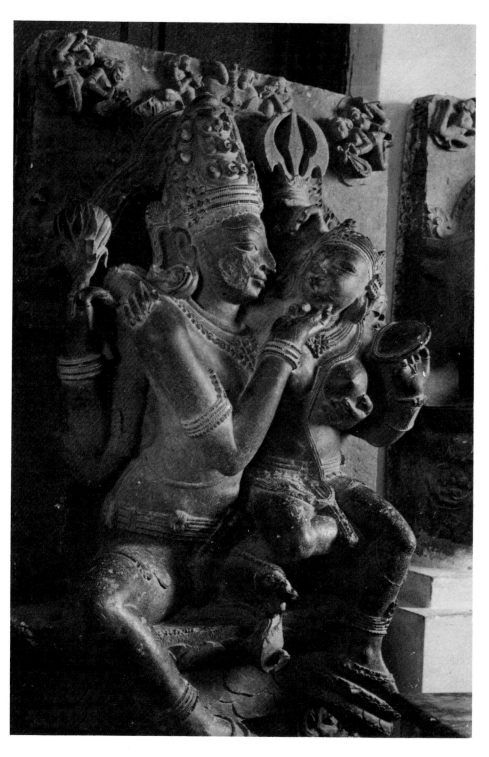

63. Shiva as the originating spark, paired
with his wife as the reflecting and diffusing
agency of creation. He is erect, she holds a
mirror. Khiching, Orissa, eleventh century.

erotically beautiful. Human-shaped Hindu icons of the main deities
evolved during the early and late middle ages expressly to depict the
Bhakti-evoking qualities of the deities. Even the terrible Shiva, who
had his horrifying aspect as Destroyer of the worlds, also had his
sublimely beautiful and tranquil aspect. Vishṇu, the Supreme Prin-
ciple sustaining Reality, was said to have incarnated himself as the
charming Kṛishna and the delightful Prince Rāma, as well as in the
more primitive shapes of gigantic tortoise and fish. The Goddess in
all her forms was 'beautiful as a sixteen-year-old girl, radiant as the
sun and moon'. The form of Shiva which personified the idea of the

Original Couple, 'Half-man-Half-woman', was no monster, but a paragon of male and female beauty combined. The point was that all the worshippers' passion and desire, including their sexual desire, should be focused onto the image of the adored deity. Then, by the power of adoration, and by specially cultivating the emotions, the worshipper could transmute his or her originally base passion into a higher condition – Prema, or divine love, as distinct from human love. This could become identical with the bliss of complete liberation, the goal of all human life and striving.

Along with this attitude towards the deity certain customs appeared. They may, in fact, have been present, unacknowledged, since a much earlier age. But they developed through a complex historical process, involving the mutual interaction of Hinduism and Buddhism during the middle ages. They focused especially upon the theory of the physical incarnation of the deity as a sublimely beautiful human being. The incarnations who attracted most attention were Vishnu's incarnations as Kṛṣṇa and Rāma, and, in South India, Shiva as Dakshinamurti. The Goddess was felt to be somehow incarnate anyway.

Under the inspiration of philosophers and poets the Bhakti-Prema movement attracted millions of followers. Writers and musicians devoted thousands of poems and compositions to the minutiae of Divine Love, describing intimate aspects using terms of physical passion. What these devotees sought was not physiological release, but the radiant inner condition, continually sustained by meditating on the Beloved, listening to and singing the stories of his or her heroic deeds and love affairs. The deity most widely beloved was, of course, Kṛṣṇa.

He had originally been the hero-deity of a tribal people who lived by herding cattle on the banks of the river Yamunā near Brindaban, which is now a sacred city. Folk-song and legend had described his charming youth, his working of miracles to help his people. Most important for us, they described his magical love affair with all the women of his people, married and unmarried; they are called the Gopīs, cowherd-girls. The chief of them was Rādhā, wife of one of the leaders of the tribe. This religion, like all true Bhakti, refused to award any ultimate value to the ordinary rules of society. Only a devotion which sacrificed everything, including respectability, for the love of God could become Prema. The Gopīs were interpreted allegorically by conservative theologians as human souls, who, in both East and West, are always 'feminine to God'. By the fifteenth century there had appeared groups of male devotees (they still exist) who took the allegory literally. They dress and live as girls, behave like girls in love, absorbing themselves totally in Kṛṣṇa and aiming at an ultimate union with him, analogous to the union of husband and wife in the Originating Couple.

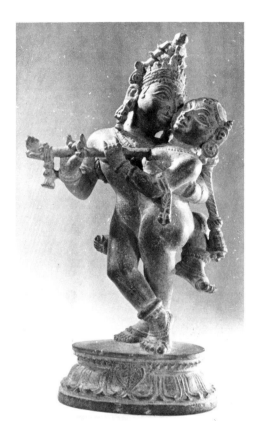

64. The divine incarnation Kṛṣṇa, dancing in intercourse with one of his Gopīs to the music of his flute. Miniature bronze sculpture, Orissa; sixteenth century.

One of the greatest Kṛishna poets, Vidyāpati (fifteenth century), wrote:

> Her hair, flying loose,
> Veils the splendour of her face
> As demonic shadow eats the radiant moon.
> The flower-strings in her hair
> Play careless games
> And tangle together
> Like twin rivers when they flood.
>
> Ecstatic, today,
> Is this exercise of love; astride
> Rādhā is riding Kṛishna,
> Beads of sweat shimmer on her face
> Like pearls from the full moon,
> Given to her as gifts
> By the God of Love.
>
> With all her strength
> She kisses her lover's lips,
> Like the moon leaning down
> To suck from a lotus bloom.
> Her necklace dangles
> Below her drooping breasts
> As if milky streams
> Dripped from their golden bowls.
> The bells on her waistband jingle, and
> Sing musical praises to the God of Love.

Poems like this inspired musicians and artists right through the seventeenth and eighteenth centuries. Even today the special mode of eroticism inspired by Kṛishna is still very much alive, and gives its unique flavour to the expression of Indian arts. In particular, miniature painters at the Rajput courts of Rajasthan and the Punjab hills created series of brilliantly coloured pictures, devoted not only to Kṛishna himself, but also to human love seen as a reflection and re-enactment of Divine Love.

An important implication in this last idea, reinforced by the whole theory of divine incarnation, was drawn out by sectarian theologians. It showed that a man might find his Goddess incarnate in either one or several actual women – especially women who were religious initiates, and this naturally included Devadāsīs. A woman, conversely, might find her God incarnate in one or several men. Hindu wives and husbands had since Upanishadic times been expected to look on each other as versions of the Originating Couple. But some of the implications of the Kṛishna cult, when lived out by men and women, were extraordinary.

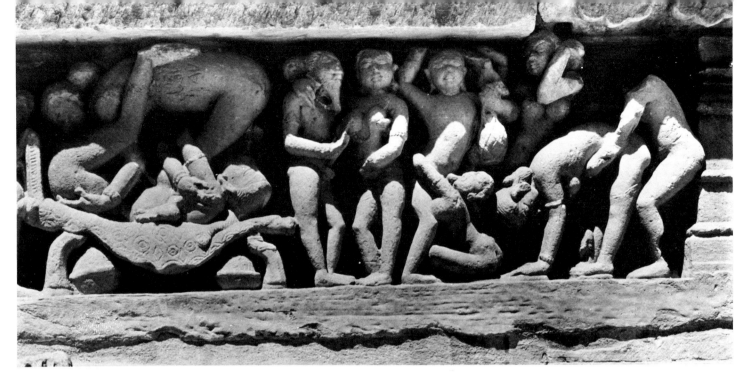

Sexual yoga

Religious circles were formed whose members cultivated the passion they needed to fuel their Prema by engaging in prolonged and ritualized sexual intercourse. There was much argument (notably in Bengal, Bihar and Orissa) as to whether intercourse between partners married to each other would work properly. Opinion tended to favour the idea that it did not fulfil the ideal of breaking the last bonds of convention and selfhood, as the Gopīs' relation with Kṛishna had. So, for religious purposes, relations between partners not married to each other were felt to be best. There was also much discussion as to whether orgasm should be allowed or not. The more conservative and high-minded opinion thought not, probably on the same theory we have already met, namely, that orgasm would release and waste the accumulated divine inner energy. But other opinion held that without occasionally reaching its natural end in orgasm – treated carefully as an offering from one partner in divinity to another – the essential passion could fade. So both kinds of sexual activity were practised. Perhaps the most extreme form of this sexual culture was developed among a school of Bengali poets. The most famous is the fifteenth-century Brahmin Chandīdās, who wandered through the cities and countryside with a beautiful but very low-caste (and hence defiling) girl called Rāmī. He adored her as his own incarnation of Rādhā, dressing her and caressing her, ecstatically praising her beauties and pouring out his love for what she represented.

This particular sexual culture was probably partly shaped by a very ancient strand of tradition – almost certainly long pre-Aryan – running through Indian society. It has surfaced during the later history of each of the major religions, interpreted according to the religion's central concepts. Being connected with ideas about the body and its mechanism, it also runs through Indian medicine. Its generic name is Tantra, which means 'the thread'. Much yoga and ritual are strung upon it. It first became prominent in North Indian Buddhism about AD 600, and in Southern Hinduism by about AD 1000. Since then

65. Sexual rituals performed by shaven-headed ascetics with women. Stone-carving on the plinth of a temple at Khajuraho; c. 1000 AD.

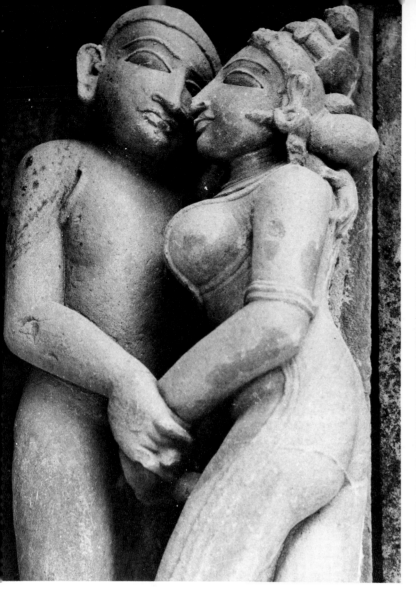 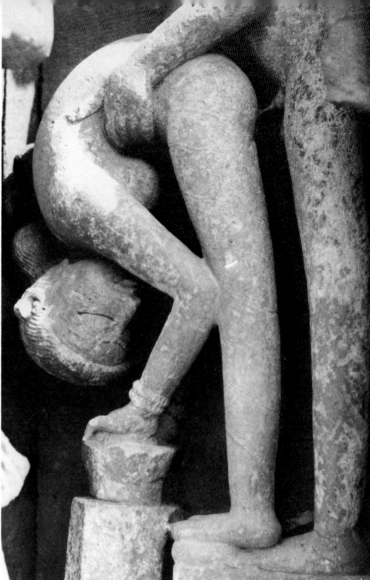

66. (*Above*) Ascetic and woman about to have ritual intercourse. Stone-carving on the plinth of a temple at Khajuraho; *c*. 1000 AD.

67. (*Above right*) Detail of the sculpture from the Lakshamana Temple, Khajuraho; c. 1000 AD.

it has flourished in a wide variety of forms especially in Bengal, Rajasthan, Nepal, Kashmir and the Deccan.

At bottom, Tantra accepts that the appearance of the phenomenal universe around each person is generated by the Great Goddess; she is the womb or matrix of inner and outer reality. She makes visible the creative intent of the seed or spark of Being who is male. She thus becomes the projection of his energy in action and works through a radiating series of subsidiary powers into which she divides herself. These are personalized as lesser goddesses. The chief agency whereby phenomena are projected is the human body with its mental and physical faculties, its sensuous and emotional urges. Divine energy coursing through the body diffuses outwards, making around it a kind of halo of experience into which it precipitates the atoms of sensuous reality. Spiritually speaking, this is a waste, like water running away into dry sand. Both ritual and yoga, which aim at attaining release from suffering through enlightenment, set out to concentrate this out-turned energy-flow, and return it to the source from which it came. Since that source is itself conceived as in some sense a sexual couple, the divine energy shows itself in human beings most clearly as the sexual urge. And the best way to concentrate and return it starts with arousing the sexual force and then controlling it.

The processes of control are shaped by a medico-yogic concept called the subtle body. Of course, the creative energy is not simply and solely sexual. It is supposed to enter the human organism from 'the beyond' as an undifferentiated bliss, like a juice or milk, flowing in through the crown of the head. (This image appears even in early Upanishadic literature.) There it divides itself into male and female principles, and is distributed throughout the organism by a network of veins and channels, rather like the veins in a plant or leaf. The chief and central channel runs down the spinal column from the point of entry in the crown of the skull. On the way down it passes through a series of nodes, where the major faculty-channels branch off. In the process of creation these channels are what first establish the subtle version of the body. Only after the processes of projection and precipitation mentioned above have taken place does the ordinary physical body crystallize around the subtle body, because only then is there a 'reality' within which it can experience itself as physical.

The element of Tantra in the later Bhakti movement (say, after AD 600) was primarily its use of a state of erotic possession vis à vis a human partner to lift a male or female self out of the rut of the everyday. Other Tantric rituals and yoga use versions of a very similar process; though perhaps the element of pure adoration may not be so strong. Different sectarian groups in different parts of India developed the Tantric process in different ways. But similar fundamental patterns lie behind them all.

The first stage in the passage towards release is built upon active worship (pūjā) which identifies the creative principle of the phenomenal world with an external female image. This image may be made by an artist into an actual icon. The Goddess can be induced by ritual to project herself into the icon, and focus the attention of the worshipper. As the individual's spiritual achievement advances, the external image he needs will become subtler and eventually purely internal. An external icon will no longer be needed. The first type may be a temple icon of a goddess to whom public offerings are made – for example, the beautiful wife of Shiva, or Kālī, the horrible Goddess of devouring time. A subtler type may be a pot covered with a palm frond into which, by special rituals, the female principle may be projected to receive private worship; subtler still is an abstract emblem of the female genitals, such as a downward pointing triangle with a cleft. And the subtlest external image of all may be a linear diagram, called yantra, which merely summarizes the creative functioning of the Goddess as she structures the world out of her impregnation by the original spark. Such yantra diagrams may represent subsidiary aspects of the process by strange personifications. The aim of all such ritual is by first externalizing the image to lead the worshipper to recognize in it his own self in creative action.

A parallel series of phases is enacted in Tantric yoga. All women

are natural embodiments of the Goddess, human icons, and are reverenced as such. But ritually each man may identify only one woman as his own visionary Goddess, with whom he will have intercourse – not physically coupling with her in all the sects, but in many. Many groups, especially those with high spiritual aims, gather about a particular woman who is looked on, because of her high initiation and sanctity, as literally the Goddess. In certain Bengali rites a kind of Eucharist takes place among each circle of initiates. First the representative of the Goddess is worshipped; then barley, fish, wine and meat are sanctified and eaten, and intercourse takes place between the members of opposite sexes, regardless of who is married to whom. The aim is to pass beyond the bounds of convention – but carefully, within a properly sanctified environment.

Yogīs and yoginīs, male and female, with high aspirations carried these rites to the extreme. We have literary evidence of their existence very early; and they still flourish today. They performed their meditative sexual rites in cremation grounds, sitting among the corpses. Great sages, both Hindu and Buddhist, were said to have been initiated by powerful and dangerous representatives of the Goddess in cremation grounds, surrounded by charred and dismembered bodies of the dead, and by jackals and crows. Such rituals were believed to defile the participants utterly, and finally divorce them from any orthodox society, breaking the last attachment they may have felt either to life or to any conventional image of the self as 'good'. It was necessary that these sexual relationships should not be permanent. For, if any human attachment to the external partner as an individual were to develop, the vital process of interiorization would be obstructed – as with the icon, so with the person. The whole purpose of these versions of Tantric rites was to enable each participant to recognize and take possession of the complementary sexual component within him or herself which normal social roles obliterated. The outer woman and outer man merely serve, just like the icons but better, as vehicles upon which a yogī or yoginī first discover their true inner woman and man projected. At the same time it is essential that the physical act of love should be as intensely stimulating and prolonged as possible. For the sexual energies need to be at their peak when they are combined and turned back up, first through the faculties of the physical body, then into the channels of the subtle body, so as to carry with them all the lesser energies normally diffused into phenomenal creation. From that point on Tantric meditation could consist of a sustained act of blissful inner intercourse, if possible unbroken and lifelong. The combined energies return back along the channels, up the spine, through the series of nodes marked by inner 'lotuses', to the top end of the spinal column, where the first sexual division of the undifferentiated energy takes place as it flows in.

This is perhaps the most powerful and uncompromising practical

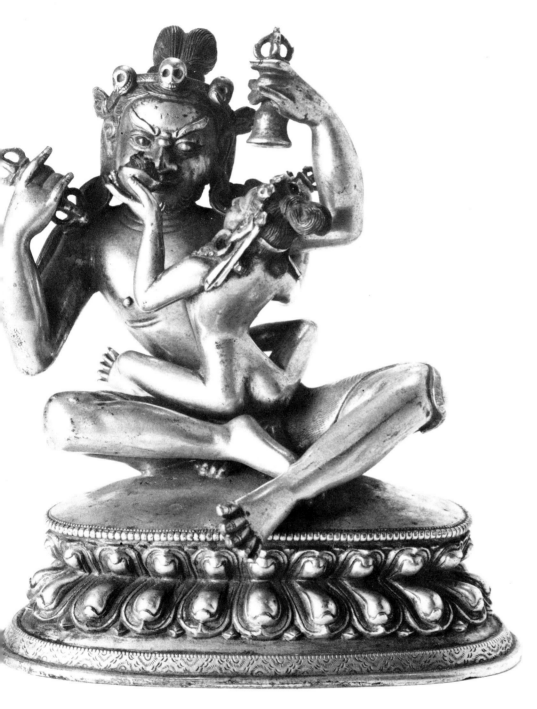

68. The Tantric Buddhist saint Gandhapa, naked with a consort with whom he performs ritual intercourse. Miniature gilt bronze sculpture from Tibet, sixteenth century.

expression we know anywhere in the world of the implications of the idea of sexual polarity within Deity. It consummates completely the spiritual meaning of the act of sexual love, giving ordinary lovers a goal towards which they can aim. By making their acts divine, lifting them out of the mundane, the fading, the banal, it may lead them to experience the Great Duality within their own organisms. Tantra, in all its varieties, thus justifies and unites the spectrum of erotic joys, to the enactment and contemplation of which Indian culture was so deeply devoted.

THREE

China

Reality as change

The Chinese attitude to sex and love represents a completely characteristic version of the Great Duality. The whole of Chinese culture is dominated by one overriding principle, which differentiates it sharply from the Indian and the European.

The key term is Tao. To quote a Ming inscription:

> Vast indeed is the Ultimate Tao
> Spontaneously itself, seeming not to act;
> End of all ages, beginning of all ages,
> Existing before earth, existing before heaven,
> Silently embracing the whole of time
> Continuing uninterrupted through all aeons;
> In the East it taught Father Confucius,
> In the West it converted the Golden Man.
> Taken as pattern by a hundred kings,
> Transmitted by generations of wise men,
> It is the ancestor of all doctrines
> The Mystery beyond all mysteries.

The term Tao can be translated in a number of different ways, according to the philosophical context in which it is being used. But the underlying assumption is that the Tao, as the unifying principle of the cosmos, consists of ceaseless change. Its essence is motion, as in flowing water, though it does not itself move. It is full of whorls and eddies, which appear to us momentarily on its surface as present events, and which are never twice the same. Thus every object we identify is really nothing but a transient phase in a constant process of metamorphosis, strung out along interweaving strands of existence. Of course we know this is true, though we Westerners rarely think about it in that way. The whole world, and we who live in it, are actually altering – slowly but certainly.

69. Landscape with Yin in the ascendant. Painting on paper, seventeenth century.

70. Plate ornamented with the seasonal trigrams of the *I Ching*, arranged around the symbol of Yin-Yang at the centre. Blue and white enamelled porcelain, eighteenth century.

Clouds change their shapes quickly, mountains change theirs slowly. The hardest rocks change their shapes and ultimately their chemical nature, and such changes are even more real than the shapes we limited humans perceive. There are static characteristics of things, which enable us to identify them, ideal forms which we attribute to them; but they are only aspects shown us for a time by the Tao, the ultimate reality. So we must realize that we never understand any thing or event properly unless we use our reflective imaginations to grasp its continuity, running from time past into time future. But the Chinese understand past and future as no mere abstract extension of a 'time-line' reaching out before and behind the 'present'. For the Chinese, what is past is past, future is future; and even the most conceptually 'distant' times we can think of are actually no more remote in the Tao than the moment when you, the reader, began reading this sentence. 'Gone' is simply gone.

To explain how changes take place at all, how things shift in one way then another, from one pattern to another, the Chinese conceived two principles of energy that constantly oppose each other, but are never separated. They interact, one predominating at one time, the other at another. In every phase of change a larger proportion of one combines with a lesser proportion of the other. These energies are cosmic; and as such they are incarnated as much in the physical and emotional qualities of the human sexes as in the whole enveloping

universe. Man and cosmos are inextricably interwoven; and human sexual relations are an image of relationships within the universe.

The two energies whose varying dialectic produces the ceaseless activity in the Tao are called Yin and Yang. The first is dark, cold, earthy and moist, symbolized by cloud and valley, predominating at winter and midnight. It is also the Female. The second is bright, hot, heavenly and dry, symbolized by constellation and mountain peak, predominating at midsummer and noon. It is the Male. Both are symbolized by other groups of animals and plants, which will be mentioned later on. But the most ancient group of symbols is connected with a set of points of the compass combining the directions, the seasons and the times of day. South is high summer and noon, when Yang predominates, and is symbolized by the brilliant bird called Phoenix (Feng); West is autumn and evening, when Yin is beginning to take over – the White Tiger; North is winter and midnight, when Yin predominates – a tortoise coupled with and coiled in a snake, called mysteriously 'the Dark Warrior'; and East is spring and morning, when Yang is beginning to ascend – the 'Green Dragon arising'. In everything that happens, in every object, these two energies are variously involved. Individuals always try with the help of oracles to reconcile the patterns of energy in their lives with those in their surroundings. But the most important resource is their sexual relationships.

71. (*Top*) Stallion, his genitals exhibited by a monkey. Jade, sixteenth century.

72. (*Above*) 'The Dark Warrior', a snake coupled with a tortoise, emblem of deep winter, midnight, and the supremacy of Yin in the earth. Bronze ritual vessel, first millennium BC.

73. A phoenix, emblem of Yang, and a female dragon with a divided tail carrying cloud-fungus in her mouth, emblem of Yin, circle around the disc of heaven. Jade carving, eighteenth century.

It is obviously desirable that the flow of events in the realms of nature, politics and personal life should be as harmonious as possible. Natural disasters, like flood and famine, happen when the energies are out of kilter. The job of the ruler of China was always to maintain a condition of harmony through the changing processes in nature and the world of man as well as he could, on behalf of the people. This he did by continuous ceremonial. And each individual aimed at inner harmony, through ritual, and through social and personal action. But 'harmony' does not mean a fixed condition of absolute balance. This is mere fiction. True harmony means complete correspondence between the currents flowing in the universal Tao and those running through the affairs of the Middle Kingdom, through society and through each member of it. Needless to say, such harmony always remained an aim rather than an achievement, save in the rare cases of successful mystics. There is a story in the works attributed to the sage Chuang Tzu which makes the point beautifully.

Once Confucius was walking with several of his disciples along the margin of a turbulent river, full of rocks, rapids and waterfalls. Upstream they saw an old man playing about in the raging water. As they watched he was swept away. Confucius sent his disciples running along the bank to try to save him. But he beached safely in

78

some shallows, and stood up unharmed. He was brought to Confucius with water pouring from his hair. Asked how he had managed to survive, he answered, 'Oh, I know how to go down with the swirl and up with the whirl.' Which is an allegorical explanation of how a genuine follower of the Tao attunes himself harmoniously with the currents and vortices of change in the world of time. In the life of ordinary humanity, of course, it is extremely difficult to learn to make the best of every swerve of the torrent, and even to attune oneself to disaster. But in the horrifyingly violent history of China, the only alternative might be never-ending grief.

There is one further and very important point. Since the Chinese understand the world as an interweaving of currents of energy, they assume that every object is imbued with patterns of energy of its own, both because of its material and because of the shapes taken by or found in or on the object. They have always treasured stones which are beautiful either because of their convoluted shapes or their inner markings; both aspects show that they condense subtle influences from the Tao. It follows that things and people brought into contact with each other influence each other's flow patterns, by a subtle process of exchange.

Among the most important kinds of contact were those involving food. The dishes in which food was served were always seen as very significant. Different foods contain different proportions of Yin and Yang; and the materials of which the dishes in which the food was served were made, as well as the designs they bore, affected the people who ate the food. So it was considered sensible to adjust both food and dishes to one's inner needs and condition, reinforcing one's personal Yin or Yang by the balance of influences.

In personal life this balancing of the influences of Yin and Yang was of supreme importance, and it was only through some kind of sexual relations that any real balancing was thought to take place. To the ordinary Chinese a life without sex was absurd and they thought that anyone living a life of asceticism and total abstinence was probably possessed by an evil spirit. Buddhists, who renounced love and all other human attachments, obviously had a different attitude. But they were always a minority in Chinese society. Certain groups of Buddhists, notably under the Yüan and Ch'ing dynasties, adopted forms of Buddhism based upon Indian Tantric Buddhism, Vajrayana, in which sexuality played an important part.

It is not possible to separate personal life from social life in China. Certainly the conventional Confucian public attitudes which have prevailed through most of China's history were very hostile to any open expression of personal feeling, sexual or otherwise. They still are. And it is primarily because of these attitudes, especially during the last two centuries, that so little direct evidence about the intimate side of Chinese life has come through to us. But we now know more

74. Symbol of the cloudy, flowing Yin. Miniature carving in blue lapis lazuli, eighteenth century.

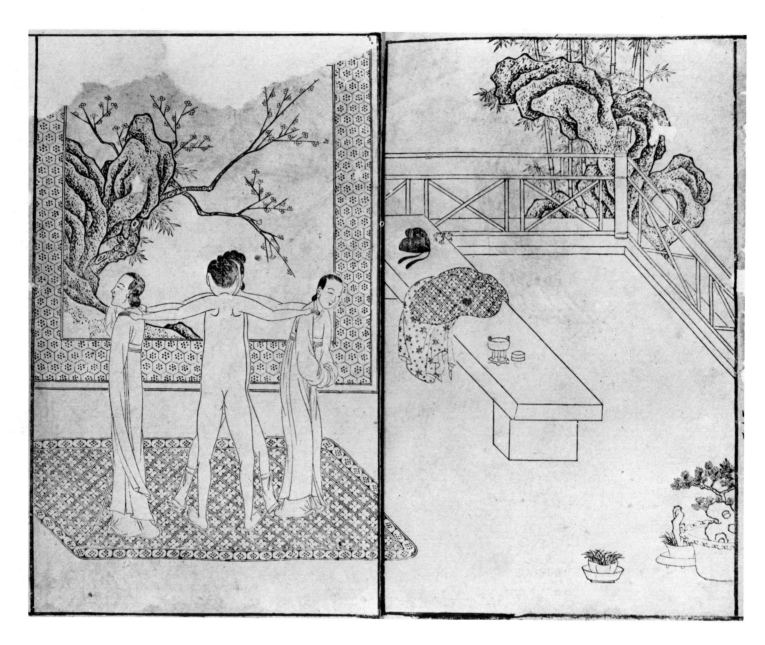

75. Wu San-ssû, the Bamboo near the
Altar. Engraving from the novel *Su Wo P'ien*
('The Moon Lady'), published about 1610.

than we did a few years ago. One important fact that has emerged
is that public Confucianism was hostile only to the open expression
of the intimate side of life, not to its cultivation as a private matter.
Inside the walls of his own home the Chinese was expected to devote
himself wholeheartedly to working towards the harmonizing of Yin
and Yang for the benefit of his household, his social position, and
even of his Emperor.

Two aspects of Chinese society – one social and the other 'medical'
– help us to an understanding of their attitudes. Chinese society, in
its upper echelons, was from the earliest times polygamous. Any man
who could afford it and wished to, be he merchant, official or land-
owner, would marry more than one woman, and perhaps maintain
concubines as well as wives. Chinese history is full of episodes of

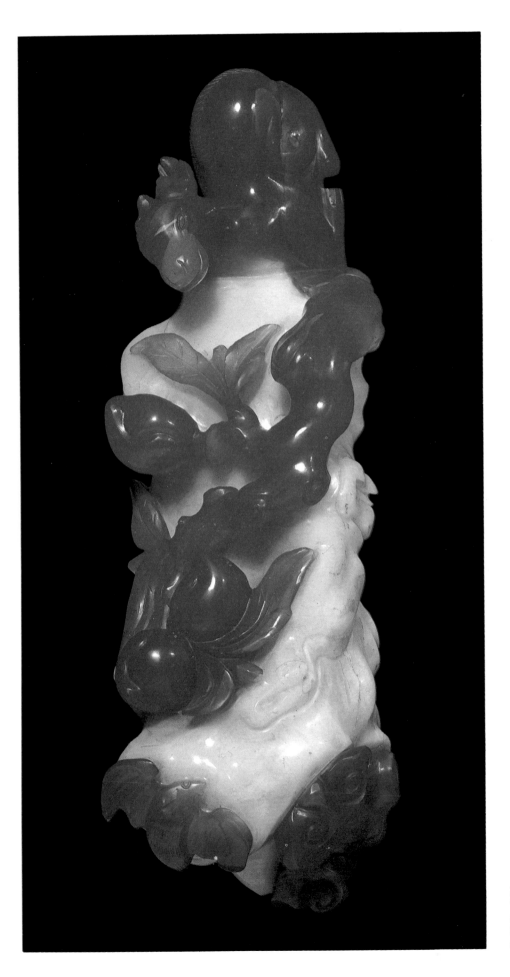

76. Carved emblem. The white part is
Yang, the dark red Yin. The peaches are
emblems of Yin as female sexuality.
Carnelian and white quartz, seventeeth
century.

77. Su Wo rides round his Garden.
Engraving from *Su Wo P'ien*.

warfare and disaster; and Chinese society was never notable for its
freedom from oppression of the weaker by the more powerful. So
households were often broken up, the wives and concubines dispersed
and then taken into other households. The important point here is
that it was normal for one man to be in the position of having to
keep a number of women sexually satisfied, and to maintain his
household free from any quarrelling and turbulence which might
become public, and so affect his social reputation. This could spoil
the confidence of his business associates or administrative colleagues,
and seriously damage his career. Here the 'medical' side comes in.
Before we discuss it, however, it is as well to remember that even in
such a society, intense personal love between man and woman was
no less possible than in our own. A woman speaks in a T'ang dynasty
poem:

To think that one night – and that one night without much sleep,
Could generate a love that lasts the whole life long!

Erotic culture

The 'medical' facts underlying Chinese attitudes towards all sexual relationships are again founded upon the concept of interchange of Yin and Yang, between man and woman. Each man is believed to contain in his psycho-physical organism a preponderance of Yang, which varies with the seasons and with age. It manifests itself physically in the semen, and other more subtle bodily secretions. Sexual stimulation enhances the Yang, making it bright and active. Similarly, women contain a preponderance of Yin, which appears in female bodily secretions. The most important emerge, when a woman is sexually aroused, from three sites. The first comes from the Red Lotus peak, under the tongue. The second, quite distinct from milk, comes from the Double Lotus peak of the breasts – the best is said

78. (*Below left*) A girl stimulates herself on the trunk of a flowering tree, which symbolizes her desire. Painting on silk, eighteenth century.

79. (*Below*) Goddess carrying a vase from which floats cloudy Yin. At her feet plays a Yang-beast. Stone relief, seventeenth century.

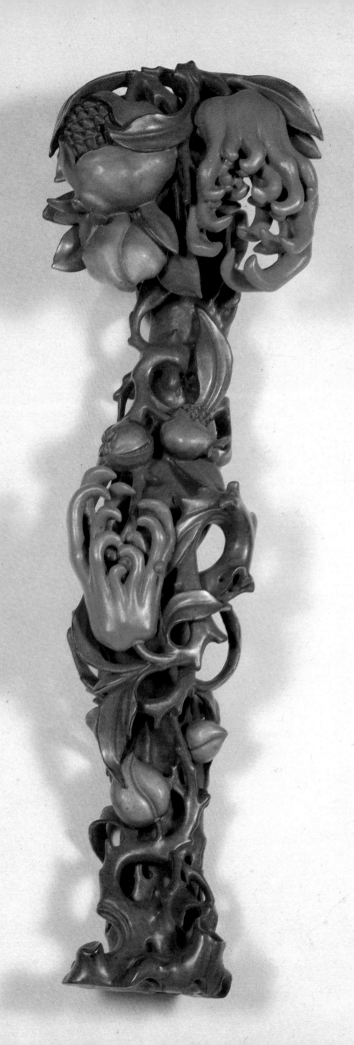

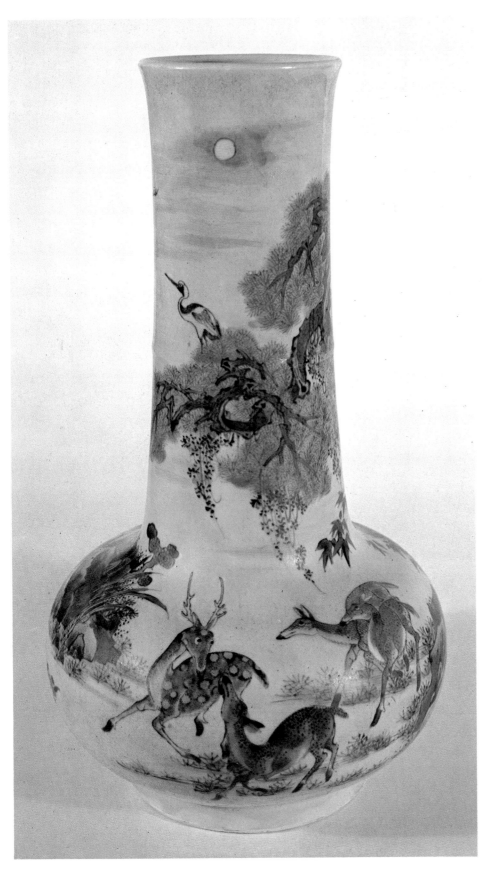

China

80. (*Far left*) Sceptre composed of Yin emblems. Carved and lacquered wood, nineteenth century.

81. (*Left*) Vase, enamelled chiefly in yellow and blue (Yang-Yin) porcelain. The male stag is accompanied by hinds under a gnarled pine symbolizing spiritual achievement in old age – an allegory of sexual success. K'ang-hsi period (1662–1722).

85

to be from a woman who has never nursed. The last comes from the peak of the Purple Fungus, the Mysterious Gateway, the Grotto of the White Tiger (that is, the vulva), and is brilliant purplish red.

The purpose of sexual relations is to establish a balance of the Yin and Yang in both partners by each absorbing the other's sexual essences. At the peak of a developed orgasm man and woman release charges of Yang and Yin, which are absorbed by the other partner through his or her genitals. This may sound quite a straightforward process. But it is complicated by several factors. The most important is that it was thought very dangerous for a man to lose much of his Yang, or a woman much of her Yin. At the same time each needed to absorb quantities of their sexually opposite energy for sheer good health, as well as for long life, and for any ultimate spiritual achieve-

82. Su Wo initiates young Wu San-ssû into Delights. Engraving from *Su Wo P'ien.*

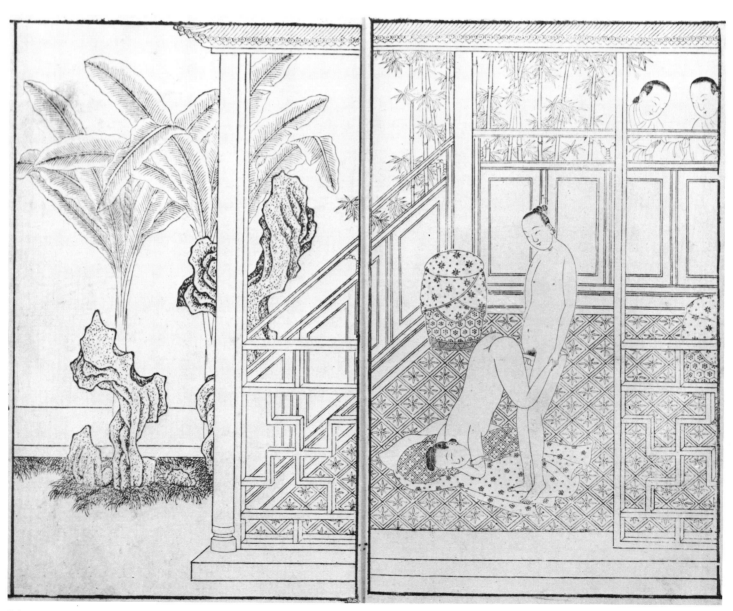

ment. Hence, from the Chinese point of view, it was desirable that the male head of a polygamous household should have his Yang stimulated by frequent sexual intercourse with its female members; during this he would be able to absorb the Yin they released to him in their frequent orgasms, while he refrained from ejaculating.

The reason for having concubines, in addition to senior wives, was that younger women release Yin more easily and generously. At the same time the man should learn with great care how to conserve his Yang, physically represented in his semen, by limiting the number of his own ejaculations, though not his pleasure. He would thus become irradiated by an inner enhancement of energy resulting from the awakening of his Yang, and its combining with absorbed Yin. Men often used a jade or ivory ring round the root of the penis, attached to the body by ribbons, with which they could help themselves to restrain their ejaculation by pressing it against the underside of the root of the penis.

According to Chinese cultural conceptions, the erotic hero is not a strapping young man who spends his Yang in wild orgies of ejaculation; in fact, two of the most famous Ming erotic novels, *Gold Lotus* and *Prayer Mats of the Flesh*, point out how stupid and fatal such uncontrolled eroticism is. The Chinese erotic hero is the elderly man who has learned to control his sexual energies so thoroughly that he is able to work his female partners to constantly repeated pleasures, while developing his own inner nature to the full. And since it is possible to absorb Yin and Yang essences by mouth, oral sex played an important part in erotic relationships.

The actual techniques of sexual intercourse were extremely important and, as with every other aspect of life, the cultivated Chinese developed them to a high aesthetic level. We know the methods in considerable detail. A long series of textbooks detailing the methods of lovemaking survive; they go back at least as far as the second century AD. Many of the texts are put into the mouth of an instructress called 'The Dark Girl' or 'The Plain Girl'. One most important aspect of the instructions differentiates them sharply from Indian or European texts: their emphasis on the qualities of movement. Other traditions describe 'postures' of love, that is to say, relatively static positions in which intercourse may take place. The Chinese, however, although they certainly recognize all the conventional attitudes of love, calling them by such names as 'wailing monkey hanging from a vine', describe a whole series of different *movements* that lovers can perform in stimulating and exchanging their Yang and Yin.

Alternating shallow and deep thrusts, or several shallow and one deep by the man, may follow different rhythms, for example, 8 and 5, or 3 – 5 – 7 – 9. A slow thrust 'parting the lute strings' can be like the 'movement of a big carp caught on a hook', another 'like a flight of birds against the wind'. Poetic metaphors describe styles of straight

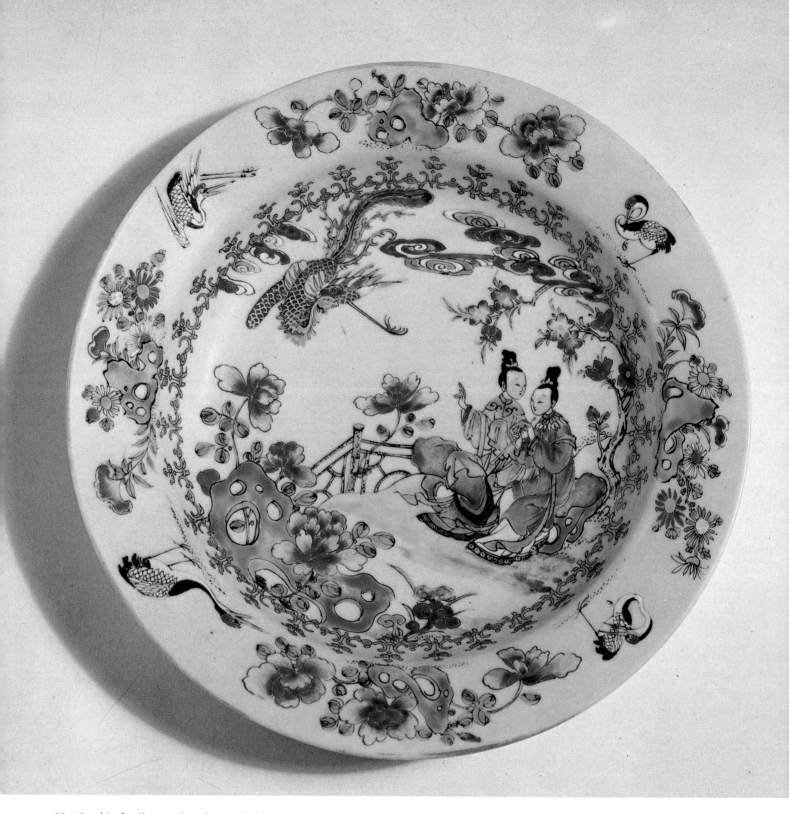

83. On this *famille rose* plate the two ladies, surrounded by Yin emblems in the garden (peony and cloud-fungus), await the descent of the Yang phoenix, under a branch of flowering prunus (symbolizing intercourse). There are also the egrets of long life and Tao rocks. Late eighteenth century.

and slanting penetration by, and movement of, the 'coral stem' within the 'red gate': 'flailing right and left like a brave general breaking enemy ranks'; 'like a sparrow pecking rice-grains'; 'rising high and plunging low like a great sail riding a gale'; 'like an iron pestle working in a mortar'; 'the goat butting the tree'; 'prying open the oyster to reach the pearl'. Such emphasis on particular qualities of activity springs from the whole Chinese focus upon motion and change as the essence of reality, the Tao. Each act of love could be

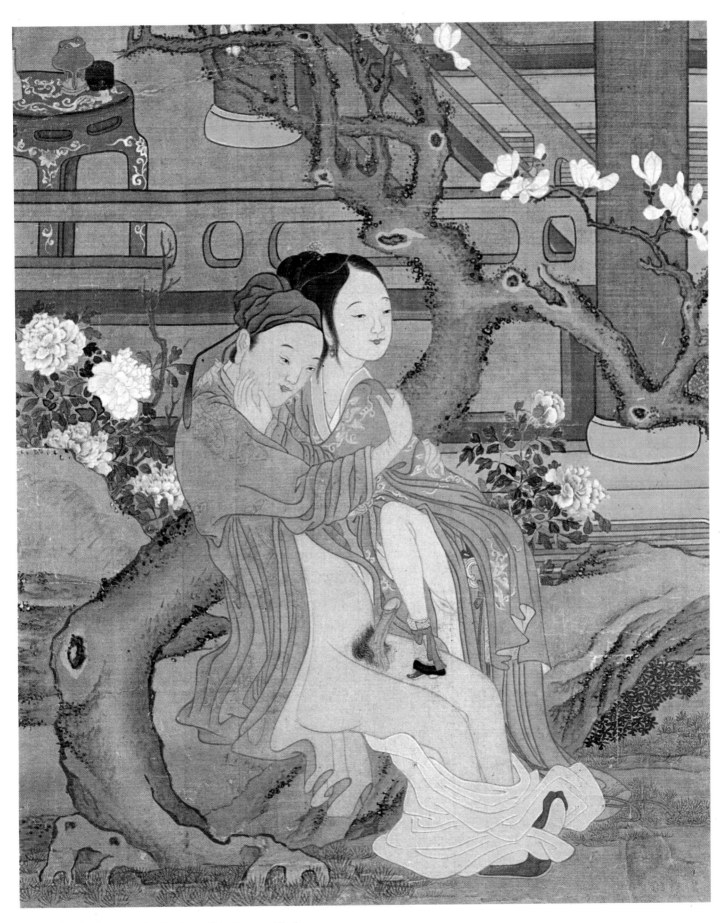

84. In the Garden on a Rocky Seat. Painting on silk from an album of the K'ang-hsi period (1662-1722).

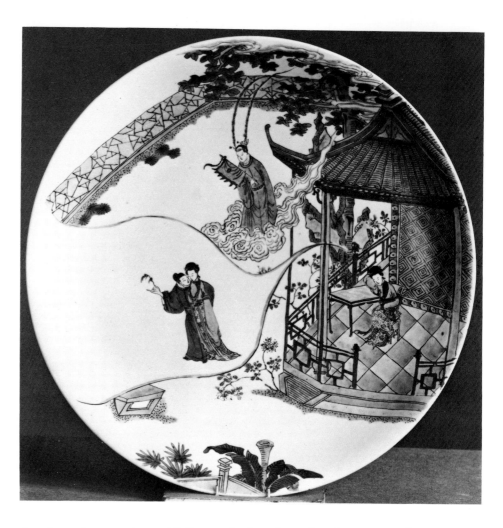

85. A girl dreams of love, watched over by an Immortal. Plate of painted *famille verte* porcelain, eighteenth century.

developed as a beautifully articulated series in time of interlaced movement and response, involving the whole bodily and spiritual entities of man and woman.

Two poems by Chang Heng (second century AD) demonstrate how important even then were fully illustrated manuals of sexual technique, which were the ancestors of innumerable later books. In these poems there are very interesting parallelisms between the main elements of sense in each line of the couplets and in the couplets themselves, so that they reflect each other like unspoken metaphors. Each line is here divided in two to make the point. In the first poem the wife offers comfort to her new husband as though she were his mistress.

Now let us fasten the door	with its golden lock
and light the lamp	to fill the room with light;
I take off my robes	and remove my makeup and powder,
I roll out the picture scroll	beside the pillow.
I take the Plain Girl	to instruct me,
So that we two can perform	all the various movements
Which the ordinary husband	has never known,
As taught by T'ien-Lao	to the Yellow Emperor.

The last line contains two interesting references. The Yellow Emperor is the mythical prototype of the great and good Emperor, who is also the 'hero' of many of the erotic manuals with their illustrations. T'ien-Lao is Shou-lao, the celestial deity of long life, who will be discussed presently. One of his tasks, however, is to fix the date of each man's death. And since length of life, according to Chinese ideas, depends upon carefully regulated sexual performance, it is extremely significant that the wife promises her husband the pleasures of transcendentalized intercourse, which the 'ordinary husband' never knows, being condemned to early death by his ignorance of sexual technique and his too frequent ejaculations.

The second poem describes a man's ideal lover, and more or less defines the physical perfections recognized in all later Chinese beauties, and constantly represented in art.

This girl is worthy to be a companion of (the famous beauty) Hsi-Shih

She is tall and handsome to look at,

Her face is soft and finely carved
Her body languorous full of charm

Her figure is faultless like a statue;
Her waist is narrow as a roll of silk

Her neck is long and white as a tree grub,
Her elegance extreme and totally fascinating;

Her nature is gentle her behaviour modest,
Her beauty is opulent and draws one to her.

Her jet black hair is beautifully bound,
Its bright sheen almost like a mirror;

She has a dimple that points up her smile,
And clear, bright eyes with a liquid gaze;

Her teeth are white between red lips,
Her body is so white it dazzles the eyes.

When her red flower unfolds its petals
It breathes out an intoxicating odour;

She stays with you all night long
You eat and drink and delightfully tangle

Pointing to the pictures you follow them through,
She glances at them pretending to be bashful

But her protesting is simply coyness;
These arouse the passion of sexual love.

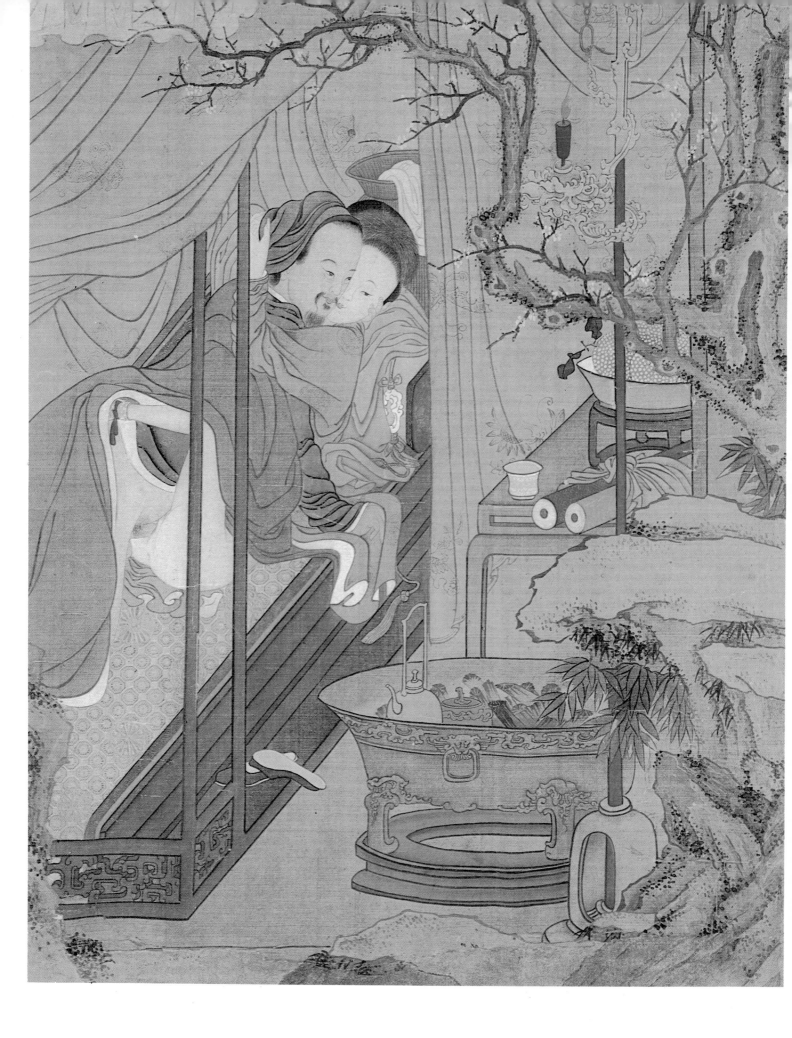

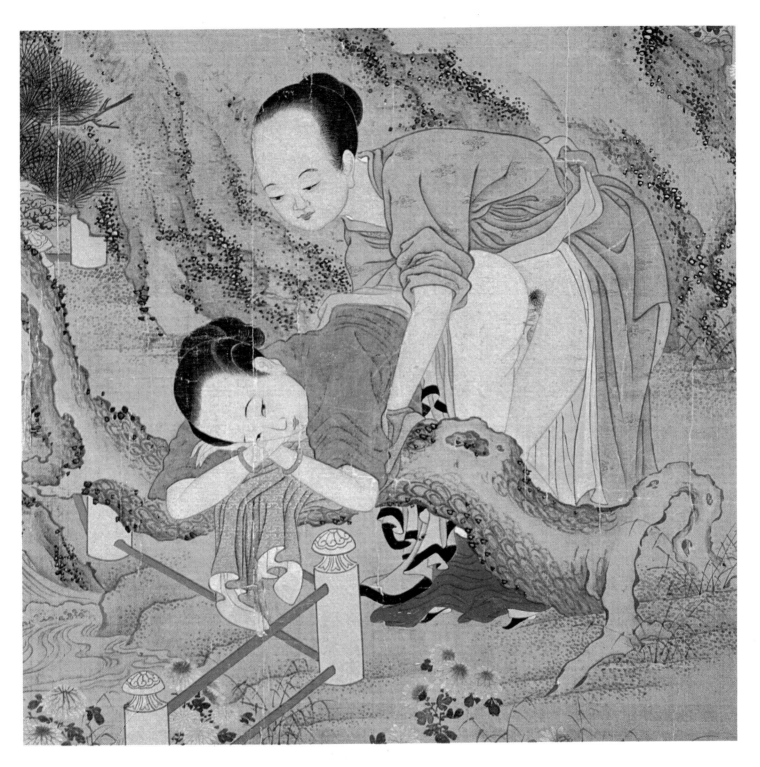

86. (*Left*) On the Embroidered Couch. Painting on silk from an album of the K'ang-hsi period (1662–1722).

87. (*Above*) The Attack from the Rear, or 'The Leaping White Tiger'. Painting on silk from an album of the K'ang-hsi period (1662–1722).

88. 'Buddha's fingers' gourd. This is intended to suggest sensually the grasp of the female vagina as the active agent of Yin. Miniature stone-carving, eighteenth century.

This poem clearly shows how the woman's vulva is seen as an important element in her beauty; it is metaphorically described as a perfumed flower – almost certainly a peony, the most important flower emblem, as we shall see later.

Literature and art often illustrate how proper sexual relations within the polygamous household should concern all the women equally. So as to avoid suspicions of favouritism and consequent jealousies which might destroy the peace of the household, relations between the man and any of his wives or concubines should take place not only in the presence, but often with the active assistance, of the others. There were works of art which represented the great mythical Yellow Emperor coupling with one of his ladies, while other ladies supported her, and yet others helped by pushing the Imperial Posterior. And the Yellow Emperor was, of course, a pattern for all Chinese.

It follows obviously that exactly the reverse procedure must be possible. A woman whose personal aim is more than simple pleasure is no less able to retain and enhance her own inner Yin energy; by coupling with numerous young boys and men, she, too, can build up a powerful inner charge of complementary Yang. Many stories tell of such women. Usually, for obvious social reasons, they would be people with high spiritual ambitions, members of a sect or an élite class.

The Yin–Yang concept clearly makes homosexual love metaphysically pointless, except in certain circumstances. Performed without care, homosexual acts would simply waste precious Yang or Yin. But in fact it did exist in China – a people who cultivated the pleasures of the senses so assiduously would be unlikely to neglect it. We know that in most of the great cities there were probably many male

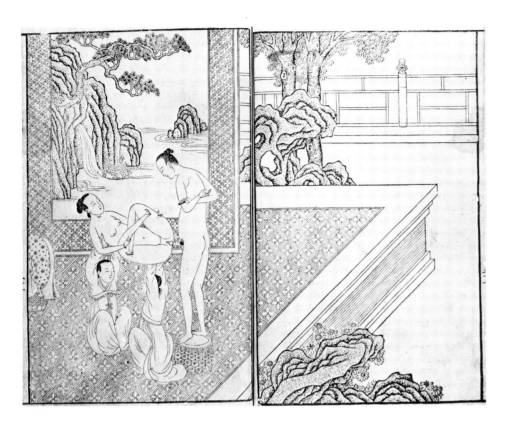

89. The Jade Stalk knocks at the Door. Engraving from *Su Wo P'ien*.

homosexual prostitutes; from Yüan times onward these included the young male actors who played female roles in the theatre, as well as eunuchs. The latter might be slaves, or people who had suffered castration as one of the common legal punishments. But there was also a large class of men who deliberately chose to have their male organs removed surgically as an avenue to political and social power. The Imperial palaces of the capital, and the courts of provincial governors and wealthy men, contained large numbers of women, married, bought, captured or seized from others, and a staff of eunuchs was retained to guard them. And since the palaces were also usually the offices of government, these eunuchs often ended up actually running the country, or large tracts of it, through their extremely intimate knowledge and control of the centres of power.

Female homosexuality would, of course, be inevitable within polygamous households. All kinds of dildos were made, out of ivory for example, or glazed ceramic which could be filled with warm water. Illustrations survive of women using them, or purchasing them from a dealer. (In fact, similar illustrations are known from the European Middle Ages.) The fibrous stalk of a certain plantain could be soaked in warm water, to swell to a pleasant bulk and texture. Within a household, that one female member should suck the Yin juices of another meant no loss of Yin within the family group. And so as to keep a woman's Yin in a state of arousal, normally as a prelude to intercourse, she might wear a simple device inserted in her vulva. One type consisted of a thin silver globe, containing a heavy metal ball, the rattling of which as she moved gave a continuous gentle stimulus. Another type produced a rather stronger effect. It consisted of two small bags of elastic membrane, joined by a narrow neck,

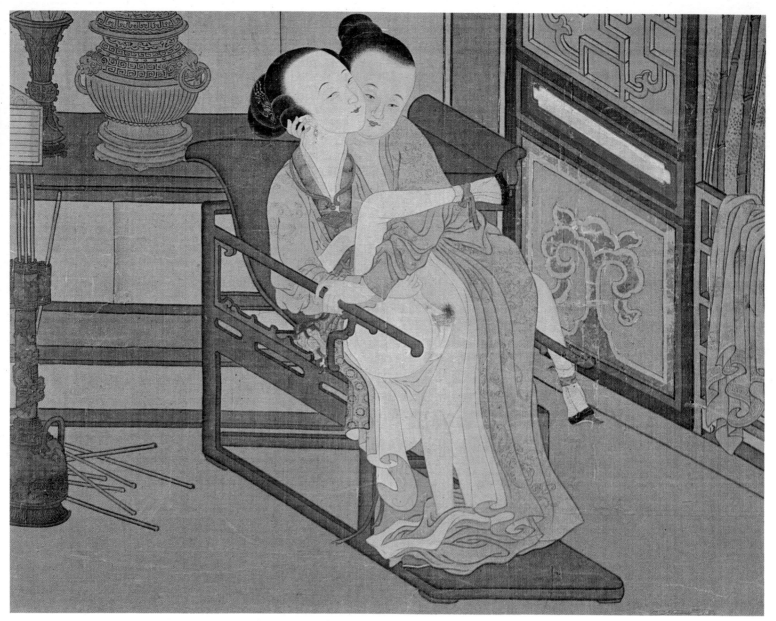

90. (*Above*) Penetrating the Cords of the Lute. Painting on silk from an album of the K'ang-hsi period (1662-1722).

91. (*Right*) Lovers reading an Erotic Book. Painting on silk from an album of the K'ang-hsi period (1662–1722).

containing a quantity of the liquid metal mercury. One bag would be inserted in a woman's vulva, the other left outside. As she walked, or rhythmically pressed her thighs together, mercury would be forced from the outer bag and would expand the inner.

What in the West is grimly defined as prostitution flourished in China. But against the background of the Yin–Yang concept it takes on a very different complexion. 'Flower boats' containing professional girls sailed the rivers and canals. Cities had pleasure quarters, where houses of 'Green Willows' flourished. The women of households down on their luck might accommodate the younger sons of neighbouring families. And, at the highest social level, there were courtesans who were also highly accomplished musicians and dancers. They might be independent, or supported by a wealthy family. Stupid and thoughtless men might spend their Yang among these women on their way to an early death, but it was also very common for such milieux to provide the opportunities for both men and women to develop the spiritual dimension of sexuality to a high level.

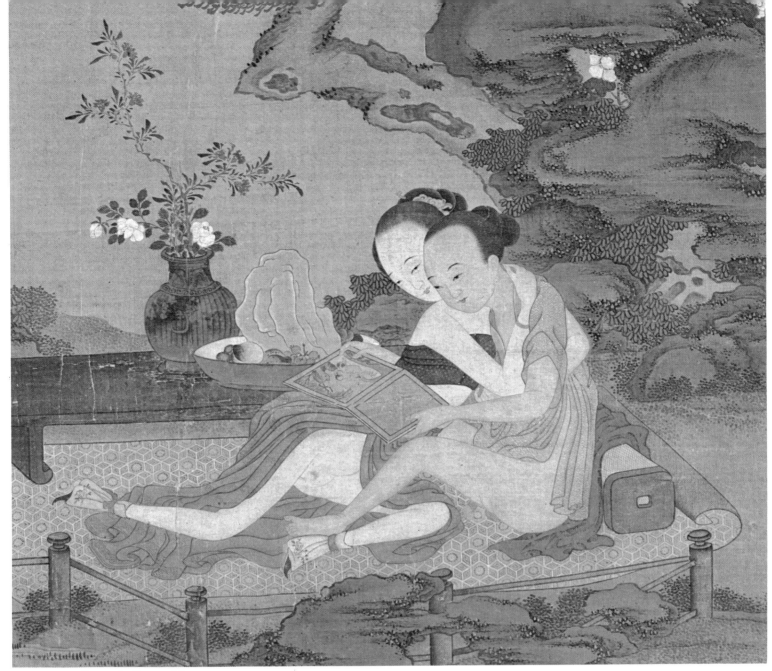

Sex and spirituality

In China, the wise man or woman, the saint who seeks after final immortality, works by accepting and cultivating sexual love, not by denying it. Many works of art refer obliquely to this fact through their symbolism. Sexual completeness is the primary equipment for spiritual completeness. To fulfil high spiritual ambition demands far more intense and frequent intercourse with partners of the opposite sex, who donate in multiple orgasms their Yin or Yang, than the ordinary household can provide. Among the flower-boats and willow-houses spiritually minded men and women were able therefore to find what they needed, almost by a kind of sexual cannibalism. We also have records of Taoist sects whose male and female members exchanged partners for spiritualizing intercourse.

At a certain stage the man or woman seeking to become an immortal (Hsien) might abandon human partners, and depart into the mountains. There he or she would find the necessary Yin and Yang to consummate their spiritual harmonization among the natural ener-

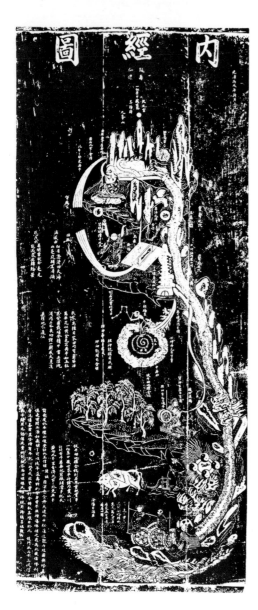

gies and substances produced by heaven and earth. This called for a special kind of inner alchemy, related to but quite different in method from Indian laya-yoga. Briefly, it involves setting energies to work inside the psycho-physical organism. First, a vivid, continuous circulation is set going. This passes up as gradually intensifying Yang along the spinal column, through three gates, one at the base of the spine, another at the level of the heart, the third at the base of the skull. The circulation passes through the crown of the head, where Yin begins to take over and intensify, then down the face, neck and chest, where it picks up 'the fire of the heart'. Down the front of the belly it passes to the root of the genitals, which may be stimulated either by intercourse or manually, so gathering sexual energies to intensify its progress. It is then fed like a flame around the 'cauldron' or 'furnace' of the lower belly, called the lower Tan-t'ien (Japanese Tanden); there it generates a great heat, fanned by controlled breathing.

Within the cauldron the sexual energy (ching) is condensed from the vegetative energies of the body within a kind of 'crucible', and purified. As the process continues a subtle pillar-like tube begins to open up through the centre of the body, originating in the cauldron. By degrees the condensed sexual energy rises up this tube to the middle Tan-t'ien behind the solar plexus, where it combines with a generic 'vital energy' (ch'i), compounded of emotional and intellectual forces, and returns to the cauldron for further firing. Continually descending to the cauldron and rising again higher and higher in the tube, the two condensed energies eventually reach a cavity in the skull behind the eyes. Meanwhile the meditator has been stimulating the inner light of his 'individual energy' (shen) by a circulation of his own, and by vigorous rolling of his eyes. As the other energies rise

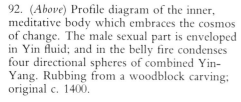

92. (*Above*) Profile diagram of the inner, meditative body which embraces the cosmos of change. The male sexual part is enveloped in Yin fluid; and in the belly fire condenses four directional spheres of combined Yin-Yang. Rubbing from a woodblock carving; original c. 1400.

93. (*Above right*) A Taoist immortal, carrying a Yin-cloud sceptre, rides a deer of Immortality. In the shadow of a pine-tree, emblematic of vast old age, a peach tree offers its female fruits. Painting on silk, seventeenth century.

94. (*Above far right*) The goddess of Immortality, bearing her basket of roses, walks across the Yin-water. Behind her is a deer carrying the Yin cloud-fungus in its mouth. Stone relief, eighteenth century.

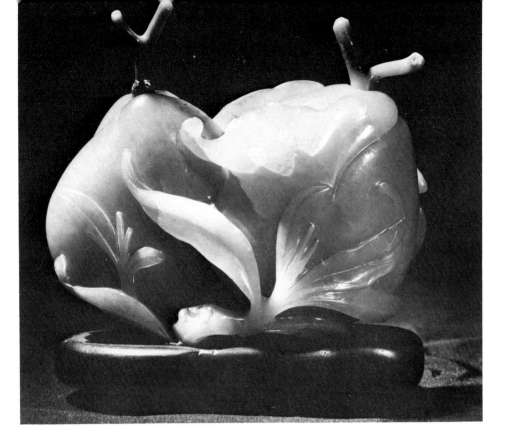

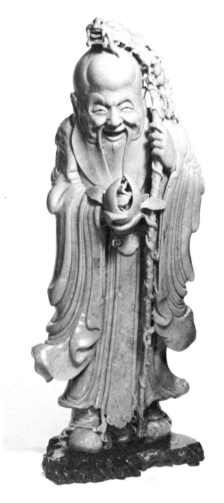

to englobe this new energy, the 'mysterious gate of individuality' opens before his inner sight, and his 'face before he was born' appears to him; the great 'inner copulation of dragon and tiger' takes place.

'Individual energy' suddenly precipitates into a 'golden elixir', and flows down the central tube with the other energies into the cauldron for a last and critical firing. To help this along a second, horizontal circulation is set up around the cauldron within the lowest Tan-t'ien, which gathers together the forces of the directions of space and the elemental substances of the world. When this is finally successful, the three energies fused as one rise to orbit in the dome of the skull. Here they encounter and intersect with their three equivalents in the cosmic Tao.

A pair of fluid radiances blossom at the intersections of the orbits, one gold, one silver, often called 'sun' and 'moon'. A saliva-like milky ambrosia then gathers in the mouth which is a precipitate of the cosmic Yin. This is swallowed down the front circulation channel into the cauldron, where it crystallizes into the seed or pearl of immortality (often represented in art encircled by a dragon). There it is joined by the two lights, which descend through the central tube and infuse the seed. All outer breathing stops, the circulations die away, and a silent, motionless 'cosmic foetal breathing' begins. Within the crucible the foetus of a new, transcendent personality takes shape, rising slowly to birth, in its envelope of energies in the 'space beyond' the crown of the head, as a 'crystal infant' breathing an air not of this ordinary world: an Immortal.

This is perhaps the clearest account one can find of the true inner significance of Alchemy in East and West. Taoist tradition (however bowdlerized its recent forms may be) recognizes that without sexuality in its personal as well as its cosmic sense, the individual with

95. (*Above left*) Double water-container. Each container is shaped like a peach; the stoppers are coral. The 'coral stem' is a name for the penis. Carved jade, eighteenth century.

96. (*Above*) Shou-lao, the star god of Immortality, holding the female peach, in whose cleft appears the egret of Immortality. Over his elongated skull peers the dragon-staff of cosmic power. Soapstone carving, eighteenth century.

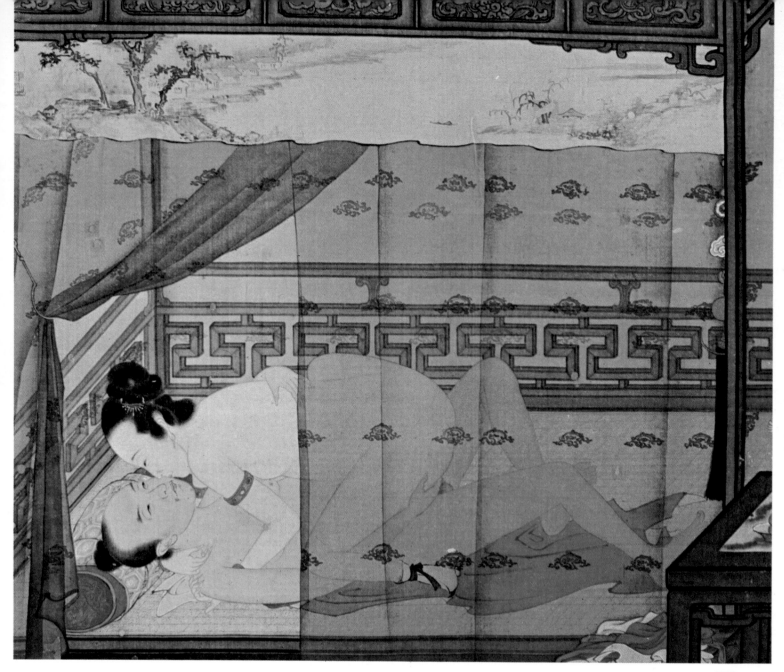

97. Amorous wrestling. Ch'ien-lung period (1736–96).

metaphysical ambitions has nothing to work upon. It is against the background of this magnificent panorama of spiritual achievement that all the apparent oddities of Chinese symbolism are resolved and fall into place.

There are two figures often represented in Chinese art who typify the masculine and feminine aspects of this intense inner process. Both are usually identified as Taoist deities; but they have a far wider significance in Chinese culture as a whole.

The first is called Shou-lao. At bottom he is a heavenly constellation deity; sometimes his garments bear constellation symbols. He appears as an old man with a much enlarged dome to his skull. These attributes – the constellation and the skull – signify highly developed Yang. But often he is also shown carrying a peach, which may split open to reveal an egret or heron, the bird which symbolizes supernatural longevity. His female counterpart is the Goddess of the West, Hsi Wang-mu. She is often represented in association with symbols of the Yin, especially a garden of peach trees; she may also be

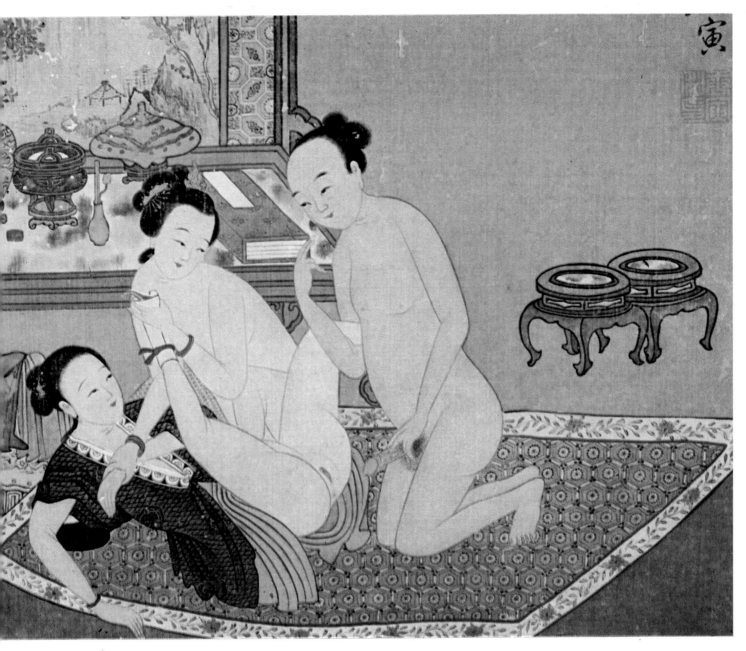

98. Three-sided games. Painting of the
late eighteenth century.

surrounded by boy-children, who have a strange and complex sig-
nificance. Both these personalities refer to the esoteric practices of
Taoist yoga; and both of them have groups of other male and female
deities loosely attached to them as *alter egos*. Chinese iconography,
although in one way fairly precise, was also much given to combining
the attributes of different deities into emblematic figures who sym-
bolized the principle uniting the group. Shou-lao is often assimilated
to Lao-tze, the author of the great Taoist classic text, the *Tao-te
Ching*, who rides on a buffalo. Tung Fang-so, who may hold the
branch of a peach tree for reasons which will soon appear, is another
of his associated personae.

Hsi Wang-mu has affinities with a number of sea and water god-
desses, whose emblems may be the watery coils of abyssal Yin, the
crayfish, the moon and pearls – which are mythically conceived as
lunar substance condensed within the vulva-like valves of the oyster
or mussel. The feminine 'immortal' Lan Tsai-ho may carry a basket
of flowers among coiling clouds of cosmic Yin.

101

China

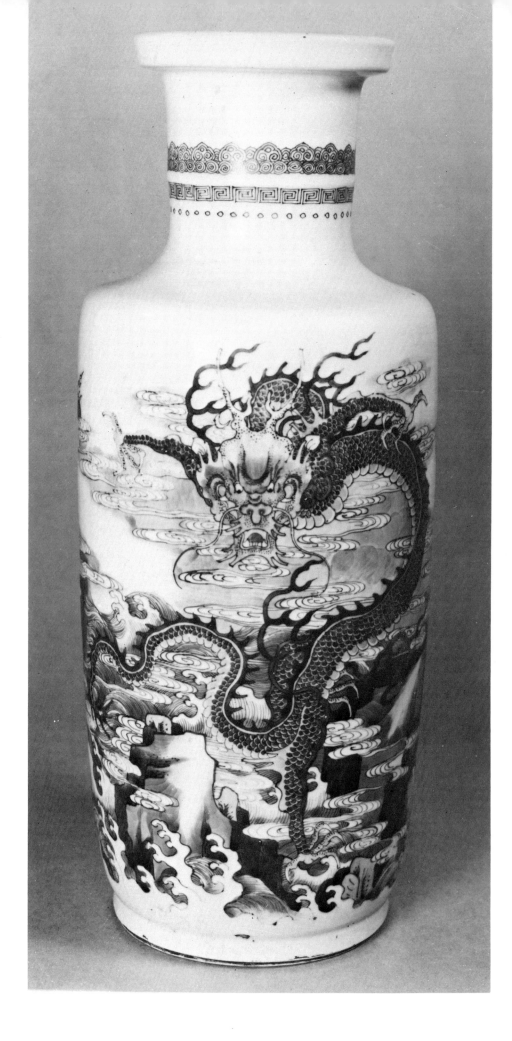

99. The dragon, emblem of the cosmic
power uniting Yin-earth and Yang-heaven
Famille verte enamels on a white porcelain
vase; eighteenth century.

The dragon

One of the commonest images in Chinese art is the dragon, a snake-like scaly monster, with lizard-like legs, horns, whiskers, and terrifying staring eyes. Its natural habitat is water; all great rivers and lakes have their resident dragons. But there is a supreme dragon, the celestial one who drives the heavens on their circuit around the pole. He or his representatives may descend to earth in the rain and play like a whirlwind among the clouds. One of the standard Chinese expressions for the consummation of sex is 'the meeting of the clouds and the rain'.

The Chinese dragon is ambivalent. It has no connotation of evil, such as the European dragon has. In fact, the European dragon seems to carry that connotation only because European Christian culture has 'outlawed' a major part of what dragons and serpents normally stand for in earlier, different cultures. A series of usages for the dragon in China casts a very interesting light on the thoughts and feelings the image can convey.

Of course, dragons do not exist as classified fauna of the earth. It has been argued that somehow or other memories of the world of dinosaurs, including the winged pterodactyls and archaeopteryx, have remained at work in buried levels of the human organism; and there are, of course, the great lizards of Southeast Asia called the Komodo dragons, stories of which may well have filtered through into Chinese culture via the early seafarers of the Dong-son epoch, who knew the Southeast Asian islands well. But the phenomena which dragons represent certainly do exist. And so the dragon as image has a clear range of content.

The basic idea it always contains is that of cosmic coherence, of the binding energy of reality and the unifying factor between heaven and earth, which the Chinese recognize as passing through the realm of man. They share with a vast proportion of mankind the archaic myth that the earth is poled apart from heaven by a great pillar or mountain. The dragon at one level symbolizes the energy generated by this separation. Many Ming temples and palaces – themselves images of the cosmos – had their structural pillars encircled by dragons. The Emperor was notionally the representative of the power of the dragon. His task in the human realm was, as we have seen, to co-ordinate by public ritual and administration the progress of the physical and metaphysical affairs of 'the Middle Kingdom'. He may have been formally addressed as 'Dragon-face'. His robes and utensils were worked with five-clawed dragons. Jade, which was looked on mythically as the congealed seed of the celestial dragon deposited upon earth, belonged notionally to the Emperor, who alone could distribute it to his subjects worked into tokens or jewelry. Because of its 'heavenly' origin, jade could also be thought of as a crystallization of celestial Yang. But the dragon himself, in his capacity as

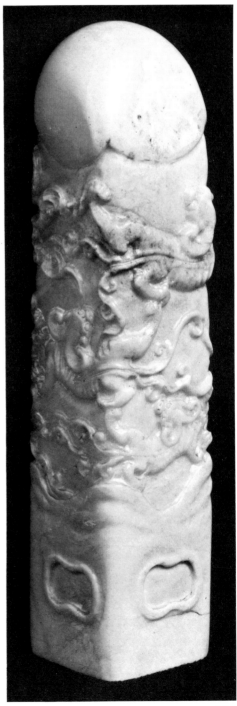

100. A male penis of white Yang stone, carved in relief with floating female Yin dragons with divided tails. Seal, eighteenth century.

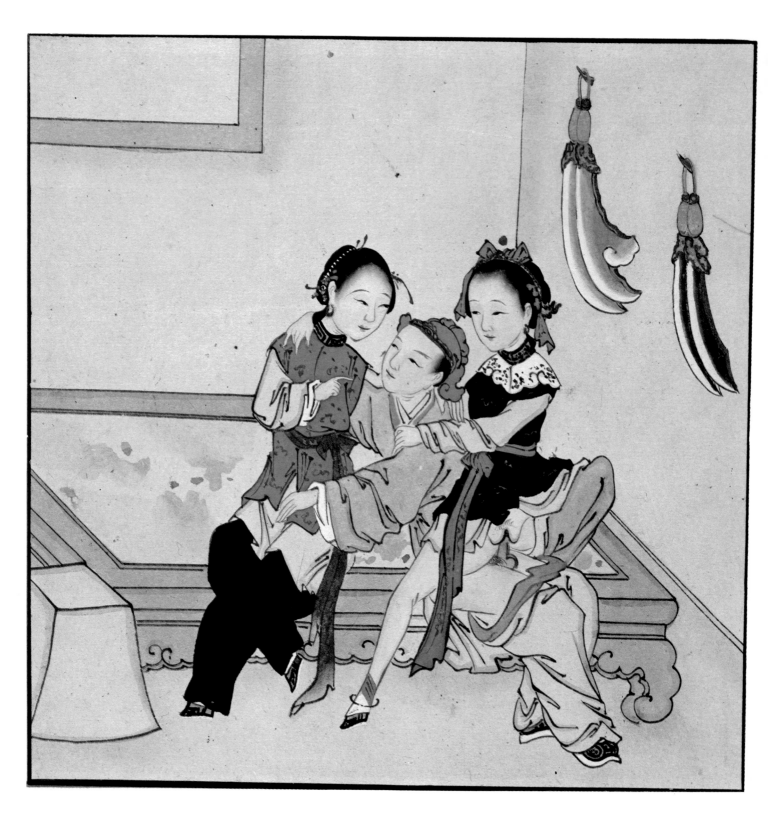

101. A young man with two girls. Album painting from a set on
paper; nineteenth century.

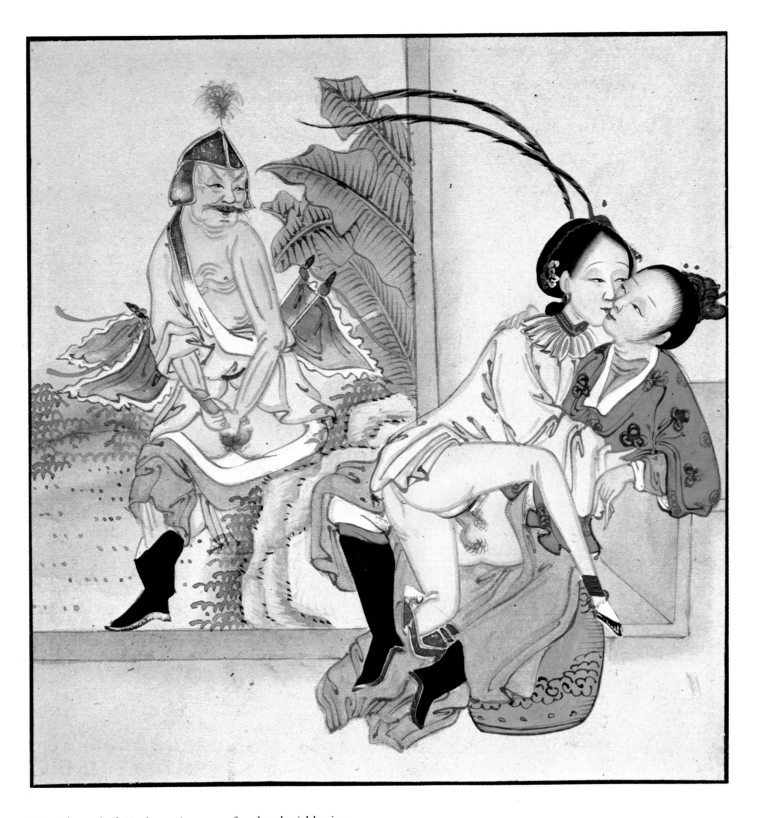

102. The god of War bursts in upon a female celestial having
intercourse with a beautiful young man. Album painting from a
set on paper; nineteenth century.

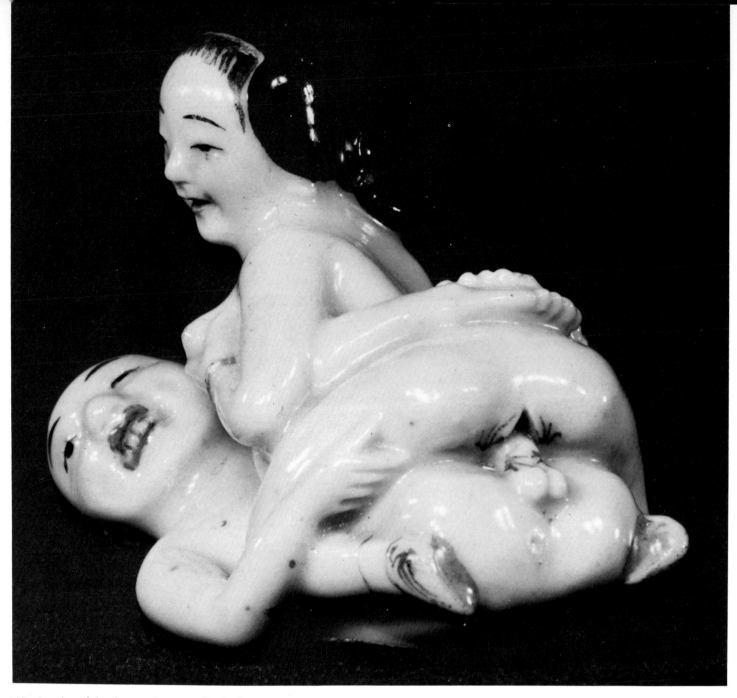

103. Amulet of the 'harmonious coupling' of Yin and Yang. Glazed porcelain, nineteenth century.

cosmic energy, was seen far more as the embodiment either of the Tao proper, or at least of the force called ch'i operating within the Tao, the great principle of vitality and unity within the cosmos.

However, since the dialectic Tao flows through both men and women, in their role as a kind of filling in the earth-heaven sandwich, female dragons were invented. Usually they are shown in art as having a split curling tail. Male and female dragons are combined in dyadic jade or hardstone emblems worn by men and women of high social rank. But, most important of all, the successful Taoist yogi (to adapt an Indian term) was felt to be able to assimilate his own psychosomatic energy with the cosmic dragon-energy. So the prototype of the Chinese mystic, called Shou-lao, 'he whose skull is swollen', may be shown in art as holding a dragon staff which curls around the back of his head to peer over his crown. As a kind of parallel to the female dragon invented to partner the male in his role as Yang-emblem, a female Yin bird was invented to partner the great

Yang phoenix, the red bird of the south (the 'red bird', incidentally, being one of the popular Chinese names for the penis). This Yin bird has a short tail, and a stubby crest and wings, in contrast to the flowing tail, crest and wings of the Yang bird. The Yin bird appears on many of the embroidered garment-patches which were stitched onto women's robes.

Many symbols are used in art to evoke metaphorically the different qualities of Yin and Yang. Some are relatively abstract; others originate in myth; yet others are based on a direct physical analogy between an object and the human genital organs, which can also stand for the qualities of Yang or Yin in the cosmic sense, and obviously have a far more directly sexual and sensuous connotation. Individual symbols can combine more than one of these features.

It is important, from the Chinese point of view, that a Yang element never appears in a work of art without some corresponding Yin factor, or a Yin without a Yang factor, as we shall see. The balance of the two is meant to have a harmonizing and, if necessary, a corrective effect through its contact with the people who encounter the work. For example, a scholar who gives a fine piece of carved jade to a friend would not only convey to him a cryptic allusion, but might also – if he chose it with insight – ensure that it had a beneficial effect on his friend by its mere presence on his writing table. One of the most striking examples of this belief is the way Chinese mothers occasionally used to fasten small charms, representing a couple happily making love, around the necks of their children, perhaps in a small leather bag, or stitched into their clothing. This was to keep them in touch with the good fortune of balanced Yin and Yang, and protect them from harm.

Using these symbols consistently, the Chinese developed a most subtle language of artistic expression, combining it with effective magic – usually described as Taoist. Very subtle combinations of symbols could be included within a single work. And, of course, the analogical references work across the board both ways; so that, for example, a vulva flower which symbolizes the Yin feminine principle, clarifies and enhances at the same time the personal and the cosmic, the one reinforcing the other. Since the Chinese were not prudish about the physical facts of sex, they were never averse from combining in one image the most intimate physical references with the most profoundly metaphysical thought.

104. (*Left*) A 'medical image'. Male doctors were not permitted to examine female patients. A woman would indicate on such an image the site of her trouble. This, however, was not made for that purpose, but is meant purely as an erotic amulet embodying female sexual Yin. Carved ivory, c. 1800.

105. (*Below*) Ritual robe: the dark blue cloth symbolizes Yin, the yellow-red embroidery Yang. The Imperial dragon symbolizes cosmic power unified in the 'pearl' it encloses. Yin clouds and fiery Yang stars float in the heavens above the waters of earth. Embroidered silk, nineteenth century.

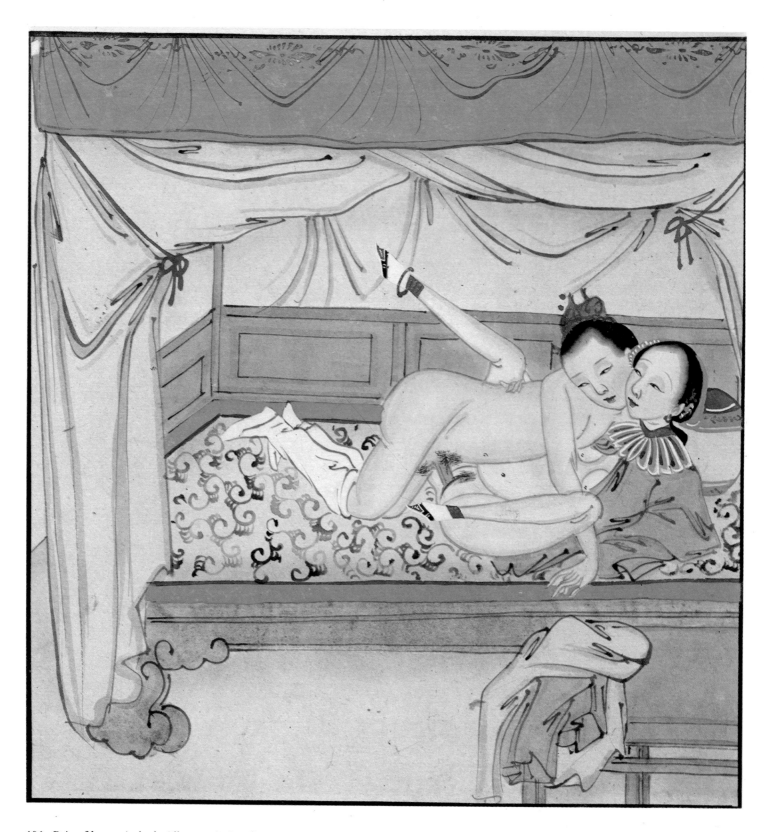

106. Pair of lovers in bed. Album painting from a set on paper;
nineteenth century.

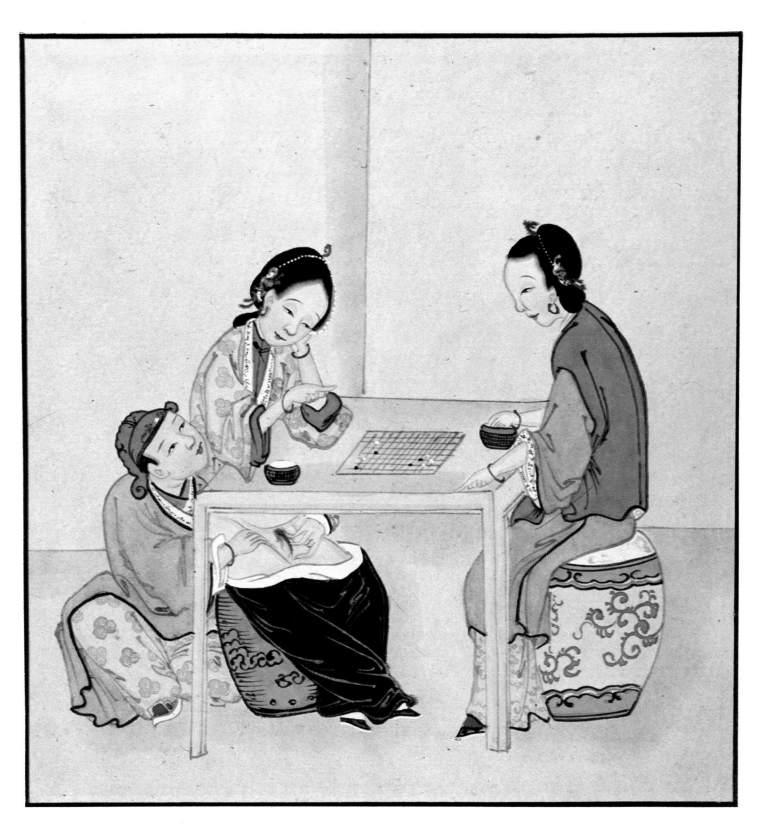

107. A young lover interrupts a game of *wei-chi* (Go). Album
painting from a set on paper; nineteenth century.

Yin symbols

The cosmic Yin resides essentially in the earth on which men live, and in its energies; and for the Chinese, as for most peoples, the earth is analogous with the female body. So Yin appears in, and is symbolized by, products of the earth. The most important is mist, which the Chinese felt was exhaled from the Yin valleys of the landscape. Coiling cloudy shapes are therefore used to represent Yin coiling throughout the realm of Nature. We may find similar shapes used to represent Yin effluent exhaling from, for example, the vase held by a female deity. The same sort of coiling calligraphic lines may be used to represent the waves of the watery abyss, the petals of a Yin flower and the cap of the magical fungus called ling-chi, or 'cloud fungus', which is purplish in colour.

This fungus was sought among the mountains by wandering Taoist wise men as spiritual food, after they had ceased having intercourse with human donors of Yin. It concentrates the Yin essence of earth. We may remember the 'peak of the purple fungus', the source of one of the three bodily Yin essences. From Ming times onward special sceptres were carved out of wood and semi-precious stones, in the general shape of this fungus; they were probably meant to enhance the Yin of anyone who held them. Such sceptres may have been used in Taoist rituals about which very little is known. The colour of the fungus, translated as purple, is important as a Yin colour. It is made from a mineral called cinnabar (sulphide of mercury) which was considered a specially powerful source of Yin from the earth. It is a crystalline compound of a most beautiful pinkish purple colour. Crushed, it was taken as 'medicine'; though, in fact, it is a deadly cumulative poison, and was probably responsible for the deaths of many people, including emperors. It was also used in art as the pink pigment for painting both open blossoms and the female genitals: the female vulva is called 'the valley of cinnabar'. And the characteristic deep pink glaze on Chinese enamelled porcelain of the eighteenth and nineteenth centuries, which we know as 'famille rose', is almost the colour of cinnabar. On porcelain it is used especially to paint Yin emblems.

All containers such as cauldrons and vases are thought of as Yin, which is also entitled 'the receptive'. Different shapes of ceramic vase were deliberately created as three-dimensional expressions of qualities of Yin, by formal analogy with womb and vagina. One type, called the Mei-ping, has a small closed mouth; others may have more generous trumpet mouths, long necks, or foliated lips. In some works of art which represent domestic interiors a vase may be shown containing a branch of pink coral (as we have seen earlier, the male penis may be called 'the coral stem') or peacock feathers. And the clay of which ceramics are made is itself extracted from the body of the earth.

109. (*Opposite*) A deer, emblem of long life, its body ornamented with plum blossoms, emblems of sexual intercourse, bears a cloud-fungus symbol of Yin. Miniature stone-carving, eighteenth century.

108. (*Below*) Vase embodying the female as container. Grey-glazed Kuan ceramic.

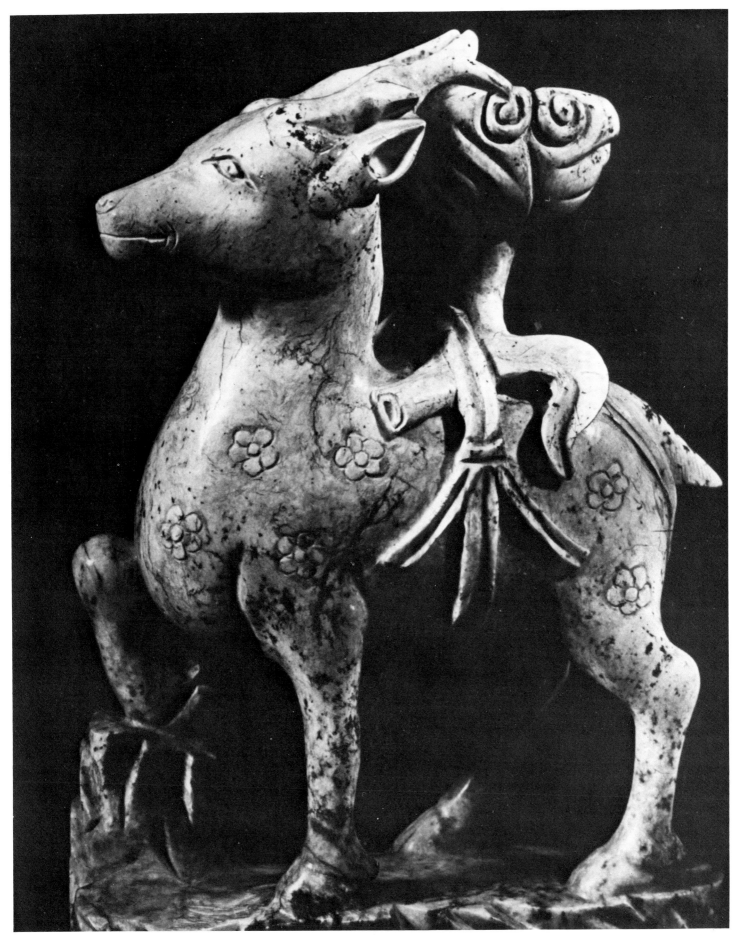

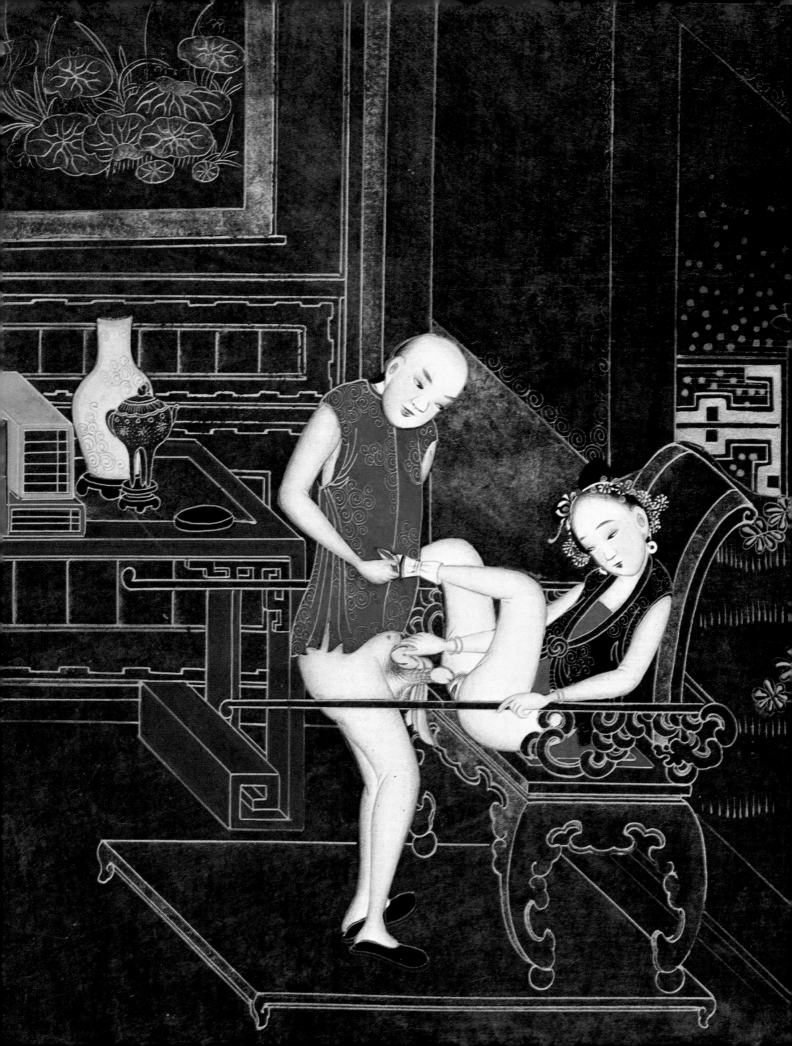

Certain flowers and plants are emblems of Yin; chief among them is the peony. Its luxuriantly pleated pink petals are interpreted as a visual metaphor for the inner lips of the female vulva. The Chinese saw these as a focus of female beauty. To the Chinese eye, the vulva can share the splendour of the peony, and the peony is imbued with the sexual force of the vulva; while both jointly make visible a hidden essence of Yin. Flower symbolism takes on more cosmic overtones with the lotus – usually also pink (but there is a white one too). As a symbol this was imported from India, along with Buddhism in the second century AD. The lotus is a water plant, growing from a root which spreads in the mud at the bottom of lakes and channels. The lotus leaf and flower rise separately, direct from the depths of the water; and in Buddhism the lotus opening above the surface is used to symbolize 'crossing the realms of existence', from one mode of being to another. The enlightened Buddha sits on an open lotus; and faithful followers of Amitābhā Buddha may be born into his Paradise from the interiors of opening lotuses. The flower is thus a kind of metaphysical womb and the Chinese recognized its Yin connotation as a less physical, more refined and elegantly metaphysical counterpart of the peony, with the added dimension of water symbolism.

110. (*Opposite*) Pair of lovers. Lacquer painting, nineteenth century.

111. (*Below*) Shou-lao, the star god of Immortality. Miniature jade carving, eighteenth-century.

Two fruits play a specially important role in this symbolic language. The first is the pomegranate. When it ripens its many seeds are set in a deep purplish-red pulp. Many peoples as well as the Chinese have taken it as a symbol of female fertility. But the meaning of the peach is more specifically Chinese. Peach fruits and peach blossom haunt Chinese culture. One of the seminal poems in Chinese literature is called 'Peach Blossom Spring'. It was written in the fourth century by T'ao Ch'ien. The Goddess Hsi Wang-mu, who un-equivocally represents the female side of Taoist sexual culture, is supposed mythically to inhabit the 'Peach Garden of the West'. The Chinese peach was larger and often more irregular than the type we know in the West. It has a deep cleft, and abundant juice. It symbolizes the female sexual organs, specifically in the context of Taoist sexual culture. The god of longevity, Shou-lao, may be shown holding a peach; and he is often represented in art standing in Hsi Wang-mu's garden, along with Taoist 'children', who themselves symbolize the ultimate achievement of Taoist 'yoga' as it has been described in the foregoing pages.

Yang symbols

Yang symbols are related to heaven and its energies that course through Nature, the world and the body of man. The mountain peak which towers towards heaven is where one encounters Yang at its most intense. There the Taoist hermit – called Shan-jen, 'mountain man' – may confront the constellations face to face. Some works of

112. (*Above*) Vase of *mei-p'ing* shape, decorated with the Yang phoenix playing among female peonies. Enamelled polychrome porcelain, seventeenth century.

113. (*Above right*) 'Libation cup' of carved jade – a Yang substance. A pair of dragons, one male, Yang, the other female, Yin, drink from its rim. It is decorated with cloud-like Yin shapes and plum blossom, symbolic of sexual intercourse. Eighteenth century.

art combine mountain and constellation into a single image. But the most potent Yang symbol of all is jade. The white and paler green varieties of this stone were most sought after from late T'ang times onward. Mythically conceived as the congealed semen of the Celestial Dragon deposited in kidney-like boulders on earth, it was carved into many forms which have celestial connotations. One is the perforated disc called p'i. This may have on it little raised dots symbolizing stars; or it may be worked with the form of a coiling dragon, and so symbolize the circling heavens. To own, and frequently to touch or stroke a piece of jade, was felt to enhance a man's Yang powerfully. The 'jade stalk' is one of the commonest names for the masculine penis.

In popular Taoism the rectilinear shapes of the constellations were interpreted as Yang containers; in fact, all hard-edged and sharply pointed shapes were considered to symbolize Yang, in contrast to the softly curving coils of Yin. Weapons such as swords, and hard pinnacles of rock or ice, shared the Yang significance. Most potent of all

Yang emblems is the 'red bird' (also another name for the penis), equated with the phoenix of the south described above. The Chinese pheasant with its gorgeous plumage was bred especially to incarnate this powerful image, which appears everywhere in Chinese art.

More difficult to understand as emblems of the bright and masculine force are male deer and their horns. Ancient and complex mythology lies behind this association, and behind the extraordinary importance attached to rhinoceros horn. This as a substance was felt to be the very embodiment of Yang, to such an extent that the Indian and even the African rhino were brought to the verge of extinction by the Chinese demand for their horns, powdered, as a male aphrodisiac. One of the commonest ritual objects exemplifying the combination of Yang and Yin in a single work is the so-called 'libation cup' made of Yang rhino horn. It has a striking vulva-like Yin shape, and is often carved in relief with Yin-Yang emblems. Among the most familiar motifs decorating these cups is the spray of winter-flowering plum, or prunus.

114. 'Libation cup', carved with emblems of spiritual success in rhinoceros horn. The substance is considered aphrodisiac when powdered, and symbolizes the power of Yang. The shape of the hollow represents the female genitals. Such vessels may have been meant to contain female Yin 'essences'. Sixteenth century.

115

115. 'Ginger jar' with the 'Prunus and Cracked Ice' design. The plum blossom symbolizes sexuality; the cracked ice, successful old age. Blue and white enamelled porcelain.

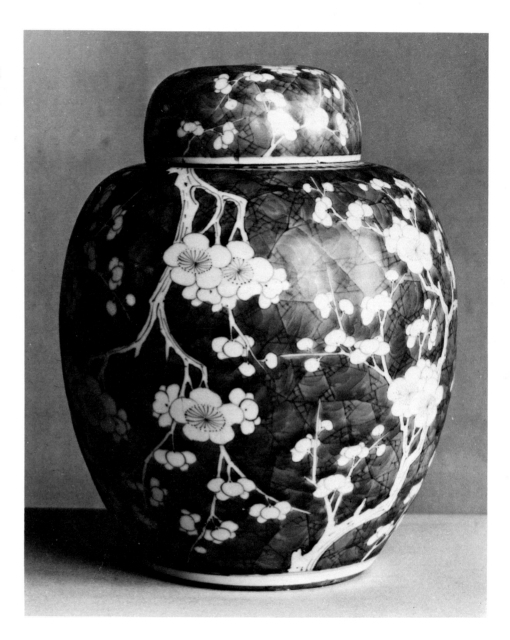

This design is perhaps the most frequently found Far Eastern motif in all decorative art. It symbolizes sexual intercourse. Women's beds were usually carved or painted with a flowering spray at the head or on the canopy; when the venereal disease syphilis first reached China, it was in fact known as 'plum blossom poison'. In all Chinese literature 'plum blossom' is a metaphor for sexual pleasure. The fact that the plum flowers late in winter (as Yin is giving way to Yang) is sometimes taken, significantly, to refer to sex ritually carried out when frosty-white hair adorns long-lived old age. This same range of thought is also referred to in the design often found on those Ch'ing dynasty blue and white ovoid jars, known to the West as 'ginger jars'. The design shows plum blossom on a 'cracked ice' ground design; ginger was regarded as a sexual stimulant.

Yin-Yang symbolism is rich and complex; and since it is part of a serious living tradition its interweavings are varied and not at all intellectually schematic. The Chinese mind has never liked thinking with closed, abstract systems based on sets of mutually exclusive defining categories. It has always preferred to work intuitively, by quoting actual instances which demonstrate a case.

The variability of the symbolism can be seen in the way different pairs of colours have been interpreted as the polarized qualities of Yin and Yang. Furthermore, it seems that at certain stages of Chinese history, notably during the Sung, Yüan and Ming periods, Imperial decrees were issued modifying the Yin-Yang livery to be used on ritual robes and vessels. This to some extent reflects the way in which, to preserve the essential fluidity of the Tao, Yang and Yin may 'exchange positions'. A legend told in *Chuang Tzu* describes how fire, originating in heaven (Yang), comes down to permeate the earth (Yin); while tranquillity (Yin), originating in the earth, rises to occupy the pinnacle of heaven. The commonest colour-polarity symbolizing Yin-Yang is, of course, black:white; but also used are dark blue:white; black:red; dark blue:red; purplish-red:pale blue; yellow (the colour of earth): clear blue. All these combinations were used in works of art to symbolize the Great Duality.

To achieve the ideal of ultimate harmony each individual must use

116. Brush washer. Writing in China is done with a pointed brush, which picks up its water from a container like this. 'Writing', involving dipping the brush, is a term for sexual intercourse. The bowl is (female) flower-shaped. The carving represents plum blossom, also emblematic of sexual intercourse. Carved jade, eighteenth century.

what is given him or her. And since change is continuous, so too will the 'instruments' available for achieving harmony change. One of the great constancies in all change is indicated by the seasons; and the 'clock-face' of the trigrams, which is used as the basis for the great ancient Oracle book called the *I Ching*, gives the clearest picture of how general change progresses in the cosmos at large. The Yang lines are unbroken; the Yin lines broken. The pattern of movement is clockwise, and from the bottom up in the individual trigram. These trigrams are images not for things, states or stages, but for phases of process in movement. In this they are probably unique in human culture. The Taoist ideal of harmony consists in accommodating the personal to cosmic and social threads of change. Sexual relationships should follow the patterns of the seasons; so should food and behaviour. Different works of art are felt to be particularly apt for certain times of year. The designs on painted ceramics, for example, show, from Sung times on, how each piece is appropriate to a given season, through the proportions and interrelationship of Yin and Yang it embodies; and these correspond with the seasonal trigrams. So the whole work conveys a Yin-Yang image suggested by one of the trigrams.

In painting, which the Chinese regard as the leading art after pure calligraphy, this balance was especially important, and most thoroughly observed. Landscape painting is perhaps the noblest expression of Chinese thought which is accessible to the non-Chinese. All the greatest landscape pictures, most of them in black monochrome ink, were painted by artists who attuned themselves to the threads of change running through the Tao, and so participated in some sense with the energies of nature and history. All such great

117. Cricket cage. 'Singing' crickets were kept, especially by women, to amuse them. Polychrome porcelain, early nineteenth century.

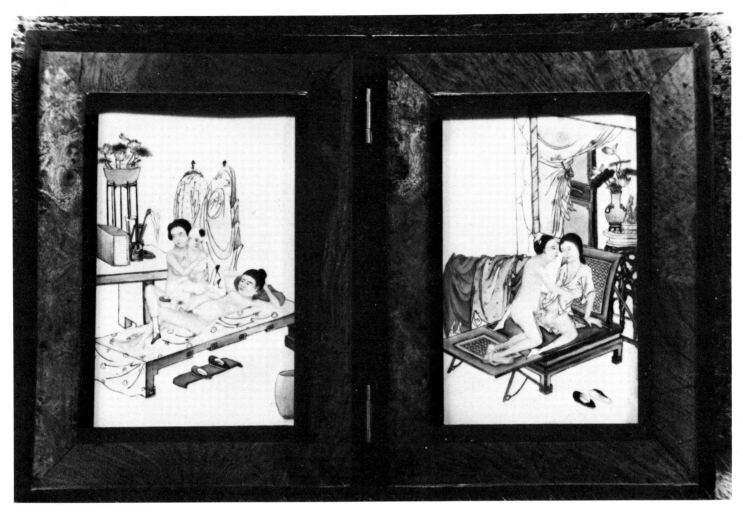

landscapes have a positive and individual seasonal quality; emblems for grades of Yin and Yang are interwoven in them so as to generate an image of the characteristic changes in the cosmos. The deep Yin valley, with its coiling cloud, rounded forms and dark ink, counterpoints the Yang sky and angular drawing of the jutting mountain-peak and bright, hard rock faces. The combination gives an insight into a phase of dialectic change, not only through the objects it depicts, but even through the implied symbolisms of how it is depicted. Dark, moist ink is Yin; active calligraphy of the brush is Yang. Since the Great Duality of nature parallels the duality of human sexuality, landscapes, as emblems of Yin-Yang harmony, appear everywhere in erotic art – on the hangings of a bed on which a couple make love, on a screen by a girl's elbow, or as the garden setting for an amorous encounter.

118. Domestic love. Ivory reliefs mounted on painted silk backgrounds; eighteenth or nineteenth centuries.

Sexual illustration

The Chinese art we know today which is overtly sexual is unfortunately not of very high quality. Little of it approaches the standard of its Indian or Japanese equivalents. But we do know that some of the greatest masters of landscape art did paint overtly sexual pictures which have disappeared. Among them are Chao Meng-fu (1254–1322), a scholar-administrator for the Yüan dynasty, whose insight

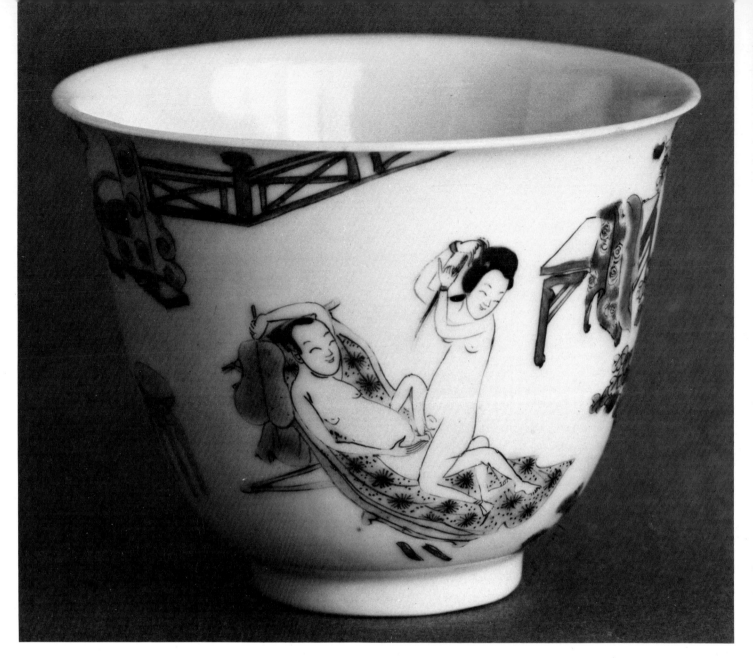

119. Rice bowl. Porcelain, painted with a 'harmonious couple', intended to produce a good effect on the food. Nineteenth century.

into the forces of nature was profound; and T'ang Yin (1470–1523), a relatively humble professional artist, whose landscapes were so good that they compelled the reluctant admiration of his social superiors. T'ang Yin is said to have created patterns for erotic composition which many later generations of artists followed.

The earliest recorded major painting that is overtly sexual is attributed to the great T'ang artist Chou Fang. A Ming artist-collector described it as representing an emperor engaged in intercourse with one of a group of his ladies. He writes that the chief lady appears 'very beautiful, her vulva moist and rosy with erect clitoris, so that her passionate feelings are very well expressed'. Chao Meng-fu had apparently owned this actual picture, since the Ming collector states that it bore the impression of one of his seals. The famous Ming erotic novel, *The Prayer Mats of the Flesh*, refers to a young man who owns a collection of erotic paintings by Chao Meng-fu.

We do not know exactly where to draw the line between the erotic art of such major masters, which we have never seen, and the illustrations to those 'how to do it' posture-manuals which had flourished

since Han times, some of whose descendants we do know. No doubt there were good and bad, and artistic achievement at every level of sophistication. Of course, actual paintings would always have been more expensive than woodblock prints, which only began to be widely diffused during the Ming dynasty.

Paintings almost certainly were the leading erotic art form. A few of those which have reached the West are of very high quality. Most belong to sets of eighteenth and nineteenth-century album paintings illustrating love in action; while others are sets of illustrations to the two novels already mentioned, *Gold Lotus* and *The Prayer Mats of the Flesh*. Part of their artistic importance lies in the way the coupling of the bodies suggests special interactions of Yin and Yang, which are based ultimately upon the seasonal trigrams of the *I Ching*. And the settings – furniture, decorations, garden features, plants – add their own particular meanings to each scene.

European writers often feel that the skills of the Chinese painter are inadequate for representing the nude human body, partly because he never practised academic drawing from the model. This is a simple error on the part of people brought up in Western conventions of portraying the nude, who fail to recognize how rigid their own visual conventions are. Chinese conventions are simply different – and also different from the Japanese conventions of the Ukiyo-e, which have now been more or less accepted by the Western eye. It is true that Chinese painters have never registered the undulating landscapes of human anatomy with the same kind of close attention they paid to the folds and promontories in the landscapes of nature. They render the body with a few plain, finely drawn contours. Contour line leads the entire composition. Volume and bulk are rejected as static and inelegant. So Chinese erotic art always aimed to achieve the maximum effect by means of subtlety of linear calligraphic drawing; it tended to avoid systematic filling-in of the format, preferring to allow the spectator's imagination free rein to complete the image. Frequently folds of garments, drawn aside, enhance the sense of movement in open space which the contours convey.

The proportions of human bodies may also look odd to the Westerner. Legs may seem short and slender, torsos long and slightly bulbous. In fact, to the Chinese, a relaxed belly is a sign of spiritual tranquillity. But apart from the fact that few Chinese actually have the long, heavy legs and massive shoulders so much admired in the West (which are also conventional in their own way), Chinese ideals of beauty positively require those particular physical characteristics. One other feature much admired in beautiful women of high social class, from Ming times, is their bound feet encased in tiny shoes which make them look like little hoofs. Such feet, doubled over and tightly bound from childhood on, were the focus of intense erotic attention; only in the most intimate stages of a sexual relationship

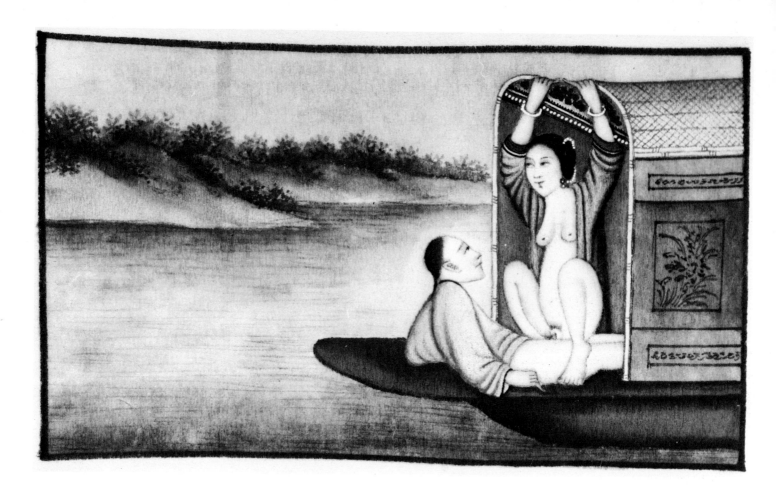

120. Love in a boat. Painting on rice-paper; nineteenth century.

would a woman allow her lover to uncover them. Originally the custom, like so many of the strange bodily deformations practised in other societies, was probably meant as a kind of caste-mark, indicating that a woman with such feet could neither walk far – needing to be carried in a litter or carriage—nor be a dancer, a low-caste occupation. And it gave her a delicate, tripping walk. In art, women with normal feet are usually servants or prostitutes.

Woodblock prints were made in fair numbers both to illustrate novels, including erotic scenes, and as independent erotic art which would reach more people. The designs were often taken from originals by artists of standing. And, remembering that the Chinese never regarded sexual love as in itself reprehensible, we can not regard even inferior works of art which stimulated sexual interest as 'pornography'. Such art was judged on the basis only of its aesthetic quality. In fact, there are many woodcut illustrations of the Ming and Ch'ing dynasties which amount to fairly substantial pictorial achievements. With the slenderest of means – a handful of printed lines – they are able to evoke a sense of deep space and activity.

Between about 1570 and 1650, under the sponsorship of a number of connoisseurs living in Nanking, sets of erotic woodblock prints of particularly high artistic quality were produced, perhaps based upon designs by T'ang Yin. At that period the art of the woodblock print was being developed in Nanking to a very high level of artistic expression. The famous album called the 'Ten Bamboo Studio' was

122

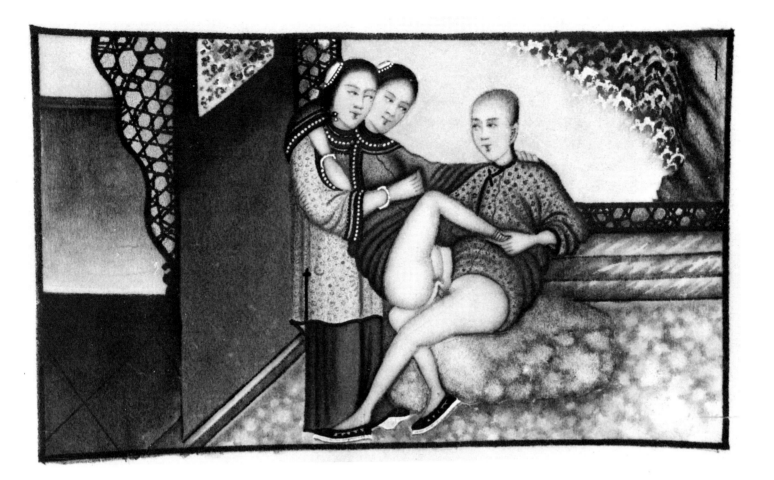

published then, probably in 1619; it has superb colour-printed illustrations of flowers, fruit and birds. Each has a black key-block giving linear elements of the design; and each of the brilliant colours is printed from an individual block, often without any drawn contours and incorporating graduated tone. But the erotic albums developed a most interesting and beautiful technique of minimal colour of their own. This consisted only of differently coloured outlines, printed in perfect register.

Down virtually into modern times an erotic imagery based on such published prints was applied also to ceramics. Many rice-bowls were painted with couples engaged in 'the flowery battle', with the intention of adding virtue to the food. But other objects, such as the very popular cages for 'singing' crickets, were painted with highly erotic scenes delightful for their own sake. Small table-screens were made which had little ivory couples carved in relief stuck onto painted silk backgrounds. Such things may seem very remote from the heights of Taoist symbolism. But the pleasant and guilt-free frankness of their imagery, as well as the calligraphic linearism of their expression, show that they share the same sphere of meaning. Where the exalted mystic works towards a psychosomatic harmony of Yin and Yang, a decontraction of inner tensions so total and unsensuous that it appears as 'wu wei' (doing nothing), the ordinary man and woman are encouraged to discover through enjoyment of each other a more modest and metaphorical reflection of cosmic harmony.

121. One chosen. Painting on rice-paper; nineteenth century.

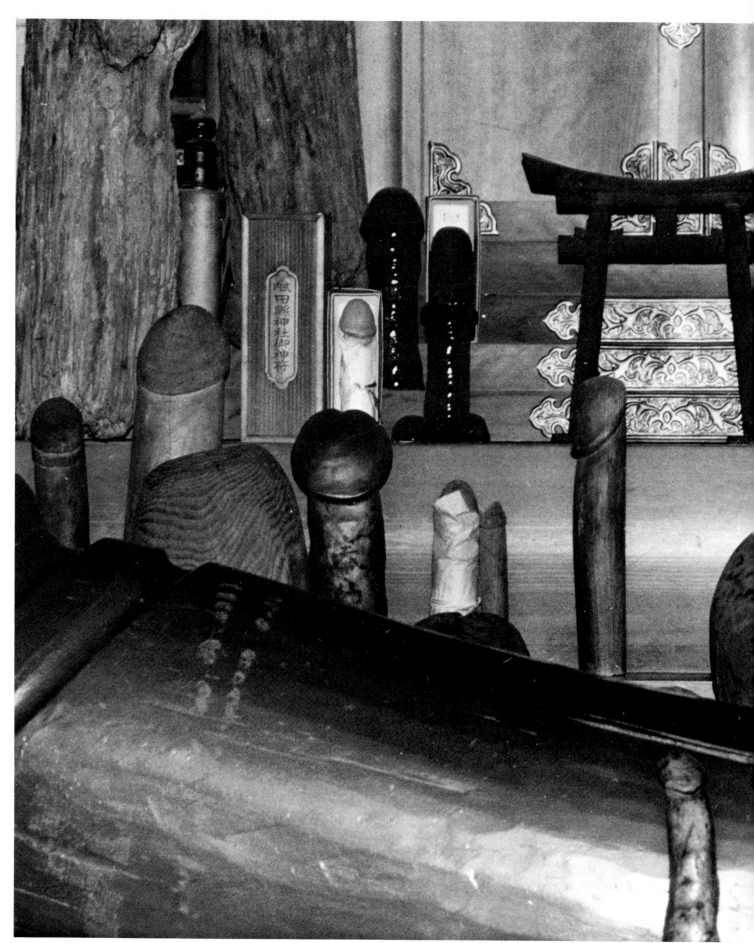

122. Penis-emblems dedicated at a sexual Shinto shrine. The Torii arch is a female emblem.

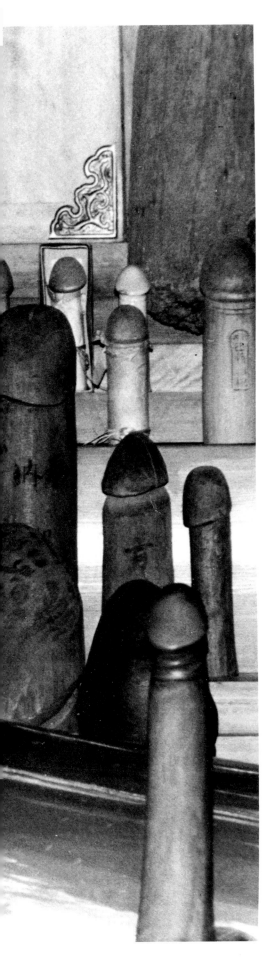

FOUR

Japan

The way of the gods

The culture of Japan has retained very archaic elements right down into modern times. These are enshrined in the religion called generically Shinto, a state religion which still reaches deep into the roots of peasant life with its rites and festivals. Buddhism arrived in Japan from Korea in the fifth century AD and co-existed and combined in interesting ways with the older cult. Since the government of Japan repeatedly imported elements of Chinese culture through the centuries, substantial influence from Chinese Taoism was also assimilated into Shinto.

Shinto means 'the way of the Gods'. And the ancient gods are called Kami. Perhaps the best translation of this term into Western languages is *numen*, the Latin word that implies awe-inspiring spiritual presence. The Japanese have found Kami in all sorts of places, people and animals; and they have recognized many sorts of Kami. They are by no means all good. The great Kami of the state include gods who dwell in major local shrines connected with the Imperial families, and even deceased Emperors themselves.

Two ancient texts first written down early in the eighth century AD, the *Nihongi* and the *Kojiki*, record legends concerning the actions of a group of gods who were especially important to the metaphysical structure of the Japanese state. Among the most important of them are Amaterasu, the Kami of the sun, who is the patron goddess of Japan, and O-tafuku, who has strong sexual overtones, and will appear later on. Some are deities related to the nature spirits of Siberia and Korea. The islands of Japan are and have Kami, as do certain places such as waterfalls, mountainsides, sea-bays and great trees.

Such Kami are not distinct and separate deities of human shape; nor are they simply the place itself. They are indwelling presences for whom people may have strong personal feelings of love or dread. Animals may also be and have Kami, such as the tiger, who is dangerous, and the fox, who is cunning and tricky. The echo is Kami;

125

123. (*Above*) The sacred mirror in a Shinto shrine.

124. (*Above right*) A huge ancient stone penis emblem at a Shinto shrine.

so is the principle of growth, and certain types of plant. Even living human beings who have done something marvellous can become Kami, and have shrines set up to them while they continue living their own lives in their own houses. The feeling the Japanese have for their country and its heroes is thus quite unique.

It is the shrine which testifies to the presence of Kami anywhere in Japan. One Kami may dwell both in the shrine as well as in the proper location – as does Amaterasu, for example. Shrines may be of many kinds, ranging from a natural stony cleft overshadowed with trees, which local people decorate with knotted ropes, to a full-fledged complex of buildings, like the great Imperial shrine at Ise, where the first daughter of the reigning Emperor traditionally becomes the priestess. One mark of a shrine is a red-painted torii, or arch, one or more of which may frame the approach to the shrine itself, defining the transition from secular to sacred ground. One of its interpretations is as a feminine 'birth passage'.

Most pertinent for our topic here is that very important group of Kami which have to do with sexuality and love. They are called generically Dosojin. Like all the other Kami they belong to the land as its fertility, and to its people as their own sexual identity. They can also be felt as individual presences. At the same time, like the

Chinese sexual amulets, they have a powerful protective effect, if they are properly invoked and satisfied with offerings.

It is impossible to understand the erotic art of Japan without realizing that human eroticism has this particular kind of transpersonal dimension. That which is sexual has also, so to speak, an existence beyond the individual. It is therefore very important that all its manifestations must be recognized and accepted, including the humorous, even the scabrous. This attitude is part and parcel of the continuum of belief described in the introduction, which sees all the paraphernalia of sex, birth and ancestral spirit as powerful, positive affirmations of human beings, all of which can be cultivated in different ways.

Like many other peoples, the Japanese have an ancient creation legend which involves a pair of mythical lovers. The story as we have it in the *Nihongi* is confused, and large sections are apparently missing. But it seems that the first event in the Japanese genesis was the appearance between earth and heaven of a deity in the form of a reed shoot, the principle of growth. Then a number of other obscure deities arrived who lived in the region of heaven. Eventually a pair emerged called Izanagi, the male, and Izanami, the female. It seems likely that they were identified to some extent, under Chinese influence, with the Yang and Yin of Taoism.

The legend describes how the couple stood on the rainbow bridge of heaven and thrust down the 'jewel spear of heaven' into the seething chaos below. The spear obviously has implicit references both to the phallus and to lightning. Foam from the spear-point coagulated into an island, and the divine couple alighted on it, to build a house with the phallic spear as its great central pillar – referring to the common Oriental image of the axis of the world we have met before. It is also the prototype of the wedding-huts the Japanese once used to build for the consummation of marriages.

Circling round the pillar the couple Izanagi and Izanami encountered each other as if newly met (though with a hitch or two). They then began to copulate. In the course of time they gave birth to the Kami islands of Japan, all the Kami of trees, of plants and grasses, the sun goddess, the moon god Susa-no-wo, the turbulent god of the stormy sea who ended up as lord of the underworld; earth, water and food goddesses, and the gods of wind and fire, and many others. The legends enter into great detail about the complexity of the family lives and adventures of all these Kami, as well as a host of others. Among them is the first Emperor of Japan.

One particular event in the story is relevant to our subject. Susa-no-wo made a nuisance of himself and ended up by flaying a celestial piebald horse, and flinging its corpse into the sacred hall where the sun-goddess Amaterasu was weaving clothes for all the gods. This offended her so much that she withdrew into the great rock-cave of heaven, leaving the world in darkness. So all the Kami met in the

'dry riverbed of heaven', the milky way, to plan how to get Ama-terasu out again. They set the celestial cocks singing, and dug up a five-hundred-year-old heavenly tree by the roots, which they decorated with strings of jewels on its upper branches, a mirror on the middle, and fine cloth on the lower. Then the goddess Ame-no-Uzume stood stamping rhythmically on a tub with her clothes pushed down to expose her belly and thighs, chanting and dancing an indecent dance which made all the gods laugh uproariously. Amaterasu couldn't contain her curiosity, so she peeped out of her cave, was dazzled by her own brilliant face in the mirror, and then was grabbed by the god 'Strength of hand'.

The erotic dance of Ame-no-Uzume, who is sometimes later called Okami or O-tafuku, becomes an important image in later art, and was treated as a divine precedent for some of the theatrical arts. She is sometimes shown as a plump-faced woman and paired with Saruta-hiko, whose nose is a great penis. By the nineteenth century in the cities the two had degenerated into rather grotesque clowns. But Okami and her dance remained an important mythical element in peasant life. Farming communities used to perform sexual fertility dances at the time of the early spring rice-planting, followed by intercourse in the paddies, to invoke the return of the sun. They thus re-enacted the gods' efforts to cajole Amaterasu and make her resume her proper function.

The friendly couple

At the great Imperial Shinto temple at Ise, Amaterasu is present in the main shrine in the form of a great circular mirror kept inside a chest. One of the subsidiary buildings is dedicated to the sexual Kami couple. And this Kami couple, known as Dosojin, personify the male-female principle in nature, once represented in thousands of images at the roadsides and among the rice-fields of peasant Japan. Many still survive, though increasingly at risk from public attitudes and developing communications. Up until the early 1950s many parts of Japan were isolated and remote, and their inhabitants preserved almost unchanged customs from remote antiquity. Few Japanese will yet admit publicly to these realities of their own cultural base, though many still adhere to them quite strongly.

Male and female emblems of sexual energy, usually coupled in some way so as to represent 'the life-force' in action, were set up and worshipped everywhere in Japan. Aristocratic culture imported from China, in both its Confucian and Buddhist forms, may have averted its eyes, and officially ignored the sexual emblems and their associated practices. But this 'life-force' has continued to make appearances even in the highest society, while the whole of bourgeois and proletarian culture has remained deeply permeated by its imagery. The range and

variety of this imagery runs all the way from natural places and objects to the most extravagant representations of human sex in action created by the Ukiyo-e painters and printmakers of seventeenth- and eighteenth-century Edo (Tokyo).

The oldest icons of the sexual couple seem to have included a pair of trees, often a pine and a myrtle. Others show a twisted cypress tree with a vulva-like split in its trunk, a tall rock enveloped by a tree or trees with roots shaped like male and female genitals. Two great rocks in the sea off the Ise peninsula are kept joined by a gigantic woven rope, and are called 'Husband and Wife deities'.

Rocks and stones of all sizes are far the most common representations of the sexual dyad – usually called by the single deity name of Dosojin. Searches made in the first half of this century located over forty thousand; and many thousands more must exist unrecorded. They generally stand at roadsides, road forks or crossroads, usually near villages; and they take a variety of forms. A common form is a pair of stones, the male stone being tall, standing perhaps a metre high, beside a flatter, rounded and often pitted and creviced female stone. An echo of this pattern is preserved in the layout of the

125. Two sacred trees joined by a straw rope, and surrounded by stone male emblems, including that in plate 124.

129

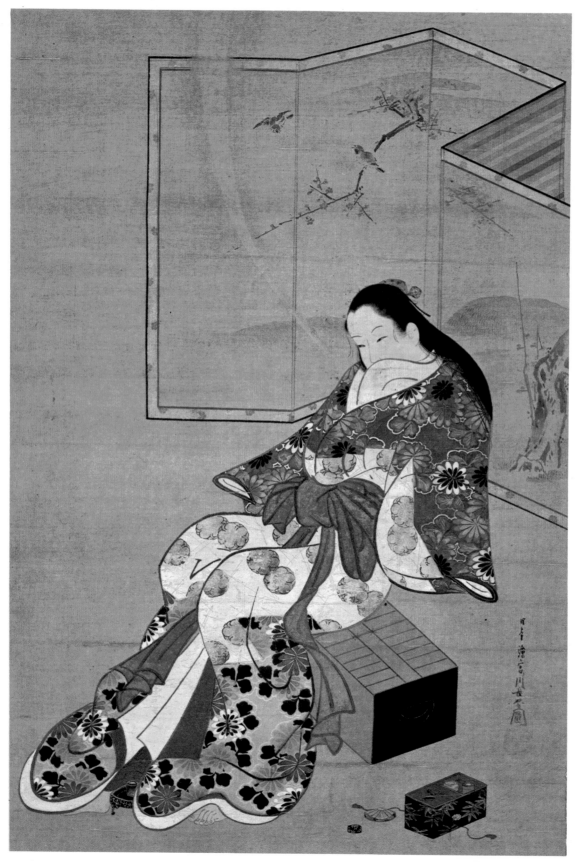

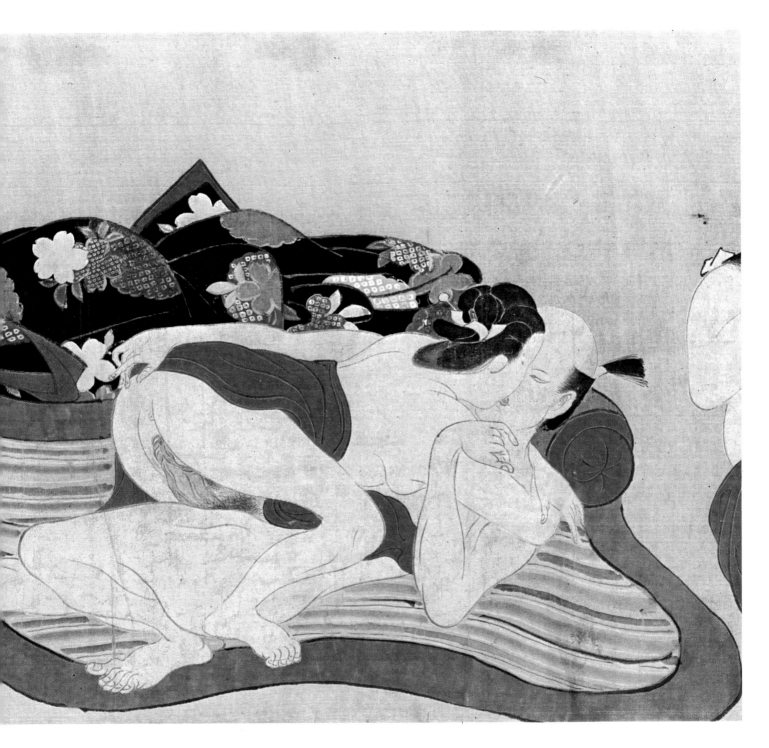

126. (*Left*) Seated courtesan, by Miyagawa Chōshun. Painting on silk, seventeenth century.

127. (*Above*) Part of an erotic posture scroll. Painting on silk, probably c. 1700.

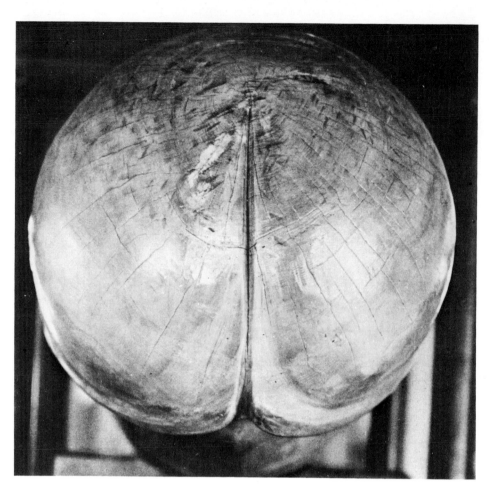

128. (*Above*) Large spirit-penis and testicles made of straw, at a Shinto shrine. Dedicatory folded papers hang below.

129. (*Above right*) Detail of the icon in plate 130

Buddhist monastery garden in the relationship between the essential guardian stone and altar stone. The male stone may be chosen for its direct similarity to the erect male penis, often resembling a mushroom, which in Japan is a common metaphor for the penis.

The female stone may be almost spherical; or it may be shield-shaped with a cleft in it. Very frequently the natural resemblances of stones to the genital organs are enhanced by carving. And, of course, there are many deliberately sculptured images. The end pillars of bridge-railings, for example, were phallic-shaped, and revered as protective deities. Sometimes miniature shrines may be filled with male-shaped pebbles; or with a single male pebble surrounded by several female ones. Such shrines may be mounted on pillars. Any large boulder of phallic shape may have the Chinese characters 'Do-so-jin' carved onto it – often the work of a master calligrapher.

There are also figurative representations of the dyad deity. Some are full-round, but most are in relief on one face of a stone. They may be given names, either by inscriptions or in village lore, for example, Saruta-hiko (Monkey – Rice-field Prince), one of the recorded Kami, or Ugadama, goddess of food. Occasionally the image is a triad; but by far the greater number are sexual couples. These depict a man and woman, clothed and perfectly equal in status, usually of quite a recognizable social type, such as prince and princess, peasant and groom, Buddhist or Shinto priest and nun. Sometimes the clothing is court dress of the Heian dynasty. They may be called

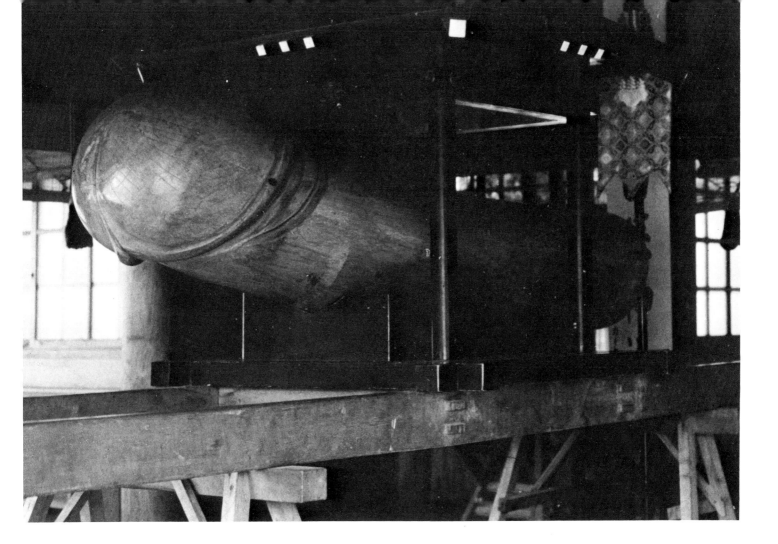

by affectionate names such as 'Chubby Cheeks', 'Night-and-Day Love', 'Beautiful Couple'.

The pair usually demonstrate their erotic relationship with true Japanese restraint, by a simple gesture such as a kiss, or by the man touching the woman's breast or genitals, or both touching each others'. A certain number are known which depict the couple, rather schematically, as engaged in intercourse in various positions. Emblematic flowers, fruit and vases may be added to the figures. One striking characteristic they all have in common is that, however modest the sculptural technique, the figures succeed in conveying a real sense of gentle and positive affection. They were very close to the hearts of the peasants. One of the reasons for the restraint and obliqueness of the sexual expression shown by the more modern Dosojin images was the firm social control over all aspects of life that came to be exercised both by the feudal hierarchy, which was often imbued with a Confucianism imported from China, and by the Buddhist establishment, which remained opposed to any affirmation of value in the present world. In fact accessories of the Dosojin figures may reflect either a distinctive Shinto or Buddhist background. Shinto, for example, are frames shaped like the torii gate-arch, like the twisted rope of rice-straw that marks off a Kami site, or a hut, and symbols like the phallus, bell or saké-bottle. Buddhist are the halo or lotus-petal frame, and the more strictly Chinese symbolic attributes such as the pomegranate and peach, pine and bamboo

130. Phallic icon, made of a tree trunk, in a Shinto shrine.

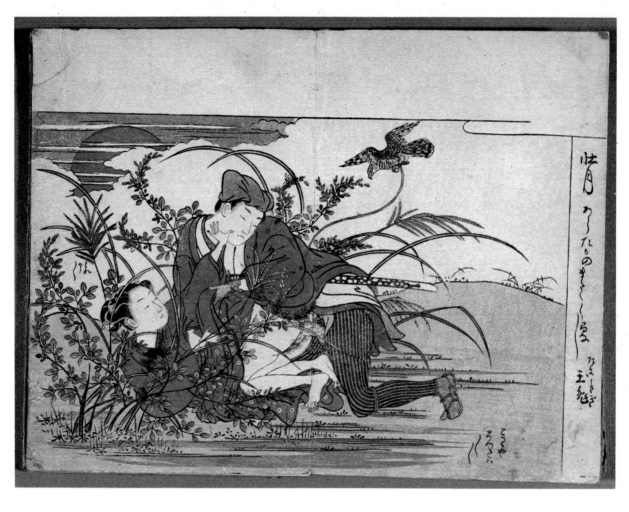

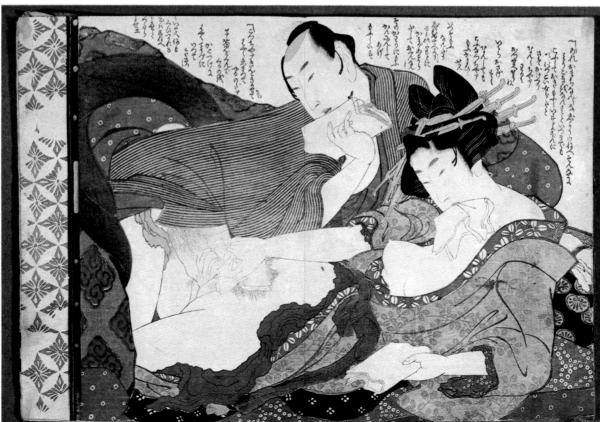

134

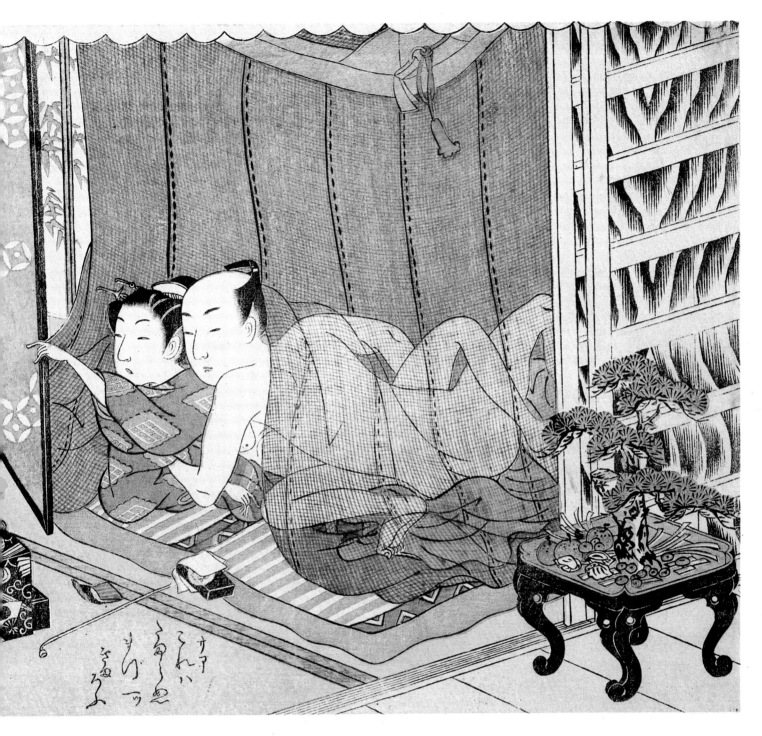

131. (*Above left*) Lovers in the country, by Koryusai, woodblock print, eighteenth century.

132. (*Below left*) Lovers on cushions, by Hokusai, woodblock print, nineteenth century.

133. (*Above*) Love in the mosquito-net. The attendant is represented by a tiny figure. The Tao is symbolized by the miniature Bonsai garden. Ukiyo-e woodblock print by Koryusai; eighteenth century.

branches, cock and hen. Buddhism in practice adapted itself to Dosojin on the ground, so to speak; some Buddhist shrines keep phallic images hidden in a secret cupboard. And, as we have seen, Shinto contained an indelible, even essential, phallic element, no matter how little it may be publicly acknowledged by the feudal hierarchy.

Rustic Dosojin were and are worshipped and given offerings for all sorts of specific reasons: to increase the fertility of the rice-paddies, to bless weddings, to give children; they also protect travellers and mothers in childbirth. The offerings are of various kinds. A common one is a forked stick, like a human figure with legs apart – an inverted Y, sometimes with a little face carved on it. Other offerings include straw horses, straw versions of the male and female genitals, and sticks with one end cut into a mop of shavings, recognized emblems of phallic ejaculation. There are annual Dosojin festivals with, in the larger towns, thousands of participants. In fact, most village people, especially the women, feel that Dosojin assist at every child's conception, birth, growth, marriage, childbearing and death. Dosojin know every secret of the past, present and future; and they protect with love and guide the passing generations. They thus represent a specifically Japanese manifestation of the great ancestral cosmic duality, even though the abstract systems of society, state and philosophy may have ceased to take account of them.

134. Phallic flower arrangement support, symbolizing long life. Wood, twentieth century.

Great shrines

Dosojin, however, are not the only form that sexual Kami have taken in Japan since the remotest times. There are certain major state temples which are still entirely dedicated to the powers of sex. Among

135. Section of a painted scroll illustrating a palace of amorous women. The recess resembling a Shinto shrine contains 'armour' and dildos, one a double dildo for use by two women. Nineteenth century.

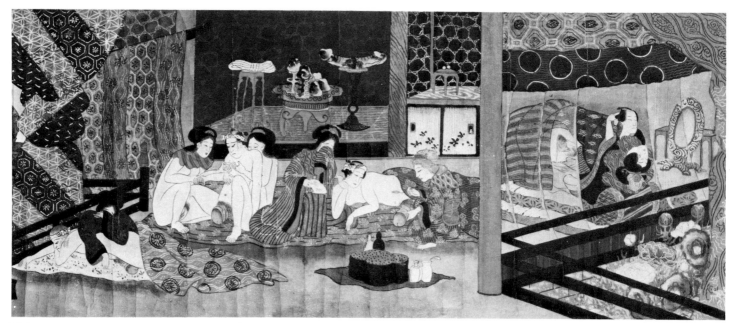

them are Fushimi Inari near Tokyo, and Tagata near Nagoya. They are garden sites, with a number of shrine-pavilions distributed over them. At Tagata, in one pavilion, for example, there hangs at a slanted horizontal an enormous tree trunk carved as a phallus with huge testicles made of rope. Each such temple has a spot where couples desiring children may sleep a night together, under a venerable pine tree.

Inside these shrines are great tiered altars loaded with ranks of sexual emblems, male and female, large and small, made of different materials, which are offerings by wealthy people. Other shrines may be fronted by avenues of female torii gates and male phallic pillars, many carved or painted with fine calligraphic inscriptions of dedication. At ordinary Shinto temples it is by no means unusual to find phallic offerings set before the shrine of a Kami. It is thus not at all surprising that on the back of the base of one of Japan's greatest early bronze Buddha icons, the colossal image in the Yakushiji, there was found relatively recently an ancient erotic drawing which had been hidden for centuries – but not obliterated!

At the edge of rice-fields, and in houses, smaller wooden versions of these larger shrines were kept. They resemble icon cabinets; some have double doors, and some have shelves inside. Their contents include phallus and vulva emblems, some painted perhaps, others lacquered or modelled in glazed porcelain. Not only the peasantry, but the urban bourgeoisie kept and still keep these shrines to the dyad, though with a very human inflection. It was, in fact, for this bourgeoisie that what are generally regarded as Japan's greatest figurative erotic paintings and prints (Shunga), were made, in what is called the 'Floating World style' (Ukiyo-e) of old Edo, modern

136. (*Below left*) Male and female stones in a small shrine. Nagano area.

137. (*Below*) Male and female stones joined: an image of that which is intrinsically good and beneficent. Shizuoka area.

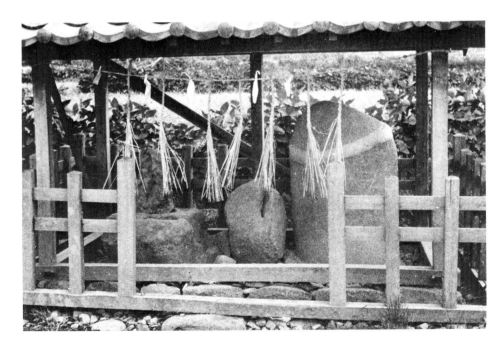

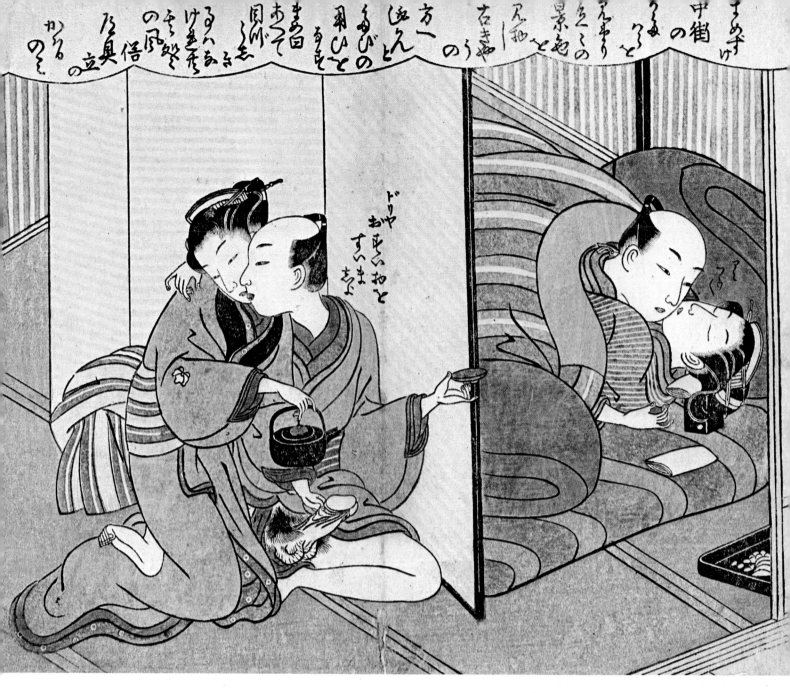

138. Male and female attendants play while master and courtesan sleep. Ukiyo-e woodblock print by Koryusai; eighteenth century.

Tokyo. 'Floating World' is a religious term. It implies that the pleasurable realities that art deals with are just evanescent bubbles, captivating illusions without value, which merely detain the individual in a world whose essence is suffering.

The development of the 'Floating World' styles in fact owed a substantial aesthetic debt to the earlier art of the very early Buddhism which so disapproved of them. Buddhism was the chief purely cultural influence laid over the substratum of native Japanese society and civilization. When it was finally accepted as the official religion of the state and feudal hierarchy in the sixth century AD, Imperial edicts ensured that it was firmly rooted throughout the heartland of Japan. Temples were set up, and images were made by Imperial guilds of sculptors and painters; often these artists were native Koreans or Chinese. The Koreans were especially gifted. But by the eighth century a Japanese style of Buddhist art had evolved which was closely based upon the art of T'ang China. This style became known as

138

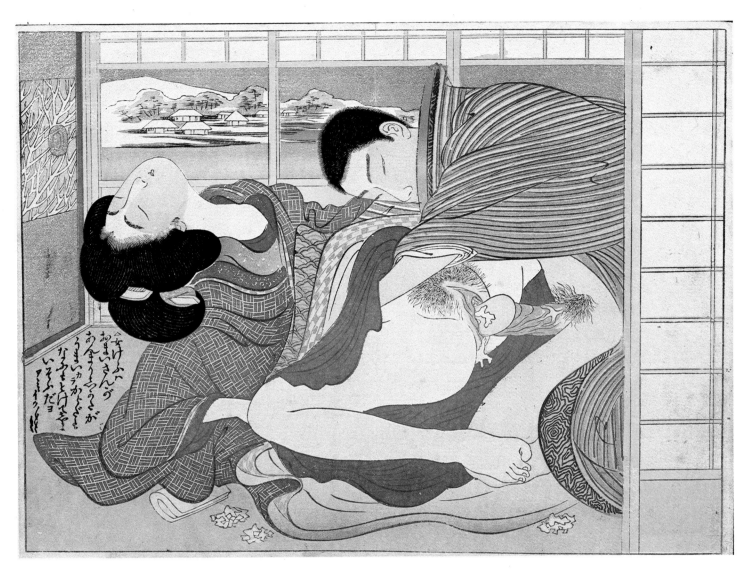

Yamato-e, 'Japanese style', when, after a few centuries of isolation from China, newer and different styles of Chinese art were adopted once again. The first great phase of art dealing with love was couched in the Yamato-e. It was produced for the courtiers of the Heian emperors. All later figural art is indebted to the Heian canons.

139. Making love in winter. Print by Shuncho, eighteenth century.

Courtly Buddhism

It is worth considering the actual qualities of Japanese Buddhist art itself, since it displays very strange and illuminating bodily attributes. There is a theory behind the figurative imagery dealing with Buddhist truth as it is incarnated in the Buddha, in the many Buddhas of the cosmos, and in the Bodhisattvas who are compassionate reflexes of the cardinal Buddha principle – and that is: that the truth itself is unrepresentable, but may be symbolized by the use of a 'body of glory'. What is particularly significant is how the idea of 'glory' was

140. Head of a celestial being. Ink drawing,
Chinese, seventh century (?), found in Japan.

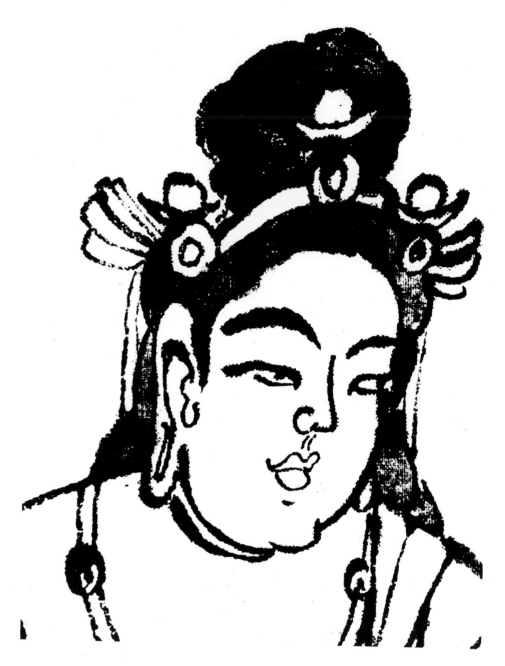

presented in art, for it both conditioned and reflected the current
ideals of human beauty. Certainly there was a central element derived
at long range from India, where Buddhist icons originated. But
Buddhist art in Japan has a characteristically Japanese inflection; and
the Buddhist conception of what constitutes the 'glory' of the human
form permeates most other art. It is totally different from Western
conceptions. What may at first seem very strange is that there is a
strong sensuous component in the figures of that ascetic religion
Buddhism. This appears not only in the carved images, but also often
in colourful painting of their surfaces; and similar sensuous qualities
appear in the drawing and colouring of Buddhist paintings.

The 'glorious body' is plump and rounded, with a gently relaxed belly. This symbolizes the extreme of spiritual decontraction; such relaxation was a much-admired quality in Japan's rigidly stratified society, where suppressed anxiety was almost universal. The face is broad and also softly rounded. This roundness is articulated as smoothness and suavity. These are conveyed in drawing by sinuous lines deeply and softly curved, in three dimensions by linear surfaces which wind to and fro across the field, in and out of its depth, and around the back of the figure represented. The important point about these major icons is that they were intended to be seductive – not in any obvious sexual sense, of course. But the main traditions of Buddhism which used icons under the Heian set out to engage the feelings of their followers at every level.

The Pure Land and Amitayus sects, in particular, were based upon the hope of a Paradise described in their literature as the epitome of all delights. Gardens with lakes like lapis-lazuli were filled with jewel-trees, and blossom cascaded continuously and mysteriously from the sky. The Buddhist persons who inhabited such a Paradise were presented as the embodiments of charm, the goal of earnest longing as the ultimate home and satisfaction of all desire by the extinction of desire itself. It is interesting that when male and female Shinto icons were carved for important shrines, as they were, in general imitation of Buddhist icons in Buddhist shrines, they were frequently represented with emphatic sexual organs, which were then probably hidden by carved or woven garments added to them.

Among the works of Buddhist art there are, in addition to the major icons, a whole series of paintings of individual monks. They, too, were based upon T'ang dynasty prototypes, with their clear, wiry outlines and areas of barely modulated colour. But in the great Buddhist monasteries a type of art evolved which was to play an important role in the history of erotic art. This was the long story-scroll – *emaki* – read in sections as it was unrolled from right to left. As a genre it again was imported from China. The earliest illustrated scrolls we know are classic Buddhist texts. The lives of famous individual monks were told through passages of text alternating with pictures. The genre was adapted to secular stories by the twelfth century; and by the thirteenth both Buddhist tales and episodes of history were being recounted as unbroken sequences of figures in vivid movement, drawn with a tautly dancing brush. All these various types of art contributed to the later, great styles of erotic illustration.

By the most extraordinary good fortune two major literary works, written by ladies-in-waiting to the Empress at the Heian court, have been preserved and translated into English. One is a very long novel called *The Story of Prince Genji* by Murasaki. The other is the diary of Sei Shonagon. They give a fascinating insight into the lives and interests of the court, especially the women, who spent their days

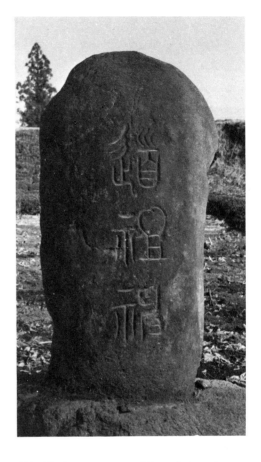

141. Votive stone carved in archaic script with the word 'Dosojin'. The right component of the middle character for *so*, meaning 'ancestor', is cut to resemble a phallus. Kanagawa area.

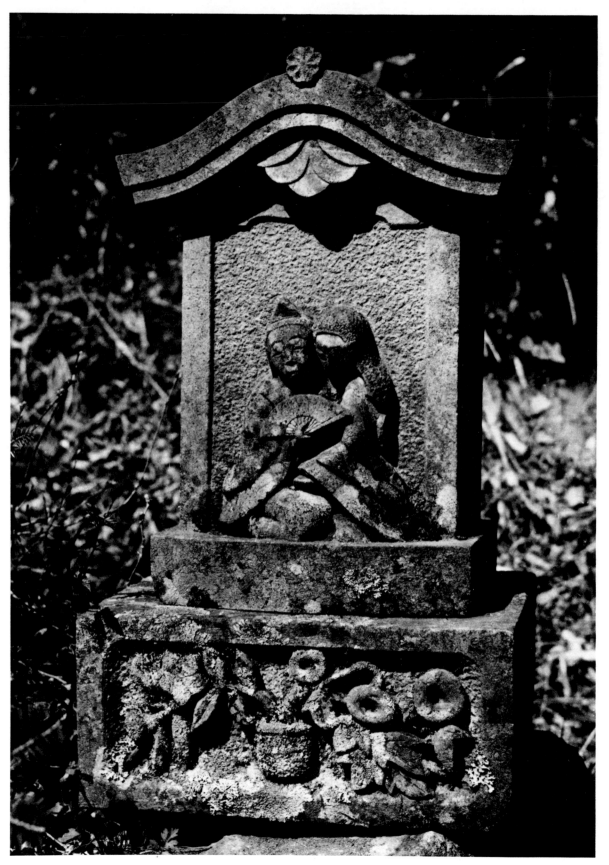

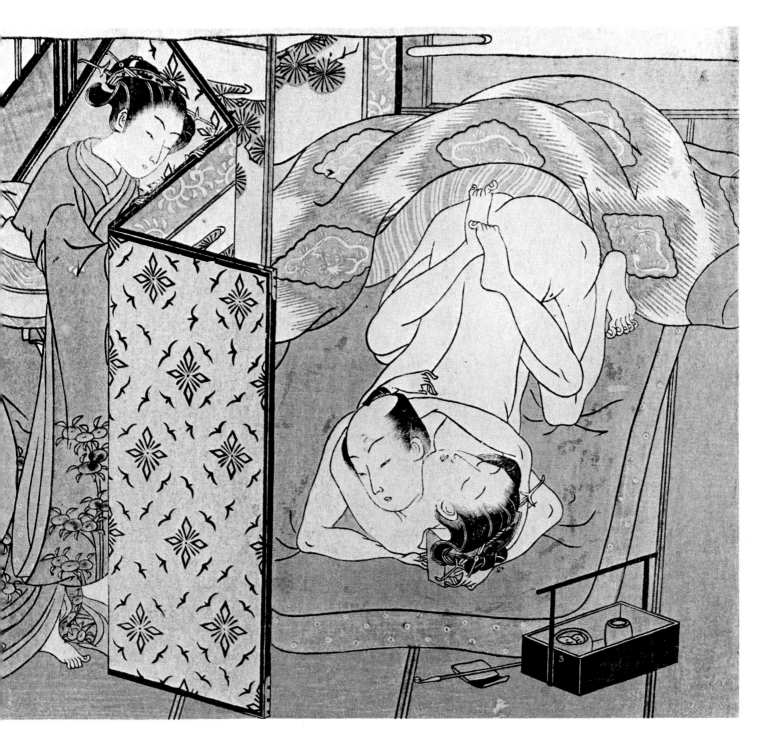

142. (*Left*) Dosojin couple. The union of the friendly couple spreads its benevolent influence into the homes of the people. Gumma area.

143. (*Above*) A second girl watches a long lovemaking in one of the houses of the Yoshiwara. The foreshortened nudes are rare in Japanese art. Ukiyo-e woodblock print by Koryusai, eighteenth century.

Japan

144. Dosojin on a votive stone cut with calligraphy. Nagano area.

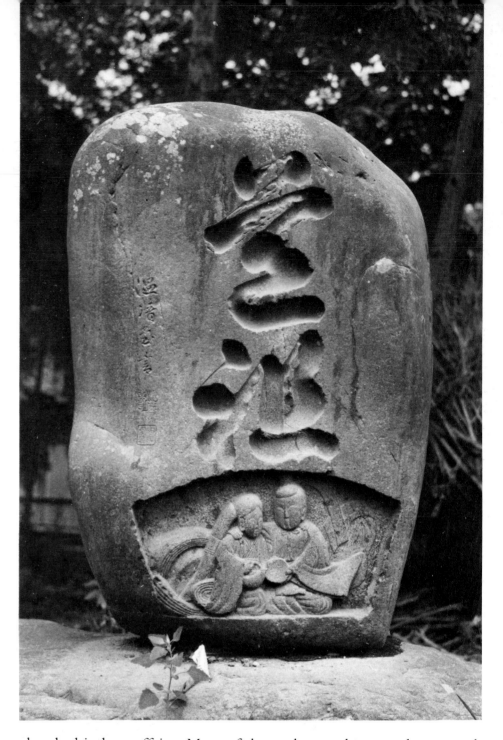

145. (*Opposite above*) Votive stone carved with a phallus. Miyagi area; dated 1832.

146. (*Opposite below*) Phallic stone. Iwate area; dated 1711.

absorbed in love affairs. Most of the exchanges between lovers took place virtually in public, since the court consisted of a complex of pavilions in which the ladies-in-waiting lived; they slept in dormitories. Court life was dominated by ceremonial, convention and good form, conducted by people who saw themselves as an aristocratic élite. The courtiers developed a very subtle and allusive code to communicate with each other by exchanging poems. But at night the young men and women were able to consummate their love physically – albeit at some risk of discovery and scandal.

The Story of Prince Genji was illustrated in scrolls; and a number of such emaki survive. The style is restrained within rigid canons of artistic convention, but in its own way strikingly beautiful. The figures sit, stand or lie motionless. Love is expressed only by the most reticent of gestures.

Bawdy scrolls

As time went on the Yamato-e illustrative court painting developed a less inhibited manner. It seems that instructional manuals of erotic technique were imported from China and imitated. Later copies show that during the fourteenth century scrolls dealing explicitly with the modes of sexual love were painted. Some were treated as illustrations to stories and were the direct ancestors of the later Shunga of the Edo Ukiyo-e. But the tradition of Buddhist emaki produced its own erotic works. Among these emaki of the twelfth century a number of comic ones survive, satirizing monks as rabbits, frogs and mice, for example. They were drawn in brusque, rippling and angular lines. From later copies we know that comic erotic scrolls were also made. Secret originals may still of course exist, as yet unacknowledged. Two such scrolls illustrate the Japanese love for bawdy comedy. One depicts a strange contest over the size and performance of the phallus, with a jury of female participants, and the other is a story about sailors wrecked on an island inhabited only by sex-starved women. In both these works the artists were given very free rein indeed.

It is hard to guess exactly for whom such scrolls were made, but it is quite probable that they were produced in and for monasteries. It was only in monasteries that real freedom from the oppressive formality of feudal society was to be found, and laughter could be uninhibited. No ordinary lay commoner was likely to be able to afford such things.

Among the Japanese aristocracy who were in a position to patronize artists a great revolution took place in the thirteenth century. At that time Japan had been ravaged repeatedly by civil wars between the great lords, and the Emperors had proved powerless to control them. The victorious noble family set up the institution of the Shogunate, a hereditary military dictatorship with its own capital city and court. The Shoguns ruled in the name of the Emperors who became mere ritual figureheads; and they made sure they did not make the mistakes, as they saw them, of the Heian dynasty. The Buddhism, art and literature of the Heian were rejected for official purposes – though they survived in cultural backwaters, notably at the Imperial capital. They were replaced by the austere, self-denying culture of the Samurai, a caste of professional warriors to whom the Shoguns themselves belonged, and whose religion was Zen – a type of radical Buddhism imported from China. The colourful ceremonial of the Paradisal sects was rejected, but the older religious forms were not in fact proscribed. Imported along with Zen were two types of Chinese art – the monochrome ink landscape and figure painting, though without, it seems, the full intuitive underpinning of Taoism. Later on, however, some of this did take root in Japan under Ieyasu.

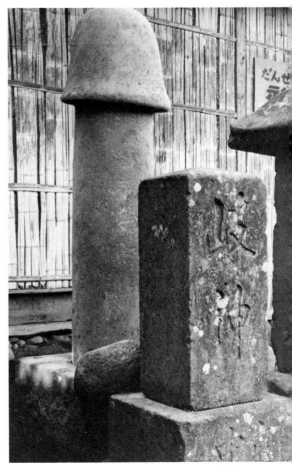

The Shoguns took control of all aspects of life, including relations between the sexes, and imposed a censorship on literature and art.

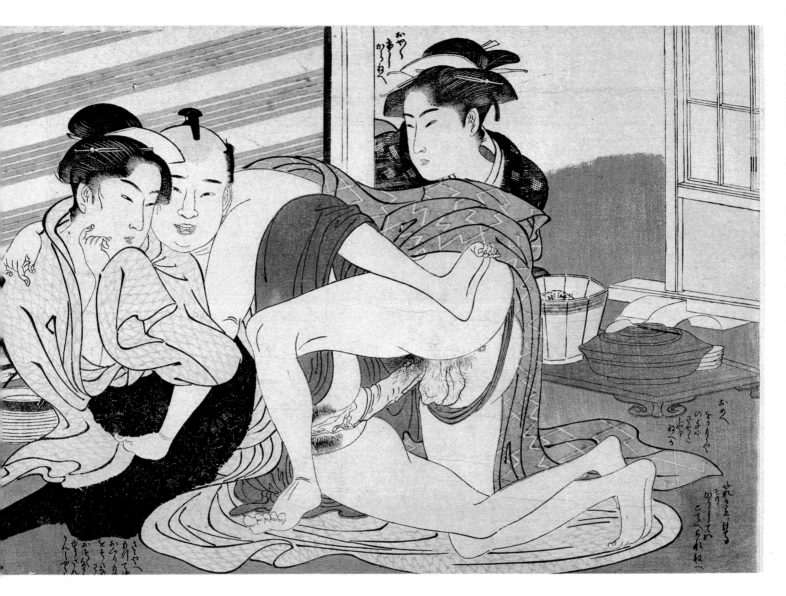

147. Lovers with attendant in the Yoshiwara. Woodblock print by Shuncho; late eighteenth century.

They closed Japan, as far as they could, to influences from outside – even from China. It was only when the isolationism was relaxed to take advantage of European trade in the nineteenth century that new social elements appeared which broke down to some extent the ideological control of the earlier Shogunate.

In Samurai society the role of women was very different from their role in Heian society. Gone was the relative freedom of Genji's day. Marriages were arranged according to aristocratic rules, without regard to the feelings of bride and groom. Just as the Samurai retainer was expected to dedicate his life totally to his lord, and to have virtually no individual personal existence or wishes, so the Samurai wife was expected to dedicate herself wholly to her husband and children – and through them to the Lord. The great majority of people accepted this state of affairs – as indeed they had to; for only through their feudal allegiance to the landholding lord were they

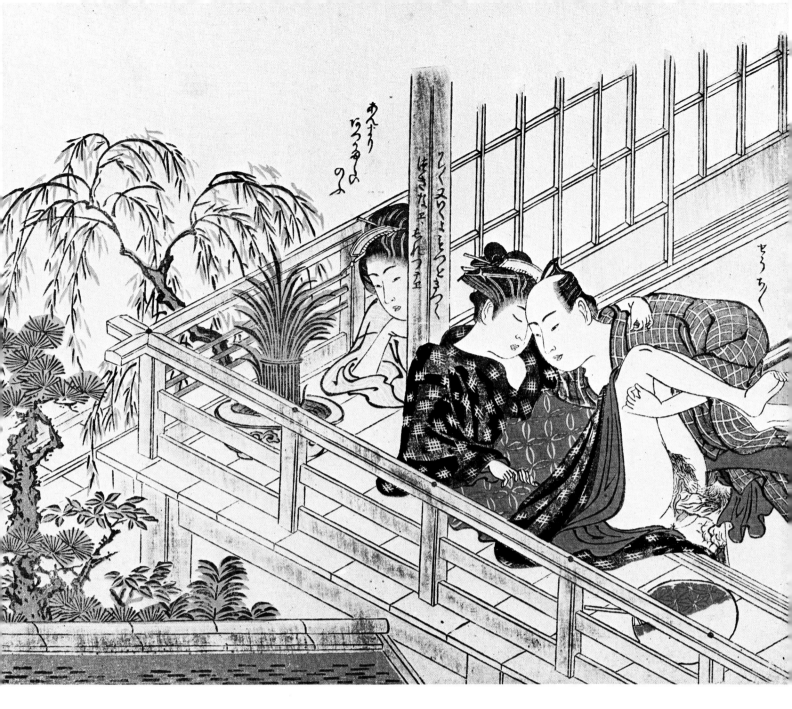

allocated the rice-ration necessary for life itself. But young couples did fall in love and try to defeat the system; usually they were driven to suicide and became martyrs to love. Many stories were told of such tragic love affairs. Often a strong element of the supernatural was introduced, since the Japanese were much interested in ghosts and spirits. The righting of an ancient wrong, at the request of the injured spirits of lovers, by some person acting as a kind of shaman or medium, is the central theme of major plays in the Noh Theatre.

There was also another class, the ronin, who were Samurai whose own feudal family had died out. They therefore had neither food nor home and owed allegiance to no one. Often they became brigands, living outside the law in wild country and preying on the peasantry, and carrying off their women. Many Japanese movies have been made based on stories of this period. Once again, by the later fifteenth century, the country collapsed into almost permanent civil war.

148. Love on a verandah. The willow refers to the traditional name for a brothel: 'a house of green willow'. The pine tree refers to the Chinese concept of long life being produced by successful sexual activity. Ukiyo-e woodblock print by Kiyonaga, eighteenth century.

149–153. Sectional medicine box (*inro*), and details of contents. Usually each section contains a different medicine. The implication here is that the erotic carvings are medically beneficial. Lacquer and ivory, nineteenth century.

Edo, city of pleasure

Soon after 1600 Japan was finally reunited by the great military genius Ieyasu. He left the country open to trade with the Dutch via the port of Nagasaki, and many of the great noble families enriched themselves during the seventeenth century by trade with both Dutch and Portuguese. But most important was Ieyasu's decision to build a vast new capital city, carefully organized hierarchically. It would both concentrate the orders of Japanese society, bringing the powerful noble families under the eye of the Shogun, and centralize the administration. By its sheer size it would testify to the power of this new Tokugawa Shogunate. The city was Edo, modern Tokyo.

A major consequence of this new city was that a bourgeoisie grew up to service it. They included merchants, artisans, and lower orders, including immigrant peasants. They had no feudal allegiances, as did the true Samurai, whose role Ieyasu reinforced. Officially and feudally these new city classes did not exist; but they became wealthy. The third Shogun in Edo, Iemitsu, found the effect of foreign trade, and of the alien ideas which entered with it, so disturbing on this new bourgeoisie that in 1637 he closed the frontiers entirely, banning all contact with the outside world. So the culture and art of Japan survived for over two centuries in total isolation, under rigid control.

Through a new bureaucratic apparatus Iemitsu imposed still harsher regulations on society including strict censorship of the arts. Even the meditative introspection which was the basis of Buddhism was frowned on, because it encouraged the belief in personal conscience. Iemitsu required of his feudal nobility and their retainers an obedience to ever-increasing government control so total that there was virtually no room for personal culture or pleasure in the upper echelons of society. Even marriages came to be organized under state supervision. There was strict control by different offices of where people might live, of what they might do, even of what clothing they might wear.

However, providing they observed the law and paid their taxes, the affairs of the bourgeoisie were beneath the notice of the feudal system as a whole. Hence it was only among the new bourgeois and proletarian populations of the cities that there was the freedom of spirit necessary for the creation of art. Its content did not matter, so long as it did not encroach on feudal privilege. The bourgeois and plebeian city of Edo thus became virtually an independent centre of culture. The lower Samurai, ronin in particular, found ways of making a living, and participated in the new culture, contributing many elements from the old Zen-Samurai ethos, mythology and art. Some took to the arts and crafts. Even members of the aristocracy became accustomed to enjoying something of the cultural advantages Edo society had to offer.

Since the bourgeoisie had no feudal responsibilities or status to maintain, they were able to devote themselves to pleasure of all kinds. They wore kimonos; they patronized the Noh and Kabuki theatres,

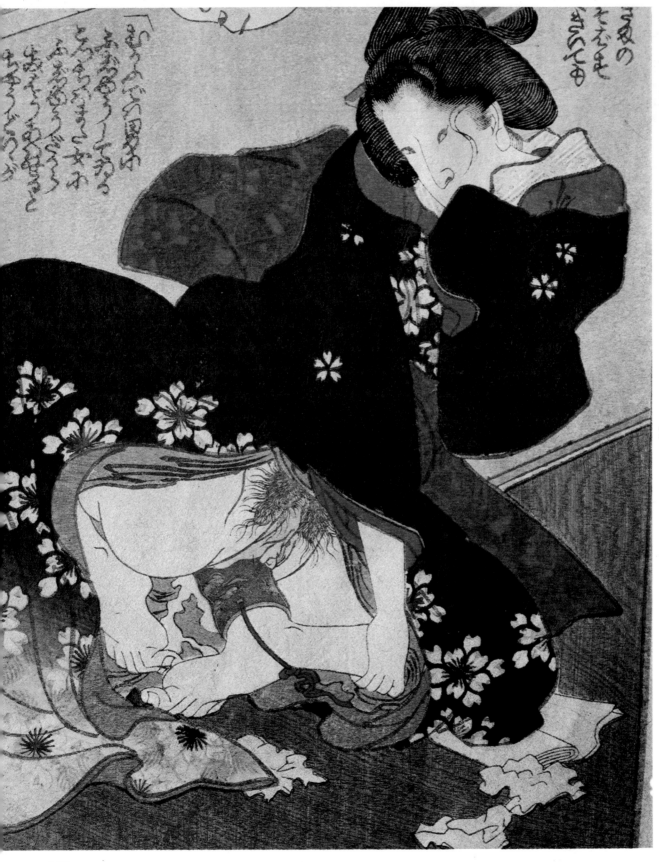

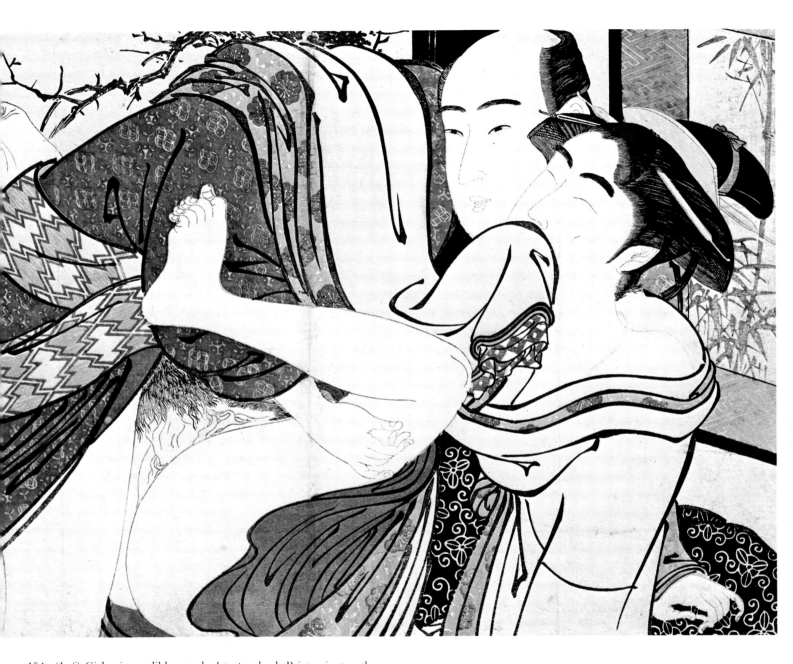

154. (*Left*) Girl using a dildo attached to her heel. Print, nineteenth century.

155. (*Above*) A courtesan with her lover. Ukiyo-e woodblock print from *The Poem of the Pillow* by Utamaro; eighteenth century.

making a cult of the actors; they decorated their persons with sword furnishings and fine carved buttons called *netsuke*, and filled their houses with paintings. They encouraged the development of a popular literature, especially translations of Chinese classics and newly written novels. They enjoyed literary gatherings, the Zen tea ceremony with its tea-wares, and flower arrangements. Most of all they enjoyed sex, and they had no inhibitions. Certainly wives were expected to be faithful while husbands were free to have relations with anyone they could, and it was quite normal for the master of the house to keep mistresses and maids at home. But there was in practice a good deal of latitude even for women, as the racy literature testifies; and there were certainly few inhibitions in humour. One seventeenth-century joke gives some idea of the atmosphere. A little girl runs indoors to tell her mother, 'Someone's drawn a mushroom on our front door.' 'Well,' says mother, 'Take this paper and rub it out.' The little girl goes out, then comes running back in. 'Mother, it wouldn't rub out; it just grew bigger.' 'Then it wasn't a mushroom, was it dear?'

A unique group of woodcut line illustrations from manuals of sex, most of them probably done in the early nineteenth century, gives an extraordinary insight into the scope of sexual pleasure accepted in Edo before the forcible opening of Japan to the West by the American Commodore Perry and his warships in 1858. They illustrate how knowledgeable the Japanese then were in sexual matters. Included in the pictures are objects which have become familiar in the West as part of the bequest of the old Japan that perished in 1945. These objects are still confined in many Western countries—which do not have the positive Japanese attitude towards sex and its manifestations, but rather a Christian prurience—to the grim ghetto of pornographic fantasy. Originally, of course, they were nothing of the sort.

Sexual sophistication

To begin with, the pictures register the ordinary male pleasure in looking at the genitals of women. In one picture a very high-class courtesan puts herself on display, virtually as if she were an icon. Then there are the sights in the female bathhouse; one girl has the enormously elongated inner lips known to Western gynaecology as the Hottentot apron, but more poetically in Japan as the long-tailed butterfly. There is an informative illustration for men of the general conformation of the vulva. And then there are images of girls caressing themselves and dreaming of love, one gazing out of the window, another doing calligraphy, a third studying an illustrated posture-book. The diagram M A S illustrates the finger positions most apt to stimulate a woman during sexual foreplay. Another series shows the preludes to lovemaking and a number of possible attitudes, including anal, domestic, and oral intercourse. Then comes a group

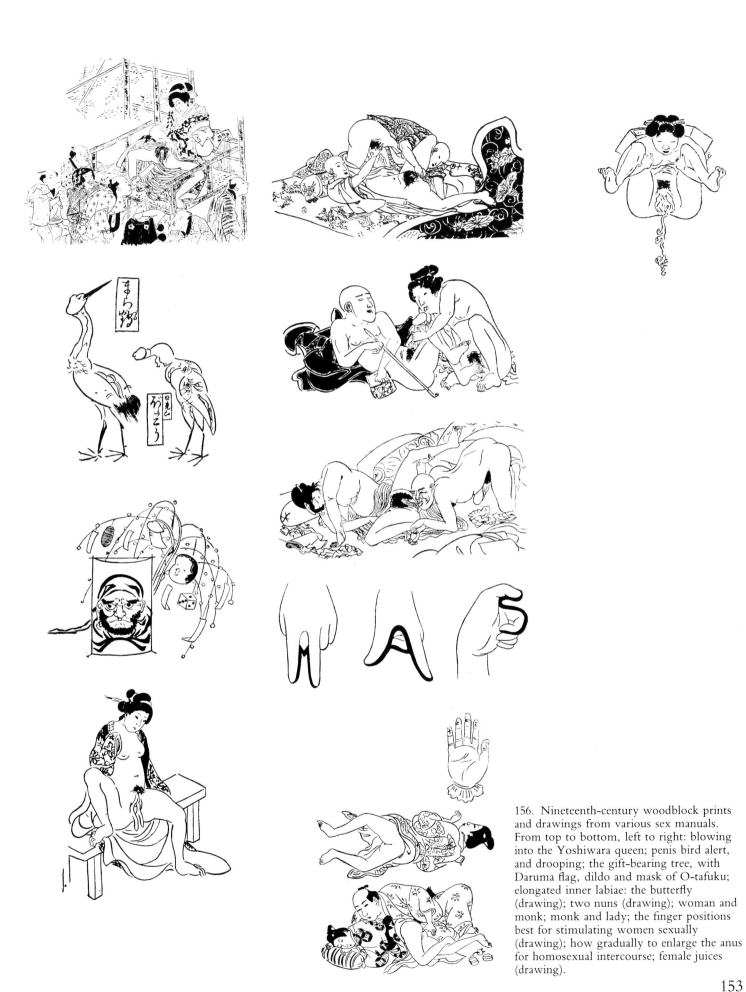

156. Nineteenth-century woodblock prints and drawings from various sex manuals. From top to bottom, left to right: blowing into the Yoshiwara queen; penis bird alert, and drooping; the gift-bearing tree, with Daruma flag, dildo and mask of O-tafuku; elongated inner labiae: the butterfly (drawing); two nuns (drawing); woman and monk; monk and lady; the finger positions best for stimulating women sexually (drawing); how gradually to enlarge the anus for homosexual intercourse; female juices (drawing).

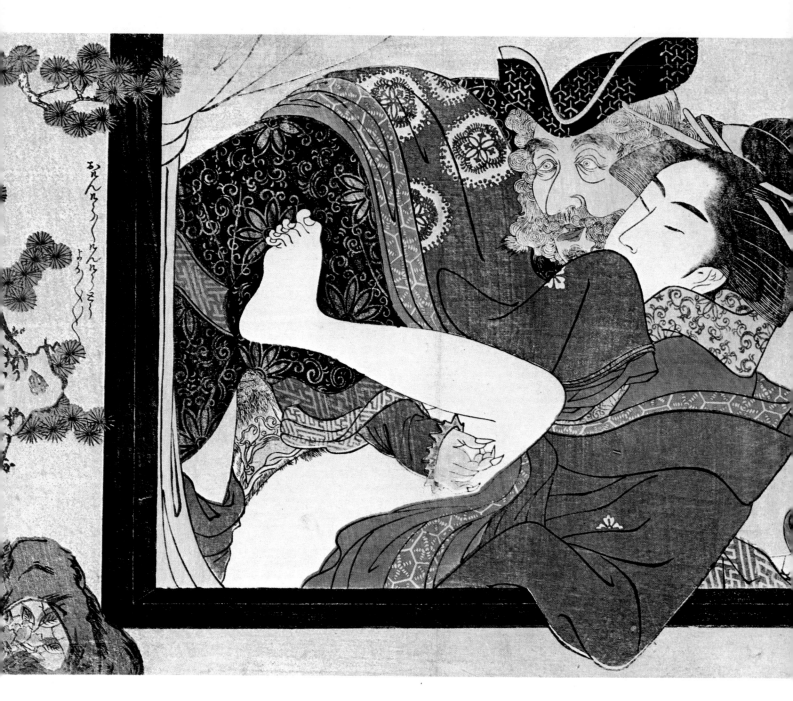

157. (*Above*) A foreigner with a courtesan. The Japanese thought Westerners – Dutch especially – in their vast eighteenth-century wigs to be amazingly ugly, uncouth and comical. Note the smoking incense-burner behind the girl's head. Ukiyo-e woodblock print from *Models of Calligraphy* by Eisho; c. 1800.

158. (*Right*) Mr Prick and Mrs Cunt. This personification of the sexual organs was not merely Japanese but for a long time international. Ukiyo-e woodblock print by Hokusai, nineteenth century.

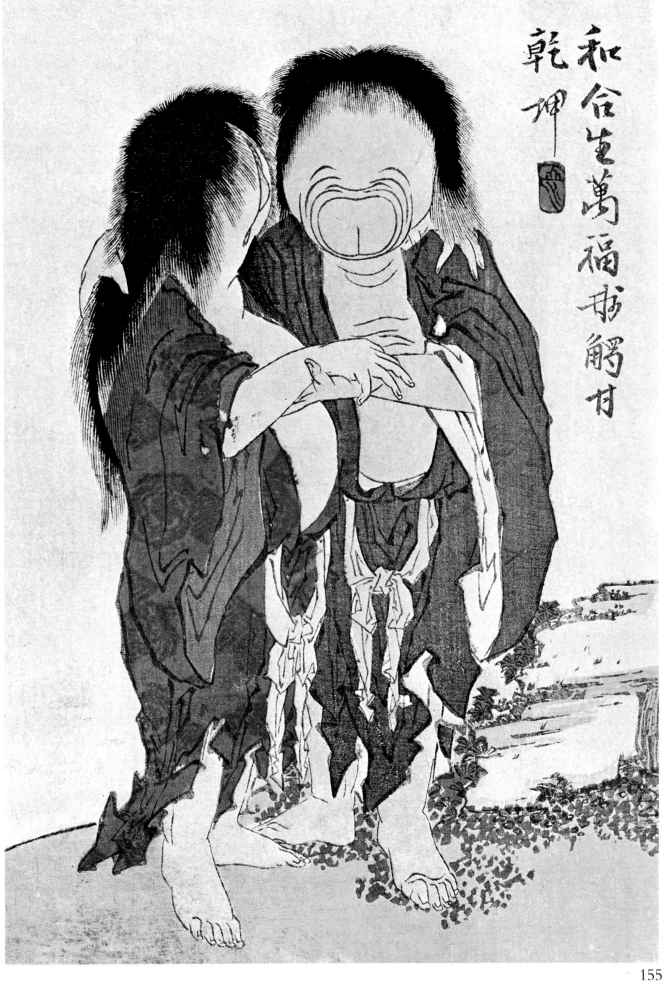

和合生萬福　解甘
乾押

155

159. More prints and drawings from sex manuals. From top to bottom, left to right: a dildo as mushroom; penis enlarger, called 'armour' (drawing); the dildo radish; dildo mounted in a roll of cloth; device for collecting female sexual juices, for use in medicine (drawing); the feminine stimulator (drawing); warming the dildo, by putting inside it a cloth wrung out in hot water (early eighteenth century); hand-operated dildo; using the heel-dildo with neck strap; ways of using the dildo fastened to the heel (drawing).

illustrating relations between women and Buddhist monks. One of them is called Shakuhachi, the Japanese word for the flute – a common metaphor in Arab countries and in the Renaissance West. There is a pair of lesbian Buddhist nuns, and two comic pictures illustrate stories: one of a husband returning in the nick of time, another of a woman who needs the services of a stonemason. Then come a series illustrating different aids to pleasure: the binding of the penis with bast-tape can come undone in use and the lovers are then joined, it is said, like the two great rocks off Ise peninsular, by their straw rope. There are considerable variations on what the Japanese call penis 'armour', suggesting all sorts of possibilities.

Many and varied are the means of solitary gratification, both for women and men. Among the women's instruments depicted is an object with bowl attached to receive the Yin effluent for use as a medicine; this reflects at least some knowledge of Chinese Yin-Yang theory. And so does the mildly stimulating instrument inserted, which seems similar to a type used in China. Soft paper was used for mopping-up; and cleanliness was *de rigueur*. In the male homosexual section there are instructions for progressive anal dilation with the fingers.

The next group of comic illustrations represent the sexual organs as independent animal entities with wills of their own – an ironical and sophisticated expression of the same ancient concept as that expressed in some of the Dosojin. It also appears in European erotic art of the nineteenth century. The Dragon Boat compounded out of sexual emblems embodies, at a semi-humorous level, the Sino-Japanese vision of the energy of nature as essentially sexual. Against the boat's sail can be seen branching penises; these are based upon the phallic carved wild-wood emblems sometimes used in traditional flower arrangements, and imitated by modern Japanese sculptors, for example Tajiri. The worldwide myth which tells of a demon taking the husband's place on his wedding night is also depicted. Another illustration is of a tree hung with paper prayer-strips and offerings to the founder of Zen Buddhism, Bodhidharma (Japanese: Daruma) with his sternly frowning face; among the offerings are a mushroom-penis, and a mask of Ame-no-Uzume, the Kami who did the sexy dance to entice the sun goddess from her cave. Phallic mushrooms, the stories say, were also used by cunning fox-spirits to bait traps in which they caught unwary girls. Finally there is a picture showing a Japanese version of the original and worldwide phallic rudery of slap-stick comedy on the stage.

One of the most important government institutions planned and set up by the Tokugawa Shoguns in Edo was the Yoshiwara. This was an entire quarter of the city dedicated to sexual pleasure and its auxiliary delights. It was intended to provide the bourgeois population with an outlet for feelings which might otherwise prove

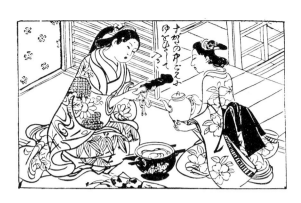

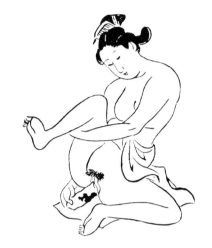

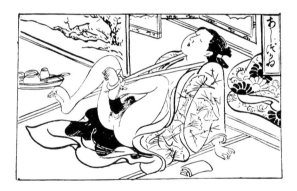

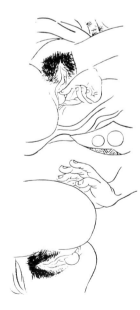

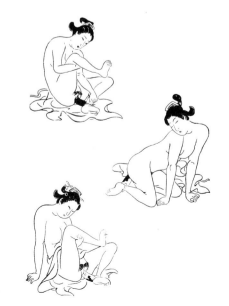

161. (*Opposite above*) Lovers. Woodblock print by an anonymous master, late seventeenth century. The looping lines give an intense expression of movement.

162. (*Opposite below*) Lovers becoming familiar. Woodblock print by Shuncho, late eighteenth century.

160. (*Below*) Tea after happy lovemaking. The elaborate and beautiful nude figures are influenced by European art. Ukiyo-e woodblock print by Kuniyoshi; nineteenth century.

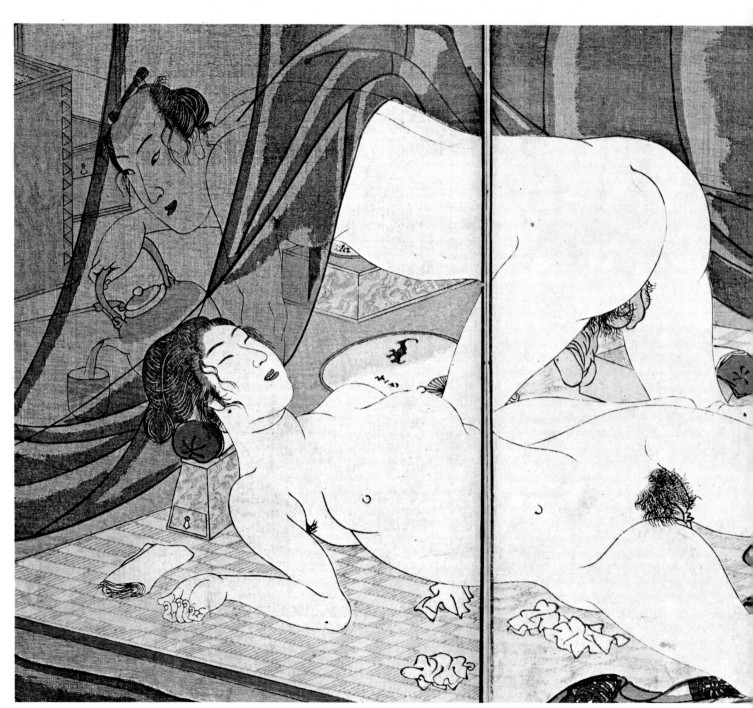

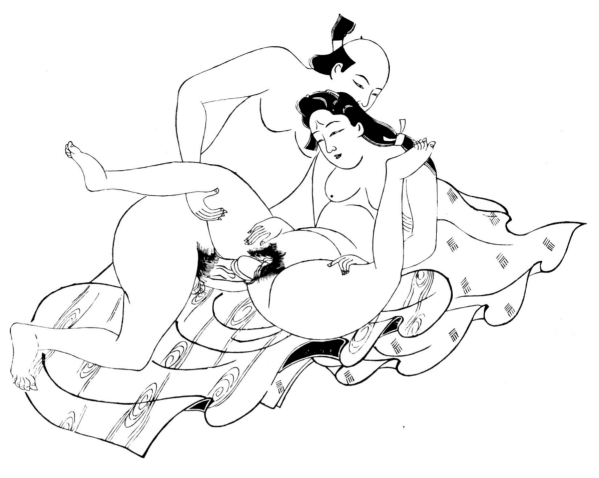

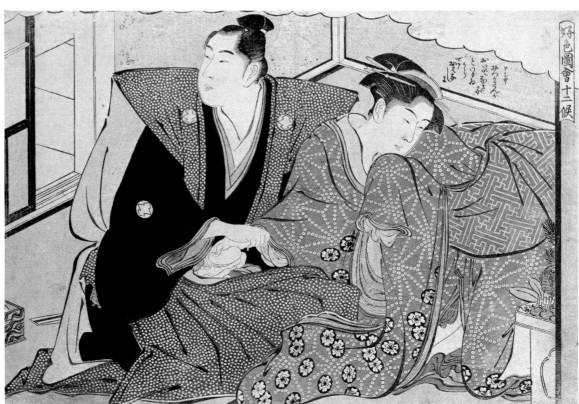

159

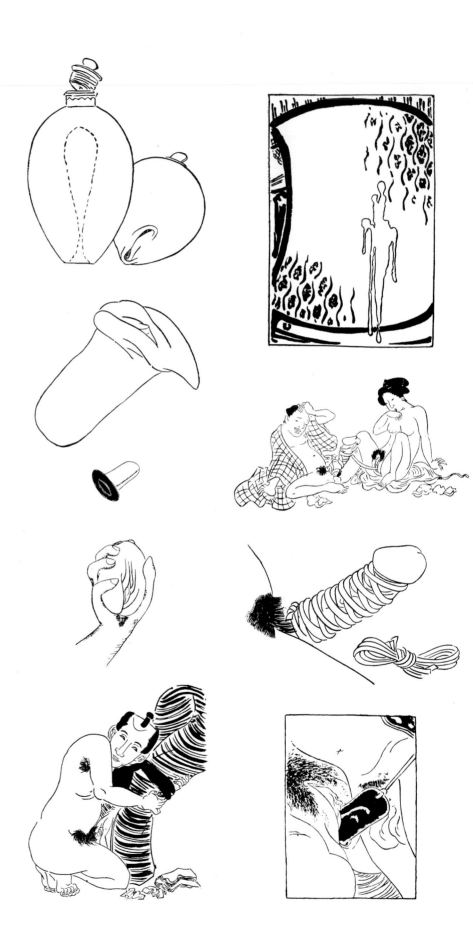

163. Group of prints and drawings from sex manuals. From top to bottom, left to right: artificial vagina (drawing); artificial vagina (drawing); artificial vagina (drawing); substitute woman (drawing); woman's sash-bow, after she has been caught up in a crowd; the penis-binding comes unwrapped (drawing); straw penis-binding, to preserve erection and prolong intercourse; 'engaging in armour'.

164. (*Opposite*) Games under the quilt-table (drawing); inverted oral intercourse (drawing); intercourse without penetration (eighteenth century); anal intercourse (drawing); no girl-friend; the sculptor's insatiable wife; intercourse with the woman above (drawing); the husband comes home in the nick of time; mopping up (drawing); cleaning (drawing); spirit-penises plunging into vulva-pots; the dragon-boat of sexual forces.

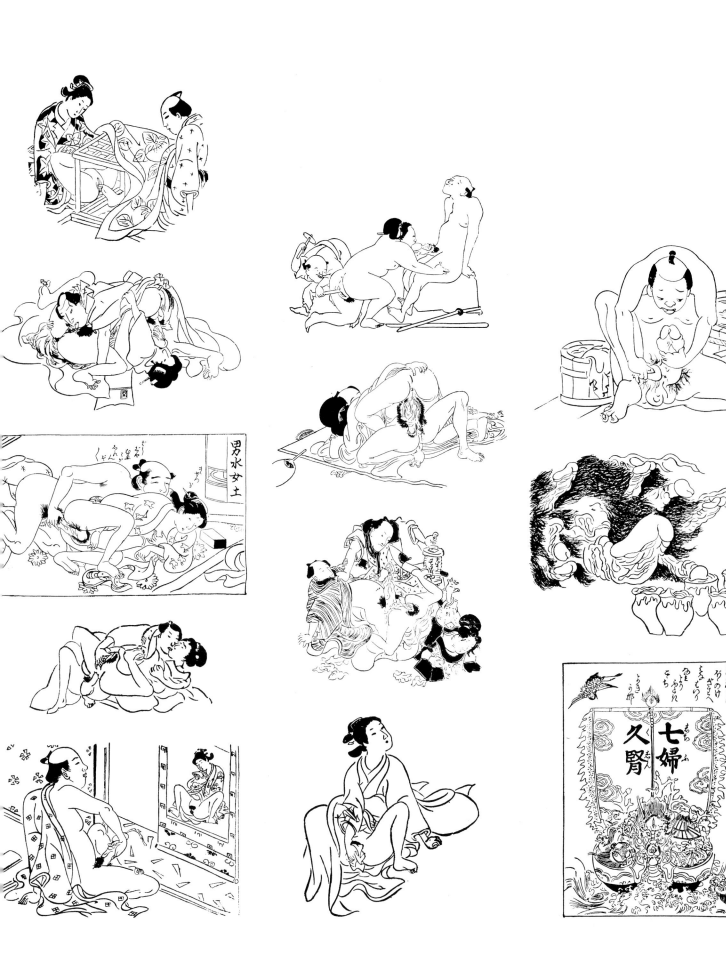

dangerous to the newly organized society. As Edo was the capital city containing the centralized totalitarian administration, it was usually full of men away from home – minor aristocracy, Samurai retainers and officials up from the provinces. It was sometimes referred to as 'a city of bachelors'.

Yoshiwara means 'rushy meadow' or 'meadow of good fortune'. The principal inhabitants were courtesans of different grades, and male and female musicians, called geisha. The entrance to it was along a curving street of tea-houses; then there was a gateway through which only doctors were permitted to ride in a sedan chair. No long weapons could be carried; and everyone, whatever their social rank, arrived on foot. Immediately inside was the broad main boulevard, always beautifully decorated, and planted down the centre with a row of great flowering cherry trees. It was lined with double-storeyed tea-houses and pleasure-houses.

The courtesans were called 'night-time cherry blossoms in full bloom', a phrase with strong overtones of regret at the quick passing of beauty. To right and left, side streets contained the main 'green-houses' where the courtesans sat, superbly dressed, in trellised windows. The splendour of their apparel was their chief method of enhancing their attractiveness. In fact, once when the government attempted to impose restrictions on the cost and design of courtesans' kimonos, the women sent an appeal asking for relaxation of the rule, because 'Unless we can dress ourselves superbly, how can we be different from ordinary women?'

The Yoshiwara and art

Courtesans were graded all the way down from the very highest, originally called Oiran, who were treated like goddesses. They wore the most luxurious and fashionable kimonos; the huge bow of the sash was tied at the front, to allow the full length of the back to be seen. They had several assistants and maids, and were staggeringly expensive. Fortunes were lost very quickly in the Yoshiwara; but the men who spent long, leisurely evenings and nights eating, drinking, smoking, reading, listening to music and making love in all the various grades of green-house, were happy to pay for these pleasures to the limit of their purses. The Yoshiwara was emphatically no mere red-light area on the grimy Western pattern; in every sense it was a genuine cultural centre. Indeed, among the geisha were artists of the highest accomplishment. They were not usually themselves prostitutes, though they might well become so if they lost their appeal as musicians. It was normal for women either to sell themselves to the green-house owners, or to be sold as children by their families, or to be themselves the children of courtesans, brought up to take a pride in their skills. They could then buy themselves out if they saved the

165. (*Opposite*) Four woodblock prints by Shuncho, c. 1800. Top left: the vulva, the gateway of life and pleasure. Below left: feminine masturbation. All sexual pleasure is good. Top right: entry. Human union re-enacts the benevolent union of the Dosojin. Below right: ejaculation, the internal realization of consummated union.

藝者開相

遊女開相

女房開相

肉具無骨「ホ子」ナクメ「ヘノコ」
アリスキ「ヒトタビ」クツチ
有鬚一怒
カツスルニ「ジヨ」ジヨ「ヤヤ」
且進徐徐
シキウ「カハ」ハ「ム」ニ
子宮半吞
キ「シモ「ノ」ツチ「ワイ」ゴトク
亀小「怒」ニ如
イ「モノ「ビ」タコ「ノ」
芋魚别章魚

necessary money, or be bought out by a lover. It is worth remembering that the Yoshiwara was only abolished in 1957; and that still today it is normal for Japanese companies to organize guiltless 'sex enjoyment' tours, especially around the countries of Southeast Asia, for their employees.

The canon of feminine beauty remained fairly constant, changing from the relatively plump in the later seventeenth century, to the taller and more elegant by the mid-eighteenth. Long black hair was perfectly coiffured into the current fashionable style to reveal the nape of the neck – always a focus of sex-appeal, like the delicate arms. Also admired were a straight nose, small white teeth, lips the colour of maple leaves in autumn, and eyebrows drawn in like small crescent moons on a virtually expressionless white painted face. (To the Japanese eye the 'expressive' face of the Westerner seemed demonic.) The torso should be long and willowy; and the lines of the body were enhanced by an exaggeratedly swaying walk – more of a shuffle perhaps—upon wooden clogs as much as eight inches high.

The life and ethos of the Yoshiwara provided the stimulus and the greater part of the subject matter for the Ukiyo-e artists, who were mainly painters and designers of prints, the latter usually being painters first. They decorated the interiors of the green-houses and the tea-houses, and painted what were virtually icons of the most famous beauties in their sumptuous flowered robes. One of the greatest such icon painters was Kaigetsudo Ando (c. 1671–1743). Many of these icons were overtly erotic. The painters also depicted the male actors who played both male and female roles in the Kabuki theatre; and they made many pictures and series dealing with the art and practice of sexual love. But it is for the art of the coloured woodblock print

166. (*Below*) Anal cosmetics. Painting from an erotic album, 'The Catamites' Scroll', dated 1321, the earliest surviving Shunga work.

167. (*Below right*) Illustration from an erotic posture album. Painted copy of an older work; original probably early seventeenth century.

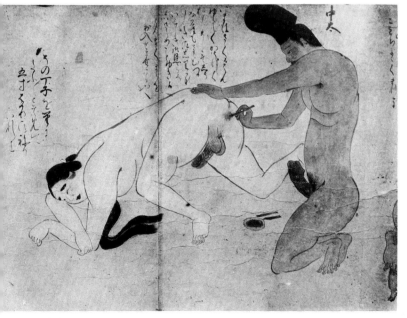
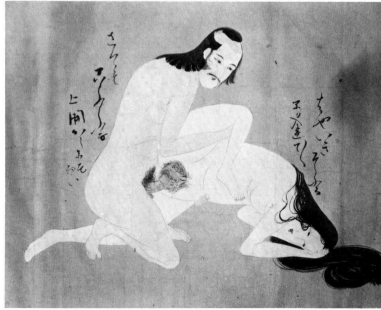

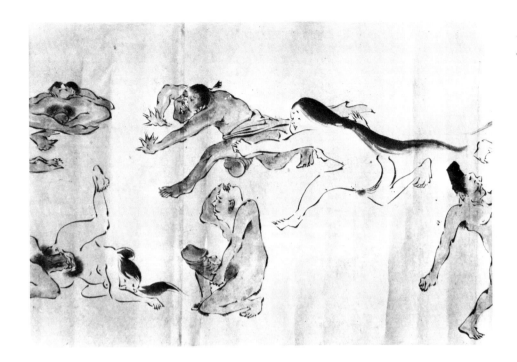

that the Ukiyo-e is best known in the West. For printing brought Ukiyo-e art within the financial reach of great numbers of people who could not have afforded paintings, and this gave a new impetus to the painters' invention.

It is significant that the great period of the development of the print-illustrated book and the independent print in Japan coincides in time with the flowering of figurative and erotic print art in Ming dynasty Nanking. There was certainly a strong influence from China, though, of course, printed books had been made earlier in Japan. But what happened in the Ukiyo-e print has never been matched in the history of the world's art. Between about 1660 and 1860 a galaxy of artists of genius poured out a torrent of designs for prints. These were executed by large workshops of immensely skilled block-cutters and printers, maintained or employed by wealthy publishers. All subjects which could possibly appeal to the eye of the Edo purchaser were exploited. At least 40 per cent of the output was overtly erotic Shunga. Among the greatest names are Moronobu (d. 1694), Sugimura Jihei (*fl.* 1680s), Kiyonobu (1664–1730) and Kiyomasu (*fl.* 1696–1720s), Masanobu (1686–1764), Harunobu (1725?–70), Buncho (d. *c.* 1780), Koryusai (eighteenth century), Shunsho (1726–92), Kiyonaga (1752–1815), Utamaro (1753–1806), Hokusai (1760–1849), and Kuniyoshi (1797–1861).

It is important to realize that this art overrides completely the facts and attitudes from which it sprang. The Buddhist and Confucian morality of Japan disapproved of it as much, for their own reasons, as Western moralists and feminists are likely to. But Japanese men and women were accustomed to accommodating themselves to their

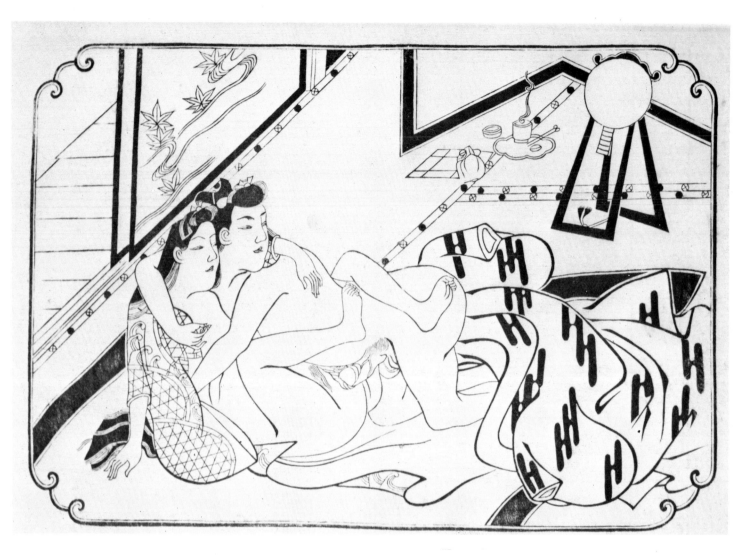

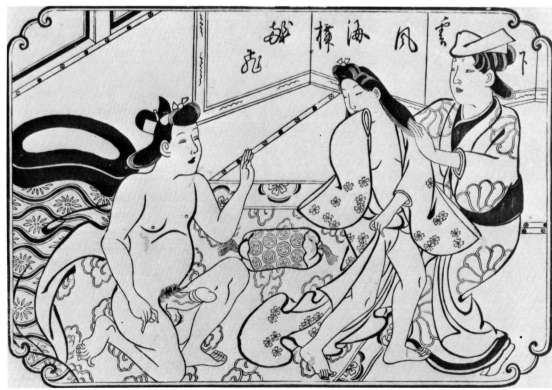

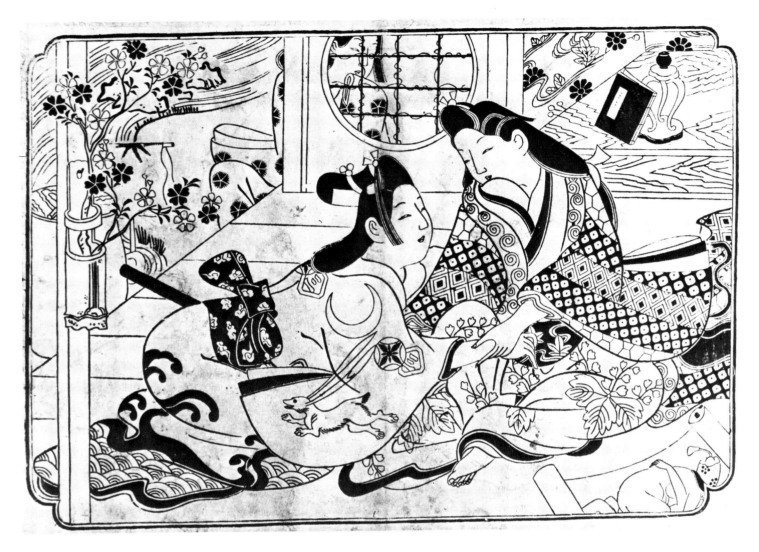

social position, their fate; and then to taking pride in the perfection with which they could accomplish their duties. Individualism in the modern Western sense was unknown virtually until this century.

The imagery of pleasure, with its erotic overtones, led artists to achieve skills, and insights into form and expression, which nothing else could or did. It is impossible to believe that a purged art without any real sexual end in view could ever have led to achievements of this kind or intensity. The point of every one of the thousands of prints representing courtesans, beauties, and many other subjects, is that in the last resort they represent realities. The image is imbued with the force of a sexuality which is accepted, not denied – this defines its difference from Western pornography. In explicit Shunga extraordinary attention is paid to the genitals. They are hugely enlarged, and made the focus of calligraphic development. Penises are magnificently ribbed, collared and veined; vulvas extravagantly pleated and mobile, adorned with luxuriant hair.

This focus on the genitals can not, despite what one or two Western 'medical' writers of Freudian cast have asserted, be attributed to centuries-long and nationwide sexual anxiety, but rather to the ancient Japanese reverence for sex as a sacred energy, the creative and benevolent force of creation. The sexual engagement in the image is, so

171. The young man makes overtures to the lady; another young man is spying in the background. Woodblock print attributed to Sugimura; late seventeenth century.

169. (*Opposite above*) Making love in front of a mirror. Woodblock print by Moronobu, late seventeenth century.

170. (*Opposite below*) The reluctant girl. Woodblock print by Moronobu, late seventeenth century.

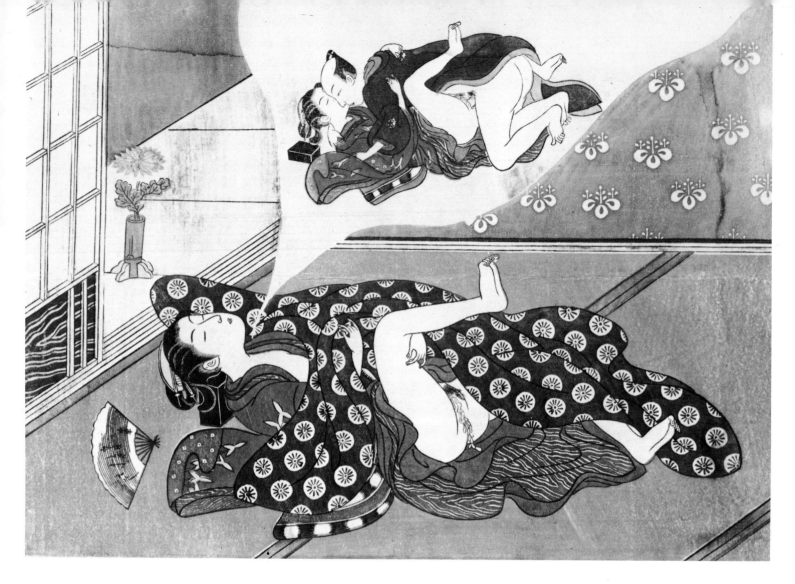

to speak, greater than the mere human actors. We know that eroticism in art, once it is openly avowed and familiar, ceases to be interesting or stimulating merely for its own sake. It keeps its interest only through the quality of its art. Once the communication-system of the art develops to a high level of sophistication, the momentum of the feelings embodied in the language enables artists to reach new insights into the forms of our experience of reality. This is what all great art does. And, however we may view its moral base, this too the Ukiyo-e Shunga print does.

Style and erotic expression

The basis of the language of both the painting and print of Edo is the sinuous and mobile line. This line is interpreted as the visual edge of something. When that something is an attractive human body, male or female, the only edges the art recognizes are those of the body itself and of individual limbs, of the face with nose, eyes, lips, hairline and eyebrows. In late Ukiyo-e the rough bodies of men especially may be given edges of musculature or pleats of skin. Very often an entire bent limb, or the whole sweep of a back from neck to thigh, may be given a single mobile contour which conveys the gesture it is making. Movement, based on the original gesture of the brush in

the act of drawing, is the essence of all such linear art.

It is not true, as is sometimes said, that Ukiyo-e Shunga do not represent nudes. They do. But the folds of kimonos and of under-robes offered a wealth of edges which the artist could latch onto and use, to fill his image with suggestions of movement. So, too, did the exaggeration of the genital organs. From this we can recognize their aesthetic importance. So the erotic pictures are filled with references to the movements of the lovers in time. There is no attempt whatever to convey rational volume or a consistent rectilinear geometry of space. There are, therefore, no logistic problems over representing the sexual organs of people engaged in deep intercourse. Depth is suggested by complex sequences of overlaps among the edges. The compositions of these works are filled with repetitions and variations of linear themes, with echoing series of lines, and with lines projecting themselves by invisible vectors across open space to carry on their movement into other lines. For example, the upper contour of a leg may continue in the pleat of a coverlet, and ultimately connect with a vase in the background. Such webs of line give a convincing unity and sense of presence to the exquisite image.

The stylistic development of the art of the print runs from an apparent simplicity in the early years of the 1660s, through an inter-mediate phase of delicacy, to an increased complexity towards the

173. (*Above*) Submarine rape by Kappa monsters of a diving Awabi fisher girl. Woodblock print by Utamaro; late eighteenth century.

172. (*Opposite*) The sleeping girl's passion is aroused by her dream of love. Colour woodblock print by Koryusai; eighteenth century.

end of the eighteenth century. The great earlier artists, such as Mo-ronobu, Sugimura, Masanobu and Kiyonobu, worked in few and clear black contour lines, winding slowly and joining to embrace well-defined areas of paper. The design is punctuated by blocks of black, on the hair and sash, for example. Some of these works were hand-coloured, usually in red and green with touches perhaps of other tints – flesh or blue. This can be interesting; but the designs were actually conceived as pure monochrome printed from a single block. The types of the lovers are always physically robust, the women in particular being plumply rounded, with tiny hands and feet.

It was Harunobu who introduced a radical change into the artistic attitude of Shunga. He developed the technique of using several separate blocks to print a number of different colours in one design, added to a dark grey outline key block. This in itself led to important

174. (*Below*) Love by moonlight. Colour woodblock print by Masanobu; early eighteenth century.

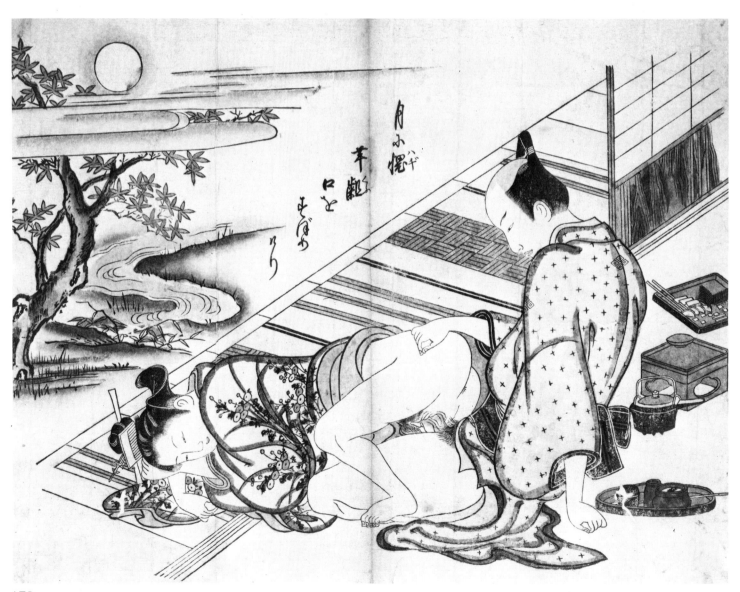

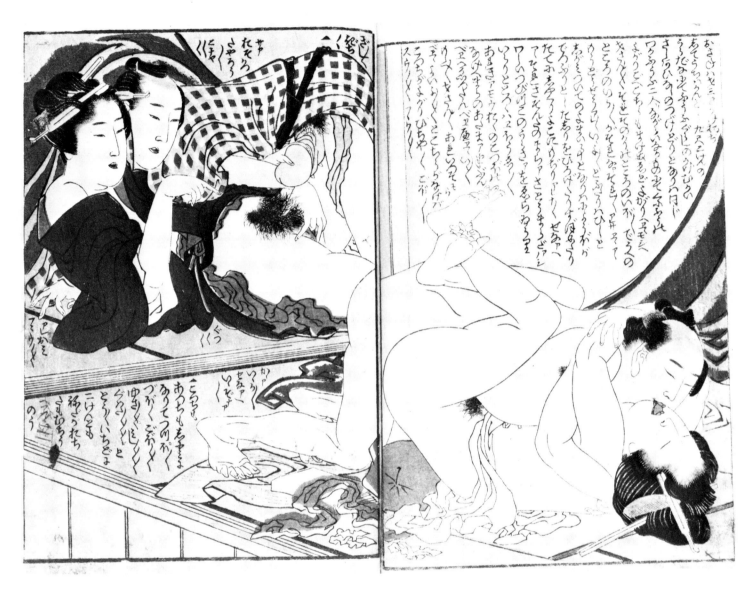

175. Page opening from a Shunga book: sexual satisfaction is happiness. Woodblock print by Hokusai; early nineteenth century.

aesthetic changes. In addition, he evolved a type of female beauty totally different from his predecessors'. She is small, slim and child-like, but sublimely and unconsciously elegant. Harunobu's designs remain relatively simple, with few figures set off by the overall colours of the print. But his imagery often moved out of the indoor setting of green-house usually inhabited by the lovers drawn by his predecessors; his beauties are often ordinary women, simply dressed, running indoors out of the rain, or making love in the street at night. His pupil Shuncho produced some beautiful work. Another pupil, Koryusai, followed in his footsteps for a while, but then moved to the larger format which was becoming popular. Using this format Koryusai produced some superb compositions of courtesans and their attendants, invested with iconic splendour by dense counterpoint of sweeping lines. He also produced numbers of the long and very narrow vertical or horizontal 'pillar prints', supposedly meant to be

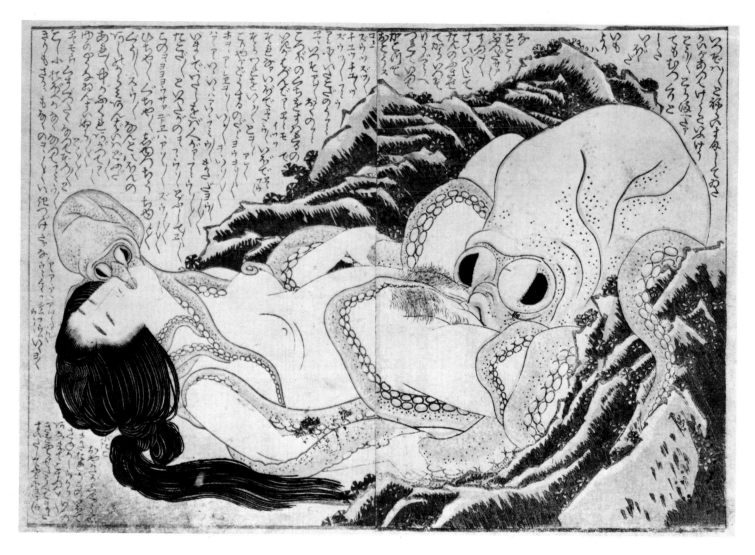

176. The amorous octopus, a female fantasy. This conveys a physical sensation very powerfully. Colour woodblock print by Hokusai; early nineteenth century.

stuck to the interior woodwork of the Japanese room. These produce tantalizing glimpses of sexual activity, as if through an aperture that cuts off large parts of the figures, leaving something to the imagination. They thus anticipate the charm of the photographic 'cut out' discovered by European painters about a century later.

With Utamaro, Shunga prints reached an extraordinary peak of achievement and inventiveness. His magnificently melodic looping lines are full of personal feeling. In his greatest works the figures are large-bodied and strong, seen so close up that they extend far beyond the frame of the format.

After Utamaro the general style of Ukiyo-e as a whole veered towards an emphasis either upon detail at the expense of poetic expression, as with Hokusai, or on hardness, as with Eisen, Kuniyoshi and Kunisada. Shunga were still made in the twentieth century.

The range of interest represented in Shunga prints also had its own history. The enduring core was always the imagery of enjoyment and lovemaking in the Yoshiwara green-house, with pictures of individual famous courtesans. The earliest Shunga book printed in 1660 dealt precisely with this subject matter. And the very earliest individual prints were Shunga, preceding non-Shunga work. A great many non-Shunga prints deal with the life of the courtesans, showing them

172

dressing or undressing in fashionable clothes, changing them with the seasons, viewing the cherry blossom, or listening to music. So in practice the erotic interest spills over onto apparently non-erotic works – which lose a lot of their point if one does not know the Shunga to which they are naturally connected. The Yoshiwara Shunga may show a man with one or two girls in a great variety of extravagant postures. The couple are usually indoors perhaps framed by a screen or curtain, while girl attendants may make tea nearby. But other popular subjects moved altogether out of the atmosphere of the Yoshiwara into the domestic realm. Husband and wife make love at home while one or other distracts a child with butterflies or a mask – perhaps a common necessity in the small Japanese house.

By the mid-eighteenth century all kinds of other subjects had been introduced, including monks with courtesans, men making love with Awabi fisher girls or with peasant girls planting rice, people making love in sedan chairs, in the country or the street at night. One very popular subject was a lover creeping into a room at night to make love to the wife while her husband sleeps on. Amazing and comically hairy Europeans in full-bottomed wigs make love to Japanese girls. A girl makes love with her lover in the countryside, while the little brother she has to look after pesters them. Two bandits ravish a girl among rocks. A cat participates on the balcony. And always the setting contributes to the meaning of the whole.

These magnificent works of art present ideas which were the common property of all the inhabitants of Edo. They both record and glorify what went on, sometimes reaching out beyond the actual, but never collapsing, as so much Western erotic art does, into total fantasy. The citizen of Edo was thus furnished with a vision of the splendour of human sexual love, which could, no doubt, enhance his or her own erotic experience. But this splendour was a secular reflection of the originally divine archetype of male-female Kami, shining through the otherwise distracting veil of city life.

Acknowledgements

The author and John Calmann and Cooper Ltd. would like to express their thanks to the following for permission to include reproductions of the paintings, prints and objects illustrated in this book.

The owners are: Gulbenkian Museum of Oriental Art: 68, 73, 74, 79, 80, 94, 96, 100, 103, 111, 114, 119; Victoria and Albert Museum: 44, 52, 72, 76, 81, 83, 85, 99, 112, 115; Victor Lownes: 45, 48, 49, 54, 55; C. T. Loo Collection: 84, 86, 87, 90, 91; Ella Winter: 92; François Duhau de Bérenx Collection: 97, 98; Tokyo National Museum: 126; Philip Goldman Collection: 14, 24; Private collections: 10, 53, 127, 133, 135, 138, 139, 143, 147, 148, 155, 157, 158, 160, 162, 165, 176.

The following were supplied by courtesy of the Art Institute of Chicago: 161 (Gift of Robert G. Sawers), 170 (Kate S. Buckingham Collection), 171 (Gift of Kate S. Buckingham – Clarence Buckingham Collection). Plates 1, 75, 77, 82, 89 came from the collections of the Institute for Sex Research Inc., Indiana University. Plates 131, 132, 172, 175, 177 were supplied by courtesy of the trustees of the British Museum.

The following kindly supplied photographs: Gulbenkian Museum of Oriental Art: 52,68, 73, 74, 79, 80, 94, 96, 100, 111, 114; Victoria and Albert Museum: 81, 83, 85, 99, 115; Jean-Loup Charmet: 101, 102, 106, 107, 110, 120, 121; Cooper-Bridgeman Library: 103, 104, 118, 119, 149–153; Zauho Press: 126; British Museum: 131, 132, 172, 175, 177; Art Institute of Chicago: 161, 170, 171; Institute for Sex Research Inc., Indiana University: 1, 75, 77, 82, 89; Wolf Suschitzky: 3, 11, 19, 22, 25, 27, 61; Ikeda Shoten: 2, 9, 128, 136, 137, 141, 142, 144, 145, 146; Alan Hutchison Library: 4, 18, 21 (photographer, Patricio Goycolea); MacQuitty International Collection: 23; Werner Forman Archive: 13, 14, 24, 51, 59, 154; Virginia Fass: 17; Robert Harding Picture Library: 20; Ann and Bury Peerless: 16, 62; Roger-Viollet: 31, 32, 34, 39, 47, 58; Giraudon: 36, 65; A. C. Cooper: 10, 44, 72, 76, 112, 139, 165, 176.

We should also like to thank the Office du Livre in Switzerland for supplying the illustration material for plates 84, 86, 87, 90, 91, 97, 98.

Index